CANON EOS
1000D/REB

THE EXPANDED G

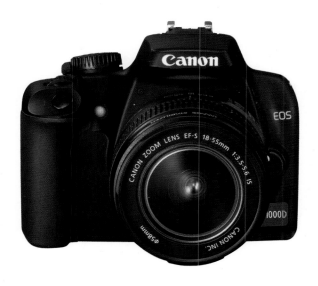

AMMONITE
PRESS

CANON EOS
1000D/REBEL XS

THE EXPANDED GUIDE

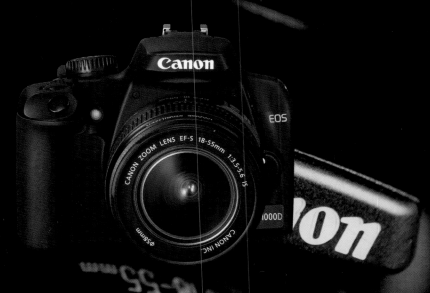

Andy Stansfield

AMMONITE
PRESS

First published 2009 by
Ammonite Press
an imprint of AE Publications Ltd
166 High Street, Lewes, East Sussex BN7 1XU

ISBN 978-1-906672-21-8

British Library Cataloguing in Publication Data:
A catalogue record of this book is available from the British Library.

Editor: Tom Mugridge
Design: Fineline Studios

Typefaces: Frutiger and Palatino
Colour reproduction by GMC Reprographics
Printed and bound in China by Hing Yip Printing Co. Ltd.

Contents

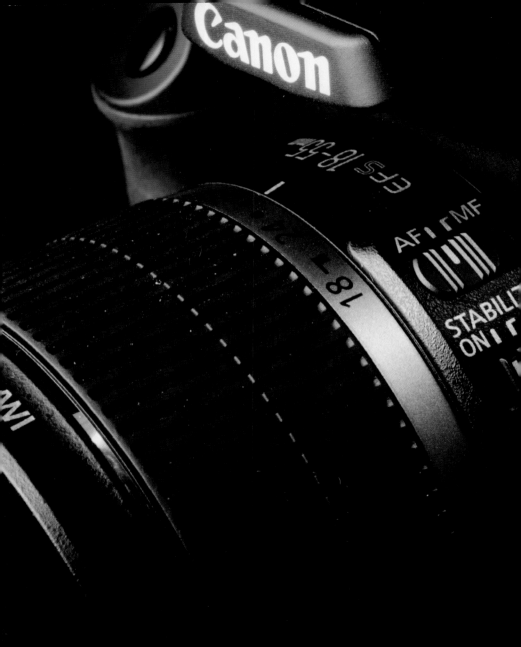

Chapter **1**

EOS

Overview

The EOS 1000D/Rebel XS is the latest entry-level model in Canon's wide range of digital SLRs. This outstanding

First announced in the spring of 2000, the D30 offered a resolution of just over 3 megapixels, 3-point autofocus and a burst of three JPEGs. Its monitor was just 1.8in (4.5cm) and could only be used for reviewing images already captured. By comparison, the new norm for an entry-level DSLR (digital single lens reflex) camera is 10 megapixels, a self-cleaning sensor, a larger monitor enabling Live View for detailed composition, and a set of adjustable Picture Styles that include built-in monochrome filter settings.

The professional EOS-1D series is also leaping ahead in specification, but if you want 21 megapixels, 10 frames per second or 45 AF points

camera evolved from the EOS D30, picking up technical developments from the EOS-1 range along the way.

you should expect a significantly higher outlay. These are not the only improvements but they illustrate the progress Canon have made in terms of speed, convenience and flexibility in the digital SLR market.

From film to digital

Back in the mists of time – or at least in the mid-1980s, when camera and lens designers were suddenly making huge inroads in forging new links between electronic and optical components – Canon designers were pre-empted by autofocus SLRs from first Minolta, then Nikon. An intense two-year period of research and development followed for Canon who saw that these new cameras would ultimately form the basis of an extensive and flexible system, so every aspect of the camera needed to be stylish as well as practical.

In March 1987 they put their ideas to the test with the launch of the first EOS model. EOS stood for Electro Optical System and the camera in question was the EOS 650, which was soon to receive the

8

accolade of European Camera of the Year. Eos was also the Greek goddess of the dawn, described by the ancient writer Hesiod as 'Eos, who brings light to all the mortals of this Earth'. Fanciful perhaps, but appropriate for the name that heralded the most successful series of developments in the history of photography. Ironically, the goddess Eos was the daughter of two Titans. Minolta and Nikon, perhaps?

During the next two years, new models appeared in the form of the EOS 620 and the EOS 630, but the most significant launch was reserved for the EOS-1, which was specifically designed to lure professionals away from other manufacturers' models. To support this drive to attract the high-end user, Canon also had to develop its lenses and worked hard to reach the forefront of lens technology. In particular, they needed to develop a superfast autofocus system that would work in all lighting conditions with the large-aperture lenses favoured by press and sports photographers.

By late 1994, Canon were ready to introduce a new top-of-the-range model in the form of the EOS-1N, which introduced much quieter operation, 5-point AF and a 16-zone evaluative metering system. Its high-speed sister, the EOS-1N RS, boasted a drive capable of ten frames per

second. While Canon continued the evolution of its amateur SLRs, introducing innovations such as eye-control focusing, the EOS-1N continued to serve professionals well for half a decade.

A new flagship model, the EOS-3, was launched in November 1998, by which time the key areas of metering and autofocus were undergoing rapid development and Canon were about to embark on a decade of model upgrades every 18–24 months.

The EOS-3 utilized a 21-zone metering system linked to AF points, of which there were eventually 45. This increased the speed of operation further, especially when combined with the eye-control system.

EOS RANGE
The EOS range began in 1987 with the EOS 650, when Canon chose to abandon mechanical connections between lens and camera, replacing them with a real-time electronic interface.
A huge range of cameras, lenses and accessories is now available. At the time of writing, Canon's top-rated film SLR in this range is the EOS 1V.

The EOS-3 also featured a top shutter speed of 1/8000 sec, along with a claimed lifetime of at least 100,000 shutter operations.

The EOS-1V was introduced in the spring of 2000 with high-speed continuous shooting of up to 9 frames per second and 20 custom functions that could be tailored to each individual. The EOS D30, also launched in 2000, brought into play an affordable digital SLR aimed at the non-professional enthusiast. With its Canon-developed CMOS sensor, the EOS D30 could boast the smallest and lightest body in this sector of the market.

The digital revolution

The EOS D30 also heralded a new approach to photography in which those with little experience could access the capabilities of a complex tool using the now-familiar Basic Zone settings indicated by symbols on the Mode Dial. Further foolproofing was added in the form of a 35-zone evaluative metering system and E-TTL (electronic through the lens) metering for its built-in flash. Canon RAW image files could now also be selected instead of JPEG files.

The EOS-1D was introduced in 2001, followed in 2002 by the EOS-1Ds. These digital versions of the renowned professional camera took specifications and speed to staggering new levels, and recent updates have continued the trend.

In early 2003 the EOS 10D was introduced as a high-specification mid-range camera for the serious enthusiast, and it has since been upgraded several times. The most recent incarnation is the EOS 50D, with its 15.1Mp sensor, 6.3fps drive, DIGIC 4 processor and ISO range up to 12,800.

With the EOS 1000D/Rebel XS the upward spiral of technological development, spearheaded by Canon, has finally been matched by the downward spiral in prices. While the 1D series of professional cameras continues to be the vehicle for the introduction of state-of-the-art features, these developments now

EOS 10D AND BATTERY GRIP
Introduced in early 2003, the EOS 10D was a high-specification mid-range camera for the serious enthusiast.

10

filter down to entry-level cameras very quickly. For example, Live View was first introduced in February 2007 in the EOS 1D Mk III, an expensive high-end camera aimed primarily at professionals. Within 18 months, the same feature had been added to the EOS 1000D/Rebel XS, an entry-level model with a price to match.

New refinements aren't always developed first for Canon's range of professional cameras. The EOS 300D led the introduction of smaller and lighter entry-level cameras, and with it came the development of a completely new lens mount.

The EF-S range of lenses uses a different lens mount from the established line of EF lenses, and makes extensive use of lightweight design and construction to match

the high-specification yet extremely light bodies of the EOS 450D and EOS 1000D/Rebel XS. They have also been used to help refine the Image Stabilization system that is used increasingly on Canon lenses.

With the introduction of the EOS 50D shortly after the launch of the EOS 1000D/Rebel XS, and the EOS 5D Mk II a few weeks later, Canon's DSLR range is now better than ever. Every level of photographic experience and ambition is catered for, with the added benefits of an extensive system of lenses, accessories and software designed specifically for the Canon user.

Those interested in the history of camera technology are advised to visit Canon's fascinating website at www. canon.com/cameramuseum.

EOS-1D MK III
The press photographer's workhorse, but the enthusiast's dream.

EOS 300D/DIGITAL REBEL
This model introduced DSLR photography to unprecedented numbers of amateurs.

Main features

Body

Dimensions: 126.1 × 97.5 × 61.9mm
Weight: 450g
Construction: stainless steel/plastic
Lens mount: both EF and EF-S.
Caution: operating environment:
0–40°C at maximum 85% humidity

Sensor & processor

The 1000D/Rebel XS uses the same
DIGIC III processor found in the EOS-1
range. The self-cleaning image sensor
is a 22.2 × 14.8mm CMOS type with
10.1 effective megapixels.

Focusing

Three different autofocus modes
including predictive autofocus can be
selected to suit static or moving
subjects: One Shot, AI Focus or AI
Servo. Both automatic and manual
selection of the seven AF points is
possible. The AF system's working
range is from EV -0.5 to EV 18 at 23°C
at ISO 100. Autofocus lock is possible
in One Shot mode and when using
flash an AF-assist beam is triggered if
selected within the Custom Functions.
Autofocus is not possible on lenses
slower than f/5.6, or effectively slower
than f/5.6 when using a teleconverter.

Exposure

The 35-zone silicon photocell sensor
provides three full-aperture TTL
metering modes: Evaluative (linked to
AF points), Partial (10% at centre), and
Centre-weighted Average metering.
The metering range is EV 1 to EV 20
at 23°C at ISO 100 using a 50mm f/1.4
lens. Both exposure compensation
and 3-shot auto-exposure bracketing
are possible to a maximum of +/-2
stops using either ½- or ⅓-stop
increments. Automatic ISO setting can
be selected between ISO 100 and ISO
800. Alternatively, manual settings
can be used in one-stop increments
between ISO 100 and ISO 1600.

File types and sizes

The JPEG file sizes that can be recorded
by the Canon 1000D/Rebel XS range
from large/fine 3888 × 2592 pixels to
small/normal 1936 × 1288 pixels with a
choice of fine or normal for each of the
large, medium or small settings. RAW
files are recorded as 3888 × 2592 pixels.
Simultaneous recording of 12-bit RAW
and large JPEG files is also possible.
Both sRGB and Adobe RGB colour
spaces are supported.

Flash

Using the established E-TTL II
metering system, the built-in flash
on the 1000D/Rebel XS has a
guide number of 13 (metres) at ISO
100 and synchronization is 1/200
second. Auto and manual modes
are provided along with selectable
red-eye reduction. Flash bracketing,
flash exposure compensation, and
second curtain synchronization are all
supported. Wireless multiple-flash is
possible with EX series Speedlites.

LCD monitor

The 2.5in (6.4cm, diagonal) monitor
with seven selectable levels of brightness
makes it easy to review captured images.
It can be used in Live View mode for
composing and checking fine detail
and will be of greatest benefit to
those working on a tripod in stable
lighting conditions. Magnification of
×5 and ×10 plus vertical and horizontal
scrolling of the magnified portion of
the image assist this process. Manual
focus is the norm in Live View mode.
Autofocus in Live View can be achieved
but the monitor display is interrupted
and you must return to normal
Live View mode in order to fire the

shutter. Flash exposure, continuous
shooting and depth-of-field preview
can all be used in Live View mode
but metering is restricted to evaluative
metering regardless of setting. The
LCD monitor's display of shooting
information and its image review
function can both be customized in
order to preserve battery power.

Custom Functions

12 Custom Functions are supported,
with a total of 32 different settings.

Memory card

SD card or SDHC card.

Software

ZoomBrowser EX/ImageBrowser,
PhotoStitch, EOS Utility including
Remote Capture, Picture Style
Editor, Digital Photo Professional
(for RAW image processing).

Full features and camera layout

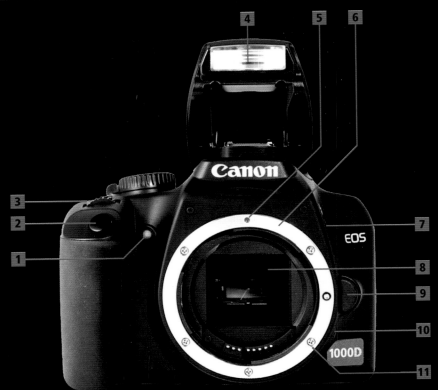

FRONT OF CAMERA

1 Self-timer light

2 Shutter release button

3 Main Dial

4 Built-in flash

5 EF lens mount index

6 EF-S lens mount index

7 Flash pop-up button

8 Reflex mirror

9 Lens release button

10 Depth of field preview button

11 Lens mount

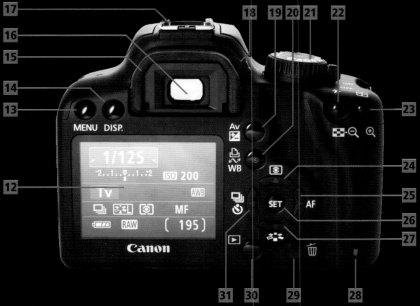

BACK OF CAMERA

12 LCD monitor

13 MENU button

14 Shooting settings/Trimming orientation button

15 Eyecup

16 Viewfinder eyepiece

17 Hotshoe

18 Dioptre adjustment

19 Aperture/Exposure compensation button

20 White balance/Print/Share button

21 Mode Dial

22 AE lock/FE lock/Reduce/Index button

23 AF point selection/Enlarge button

24 Metering mode/Jump button

25 AF mode button

26 Setting button

27 Picture Style selection button

28 Access lamp

29 Erase button

30 Playback button

31 Drive mode button

TOP OF CAMERA

32 Focal plane mark

33 Camera strap eyelet

34 Lens release button

35 Hotshoe

36 Shutter release button

37 Main Dial

38 ISO selection button

39 Camera strap eyelet

40 Power on/off switch

41 Mode Dial

42 Dioptre adjustment

LEFT SIDE

43 Video out terminal

44 Remote control terminal

45 Digital terminal

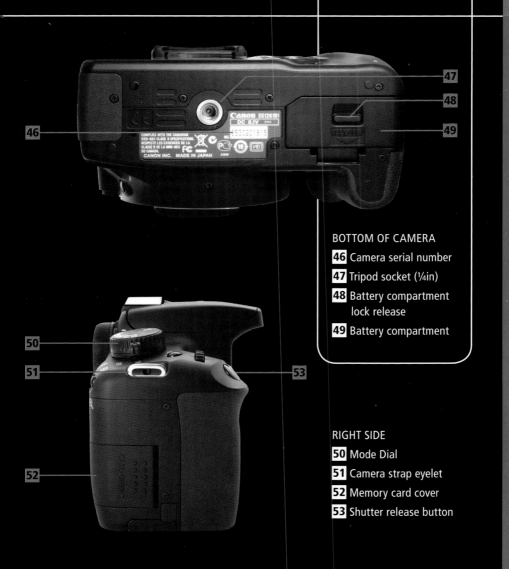

BOTTOM OF CAMERA

46 Camera serial number

47 Tripod socket (¼in)

48 Battery compartment lock release

49 Battery compartment

RIGHT SIDE

50 Mode Dial

51 Camera strap eyelet

52 Memory card cover

53 Shutter release button

Viewfinder display

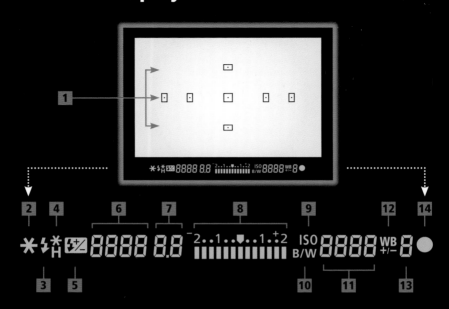

1 Focus points

2 AE lock/AEB in progress

3 Flash ready indicator

4 High-speed sync/Flash exposure lock/ Flash exposure bracketing in progress indicator

5 Flash exposure compensation

6 Shutter speed/Flash exposure lock/ Busy indicator/Built-in flash recycling/ Card full indicator/ Card error indicator/ No card indicator

7 Aperture value

8 Exposure level indicator/Exposure compensation indicator/Auto exposure bracketing display/Red-eye reduction lamp-on indicator

9 ISO indicator

10 Monochrome shooting

11 ISO speed

12 White-balance correction

13 Maximum burst indicator

14 Focus confimation indicator

LCD control panel

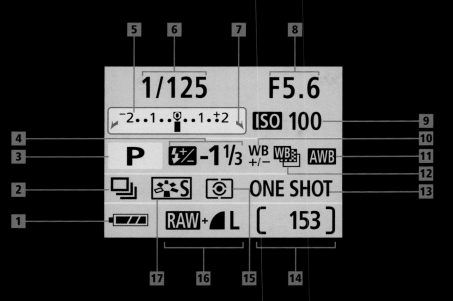

1 Battery check

2 Drive mode

3 Shooting mode

4 Flash exposure compensation indicator

5 Exposure level indicator/Exposure compensation indicator/Auto exposure bracketing display

6 Shutter speed

7 Main dial pointer

8 Aperture

9 ISO speed

10 White-balance correction

11 White-balance preset

12 White-balance bracketing

13 AF mode

14 Shots remaining on card/Shots remaining during white-balance bracketing/Self-timer countdown/ Bulb exposure time

15 Metering mode

16 Image format, size and quality

17 Picture style

Menu displays

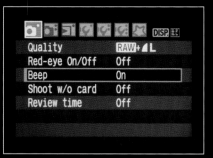

SHOOTING MENU 1 📷
Quality
Red-eye On/Off
Beep
Shoot without card
Review time

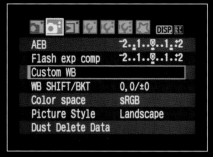

SHOOTING MENU 2 📷
Auto-exposure bracketing
Flash exposure compensation
Custom white balance
White-balance shift/bracketing
Colour space
Picture style
Dust delete data

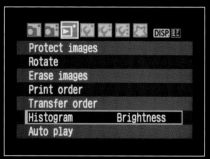

PLAYBACK MENU ▶

Protect images	Transfer order
Rotate	Histogram
Erase images	Auto play
Print order	

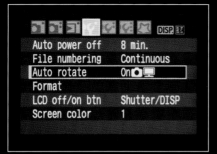

SET-UP MENU 1 📷
Auto power-off
File numbering
Auto rotate
Format
LCD on/off button
Screen colour

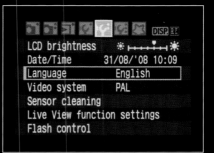

SET-UP MENU 2 📷
LCD brightness
Date / Time
Language
Video system
Sensor cleaning
Live View function settings
Flash control

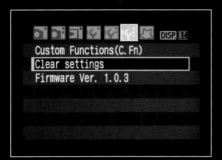

SET-UP MENU 3 📷
Custom Functions
Clear camera settings
Firmware version

MY MENU ⭐
This menu can be customized to include
up to six of your most frequently adjusted
settings, enabling you to access them
quickly and easily.

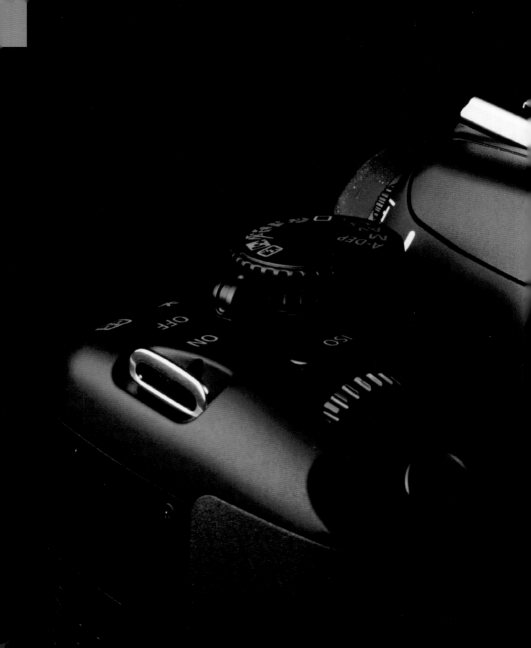

Chapter 2

Functions

Anyone making the transition from a compact digital camera to the EOS 1000D/Rebel XS may at first feel daunted by the large array of buttons and dials. Fortunately, Canon also offer Full Auto and Program modes that you can work with while you're getting to know the camera better.

Those upgrading from other Canon digital cameras will be familiar with some of the design concepts of the 1000D/Rebel XS, if not the actual placement of the controls.

This chapter will explore the camera's full potential, step by step, by presenting basic information first and examining more complex issues in subsequent sections.

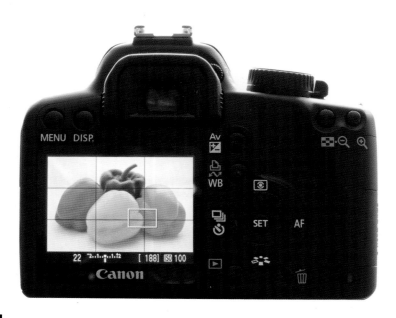

24

ELVIS IS ALIVE AND WELL

As soon as you can, take your newly acquired camera with just one lens to an inspirational location and have fun exploring its features.

Settings
Aperture priority (Av) mode
ISO 400
f/8 at 1/1500 sec
Evaluative metering
White balance: 5200°K

Camera preparation

Attaching the strap

A camera strap should be used at all times to ensure the safety of your camera. To attach it, pass the end of the strap through either the left-hand or the right-hand eyelet, situated at the top of each side of the camera. Then pass the end of the strap through the buckle, under the existing length of strap that is already threaded through the buckle. Repeat the operation on the other side of the camera. Pull the strap lightly to remove most of the slackness, position the buckle as desired, then pull more firmly to ensure the strap will not loosen within the buckle.

Fitting and removing a lens

Remove the rear body cap of the lens to be fitted, and the camera body cap or the lens already fitted to the camera. This is done by depressing the lens-release button while turning the cap or lens anti-clockwise as it is facing you.

Canon EF and EF-S lenses can be used with the 1000D/Rebel XS. For EF-S lenses, align the white mark on the lens to be fitted with the white mark on the camera's lens mount, insert into the camera and turn clockwise until a faint click can be heard. For an EF lens, align the red marks. Check that the AF/MF switch on the lens is set to the desired position.

After removing a lens, ensure that the lens cap is fitted and put it down safely with the rear end up. Fit the rear lens cap as soon as possible. Avoid touching the lens contacts, as dirty contacts can cause a malfunction.

Common errors

Before you attempt this operation, always ensure that there is as little risk as possible from the people or circumstances around you of being caused to drop either camera or lens. Also make certain that the wind is not likely to raise dust or sand while you are changing lenses.

26

1) Ensure that the camera is switched to **OFF** and that the access lamp on the back of the camera is not illuminated.

2) With the camera facing away from you, the SD card slot cover is on the right side of the camera body. To open it, slide the cover towards you with firm finger pressure and it will swing outwards on its hinges.

3) To remove a memory card, use a fingernail to locate the slight groove on the projecting card and slide out the card.

4) To insert an SD card, slide it into the camera's slot with its label side facing you until you hear a faint click and the card stays fully inserted. If the card springs out, repeat the operation.

5) Press the cover shut and slide it forwards until it snaps into position.

To prevent shooting without an SD card inserted, see ◘ Shooting Menu 1.

Warning!
Inserting the memory card incorrectly may damage the camera.

Warning!
Do not open the card slot cover or remove the battery when the access lamp is lit or blinking.

Common errors
When the red access lamp on the back of the camera is lit or blinking, it indicates that images are being processed – this may include being written, read, erased, or transferred to another device. Do not remove the battery or SD card when the red access lamp is illuminated or blinking. Either of these actions is likely to damage image data and may cause other camera malfunctions.

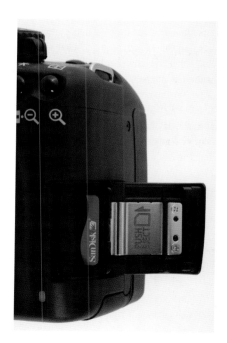

FUNCTIONS

Inserting the battery

Turn the camera upside down and locate the battery compartment on the right-hand side. Using a fingernail, release the catch and open the compartment. With the projecting battery contacts downwards, press the battery against the hinged white plastic catch on the left of the compartment and insert the battery until it locks in position. Shut the battery compartment cover until there is an audible click. To remove the battery, ease the white plastic retaining clip to the side. Once removed, a battery should have its protective cover attached to prevent shorting.

Using mains electricity

By using the AC Adaptor Kit ACK-E5 (available separately) you can connect the camera to a mains power outlet instead of using battery power.

1) Connect the mains power cord to the AC adaptor first and then to the power outlet.

2) Connect the adaptor's cord to the DC Coupler DR-E5.

3) Open the battery compartment on the camera, remove the battery and insert the DC Coupler until you feel it lock in position.

4) Flick back the small rubber DC cord cover and press the cord into the notch. Close the battery compartment cover.

Battery charging

The dedicated Battery Charger LC-E5E (or LC-E5 where provided) should be used to charge the battery provided with the camera. Remove the protective cover and insert the battery into the charger. Connect the power cord to the charger and insert the plug into a mains outlet.

Recharging is indicated by an orange lamp. This will turn green when the battery is fully charged. A fully discharged battery will take approximately two hours to charge.

Warning!
Never connect or disconnect the power cord while the camera is switched on.

28

Battery life

The life of any battery will depend upon several factors: working temperature, past treatment of the battery, use of the image review facility, choice of lens, auto power-off setting, use of the built-in flash, long periods with the shutter button partially depressed (as when tracking a moving subject), and especially use of the Live View function. The table below is a rough guide to the number of exposures you can achieve with a single LP-E5 battery.

Tips
Even when it is not in use, your camera battery will gradually lose its charge. Remove the battery if the camera is to remain unused for a long period. Storing the battery after it is fully recharged may have a negative effect on the battery's performance.

The camera's operating range is 0–40°C but in temperatures of 30–40°C or 0–10°C the battery may not perform optimally.

Dioptre adjustment

Using the camera without spectacles is facilitated by the dioptre adjustment. Turn the knob so that the AF points in the viewfinder are sharp. If this is insufficient, ten different versions of the Dioptric Adjustment Lens E are available separately.

Tips
The battery charger can be used abroad (100–240v AC 50/60 Hz) with a travel adaptor. Do not attach any form of voltage transformer.

If your battery runs out quickly, check the Auto power-off (⚙ Set-up Menu 1) and Image review time (📷 Shooting Menu 1) settings to see if you can save power.

Temperature	No flash	50% flash
23°C	600 exposures	500 exposures
0°C	500 exposures	400 exposures

Basic camera functions

Switching the camera on

The power switch is incorporated into the Mode Dial on the top of the camera and provides a simple on/off switch. Care should be taken not to accidentally change the Mode Dial setting when switching the camera on or off.

Sensor cleaning takes place automatically each time you turn the camera on or off. A message to this effect is displayed briefly on the LCD monitor on the back of the camera. Automatic sensor cleaning can be disabled in ⚙ Set-up Menu 2.

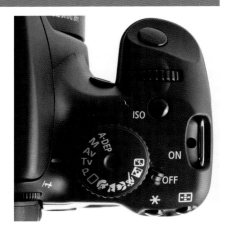

Tips

If the camera is set to power-off automatically after a set interval (⚙ Set-up Menu 1), partially depressing the shutter button will fully reactivate the camera.

If the power switch is turned to **OFF** while an image file is being written, the camera will finish recording the image before turning itself off.

Common errors

Continuous shooting is not possible when **High ISO speed noise reduction** has been selected in the Custom Functions menu.

The self-timer setting (indeed any Drive mode setting) is not cancelled when the camera is switched off.

Drive mode

The 1000D/Rebel XS provides two frame-advance modes, Single or Continuous, plus three self-timer settings.

Frame-advance in each of the Basic Zone settings is selected automatically, with Continuous selected in Portrait and Sports modes and Single in all other Basic Zone modes.

In all of the Creative Zone modes, either Single or Continuous shooting is possible. Continuous shooting will provide up to approximately three frames per second when file quality is set to JPEG only. This is reduced to approximately 1.5 fps when RAW or RAW+JPEG is selected.

Self-timer settings are available for both 2-second ⏱₂ and 10-second ⏱ single-frame shots. The camera offers a useful third alternative in the form of a 10-second self-timer that provides programmable Continuous frame-advance ⏱C. This can be set to shoot 2–10 images.

To set the Drive Mode or Self-timer:

1) Press the ◀ button to display the menu.

2) Use the ◀ and ▶ buttons to scroll through the selection.

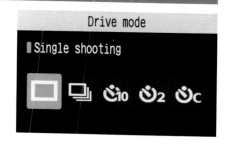

3) If selecting ⏱C, use the ▲ and ▼ buttons to adjust the number of frames.

4) Press **SET** to select the desired setting.

Note
When ⏱C is selected there is a 10-second delay between pressing the shutter release and the first exposure. Thereafter the shots are continuous, possibly with a brief delay between frames while the data is written to the memory card.

Tip
The maximum available number of burst frames possible is shown in the viewfinder at bottom right, to the right of the ISO setting.

Mode Dial

The Mode Dial provides 15 different shooting modes, each of which will be explained in detail later in this chapter. These modes are divided into the Basic Zone and the Creative Zone.

The Basic Zone provides seven fully automated modes for different types of subject, each indicated by an icon. The Creative Zone has five advanced modes offering total control of all camera settings. To select a particular

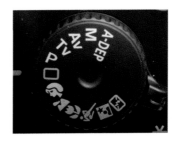

mode, turn the dial until the icon for the desired mode is lined up with the mark on the camera body.

Mode Dial

Basic Zone		Creative Zone	
Full Auto	⬭	Program	**P**
Portrait	🙎	Shutter Priority	**Tv**
Landscape	🏔	Aperture Priority	**Av**
Close-up	🌷	Manual	**M**
Sports	🏃	Auto depth of field	**A-DEP**
Night Portrait	🌃		
No Flash	🚫⚡		

The shutter-release button has two functions. Partially depressing it brings into play the autofocus and metering functions. Pressing it fully releases the shutter and takes the picture using the focus and exposure settings that were registered when you only partially depressed the shutter release. If the shutter-release button is fully depressed immediately, there will be a momentary delay before the picture is taken.

If you have purchased the Battery Grip BG-E5 to go with your camera, then exactly the same applies to the additional shutter-release button provided on the battery grip for vertical shooting.

Tip
Even while menus are displayed or an image is being reviewed or recorded, the 1000D/Rebel XS will immediately go to picture-taking readiness when you partially depress the shutter-release button (unless the buffer is full). This means you will very rarely miss an opportunity to take a picture.

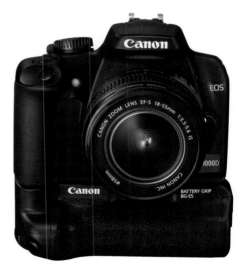

BATTERY GRIP
Battery Grip BG-E5 provides an additional shutter-release button for vertical shooting.

FUNCTIONS

Operating the Main Dial

The ⚙ Main Dial next to the shutter-release button is used for adjustments to the settings required for shooting. It is used sometimes on its own, and on other occasions after depressing a button to select the function you wish to adjust.

In **P** mode the Main Dial used on its own will adjust both aperture and shutter speed while retaining the equivalent exposure. Used on its own in **Tv** and **M** modes the Main Dial adjusts the shutter speed, and in **Av** mode it will adjust the aperture.

Holding down the **Av+/-** button while rotating the ⚙ Main Dial will set the amount of exposure compensation to be used in any Creative Zone mode – except in Manual mode, when it simply adjusts the aperture.

All these functions are explained in more detail later in this chapter.

Focusing

The 1000D/Rebel XS accepts both EF and EF-S lenses, both of which are equipped with an AF/MF switch so you can change to manual focusing. This may be necessary in very low light or when focusing on something with insufficient contrast for an AF point to latch onto. It may also be useful when photographing landscapes to obtain maximum depth of field, or when taking extreme close-ups – especially if you are using the ×5 or ×10 magnification facility in Live View mode.

The camera is equipped with seven AF points which may function as a group or can be selected singly (see page 62).

Three AF modes cover most eventualities:

One Shot mode

One Shot mode is suited to relatively still subjects. When you partially depress the shutter-release button, the camera will focus just once on the subject. It will not refocus until you withdraw the pressure and partially depress the shutter-release button again.

When focus is achieved, both the green ● Focus Confirmation light and the red AF point(s) that achieved focus will be visible in the viewfinder. There will also be a **beep** unless this has been switched off in Shooting Menu 1. If you continue to hold down the shutter-release button, focus will be locked and you will be able to recompose your photograph.

34

AI Servo mode

This facility is particularly useful when the camera-to-subject distance keeps changing. While you partially depress the shutter-release button, the camera will continue to readjust focus automatically. The exposure settings (normally selected when you partially depress the shutter-release button) will be fixed at the moment the picture is taken.

When AF point selection is automatic and AI Servo is selected, the camera will first use the centre AF point to achieve focus, so it is necessary to place your subject centrally at the start, otherwise focus may track the wrong subject. During focus tracking, if the subject moves away from the centre AF point, tracking will continue as long as the subject is covered by an alternative AF point.

In AI Servo mode the **beep** will not sound and the ● Focus Confirmation light will not be displayed in the viewfinder.

AI Focus

In this mode the camera will switch between One Shot and AI Servo modes according to subject movement. If focus is achieved using One Shot mode but the subject starts to move, the camera will automatically shift to AI Servo mode and track the subject, provided you keep the shutter-release button partially depressed.

Unlike with AI Servo mode fully selected, if focus is achieved while AI Servo is active in AI Focus mode, then the **beep** will sound, but more softly than normal. However, the ● Focus Confirmation light still does not light up in the viewfinder.

Tip

If focus cannot be achieved, the ● Focus Confirmation light will blink and you will not be able to take a picture even if you fully depress the shutter-release button. Under these circumstances, select the centre AF point in one of the Creative Zone modes or, if in a Basic Zone mode, reposition the camera and try again or switch the lens to manual focus.

Depth-of-field preview

The depth-of-field preview button – on the front of the camera, just below the lens-release button – will stop the lens down to the currently selected aperture, providing a more accurate impression of the range of acceptable focus. A smaller aperture will provide greater depth of field, but the viewfinder will appear darker as you stop down. Exposure is locked while the depth-of-field preview button is depressed.

ISO setting

The ISO speed is the sensor's sensitivity to light and effectively governs the combined exposure values of aperture and shutter speed. A higher ISO speed enables a faster shutter speed and is therefore more useful in low light. However, higher ISO speeds bring more 'noise', producing a more grainy-looking image; so the slower the ISO speed, the crisper the final image.

In all Basic Zone modes, the ISO is set automatically within the range ISO 100–800 and cannot be overridden. In Creative Zone modes, Auto ISO is possible and the ISO can also be set in the range ISO 100–1600 using 1-stop increments. Doubling ISO is equivalent to a 1-stop reduction in exposure.

1) To set the ISO speed, press the **DISP** button followed by the **ISO** button next to the Main Dial on the top of the camera.

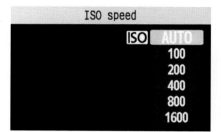

2) Use the ▲ and ▼ buttons to select the desired ISO and press **SET** to save the setting. The setting is shown both in the viewfinder and on the Display screen on the LCD monitor.

Tip
Increasing the ISO speed also increases the effective range of a built-in or external flash.

Built-in flash

The built-in flash operates automatically in all Basic Zone modes except Landscape, Sports and No Flash modes, in which it is disabled. In Creative Zone modes it can be raised and activated by pressing the small button on the front of the camera, just above the lens-release button. When the built-in flash is active and charged, the **4** Flash symbol will appear in the viewfinder at bottom left.

Metering mode

The 1000D/Rebel XS has three different metering modes to cover any eventuality:

Evaluative metering
This mode can cope with a wide range of lighting situations, including backlighting. It takes readings from 35 different zones and is used for all Basic Zone modes.

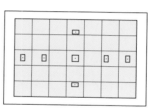

Centre-weighted Average metering
This mode gives added bias to readings taken from the centre of the frame, then averages readings from the whole area. Only selectable in Creative Zone modes.

Partial metering
Takes readings from just 10% of the frame at the centre and is very useful when the background is significantly brighter than the subject. It can also be used, in effect, as a spot meter with a larger than normal 'spot'. Only selectable in Creative Zone modes.

White-balance presets

Press the **WB** button on the back of the camera to select Auto WB AWB or one of six predetermined settings (shown below), or to set up a Custom WB 🔲 setting. The correct setting from the examples below is the Daylight setting.

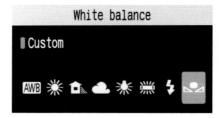

White balance

▌Custom

🔅 Tungsten (3,200°K)

🔆 White fluorescent (4,000°K)

🔅 Daylight (5,200°K)

☁ Cloudy (6,000°K)

⚡ Flash (6,100°K)

🏠 Shade (7,000°K)

38

Using Shooting Menu 1, immediate automatic playback of an image can be disabled or enabled for a duration of 2, 4 or 8 seconds, or displayed indefinitely.

All the images on the memory card can be reviewed manually by pressing the ▶ Playback button on the back of the camera (not to be confused with the ▶ AF selection button). The first image to be shown will be the most recent taken or the last viewed. Use the ◀ and ▶ buttons to scroll through the images one at a time.

Press the **DISP** button to change the display style. The styles available are Single image, Single image with file-quality setting, Shooting information with either brightness or RGB histogram (selectable in ▶ Playback menu), or both histograms with limited shooting information. When any histogram display is selected, the Automatic highlight alert will cause overexposed or very bright areas to blink. You may need to shoot the image again, reducing the exposure.

Single image with file-quality setting

Shooting information with brightness histogram

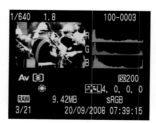

Shooting information with RGB histogram

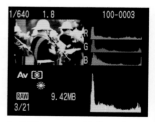

Both histograms with limited shooting information

FUNCTIONS

During image playback you can zoom into the image by repeatedly pressing the ⊞/🔍 button. Use the ▢▢▢▢ buttons to move around the magnified image. The ✱/⊞•🔍 button zooms out again in steps; alternatively, you can return to the full image view after zooming in by pressing the ▶ Playback button once.

If the ✱/⊞•🔍 Reduce button is pressed while an unmagnified image is displayed, the LCD monitor will display four images. If pressed a second time, nine images will be displayed. This multi-display is referred to as the index display. The current image is highlighted in blue. To select a different

image, use the ▢▢▢▢ buttons or the 🔄 Main Dial (when the Jump function is set to a single image).

To exit playback, press the ▶ Playback button again.

Jump

The Jump function can be set to jump 10 or 100 images at a time during playback, or to jump to the next date. With an image displayed in playback, press the ▲ button and scroll through the three choices using the ▲ or ▼ buttons. Press ▶ to save. Use the 🔄 Main Dial during playback to operate the Jump facility.

Auto Play

The Auto Play option runs a slide show of the images on the memory card. Press SET to pause the slide show; press it again to resume. Press MENU to stop. Auto power-off will not work during Auto Play.

Rotating images

To rotate all portrait-format images automatically, enable Auto Rotate in 🛠 Set-up Menu 1.

To rotate a single image during playback, press MENU and select the ▶ Playback Menu. Highlight Rotate and press SET. The display will return to Playback mode. Scroll through the images and, when the image you wish to rotate is displayed, press SET again. The image will rotate. Pressing SET repeatedly will rotate the image through different orientations.

Deleting images

Method 1

To delete a single or highlighted image during playback:

1) Press the 🗑 Erase button.

2) Confirm deletion by highlighting **Erase** and pressing **SET**. Alternatively, select **Cancel** and press **SET** to return to Playback mode.

Method 2

To delete selected or all images via the menu system:

1) Press **MENU** and use the 🖎 Main Dial to select the ▶ Playback Menu.

2) Use the ▲ or ▼ buttons to select **Erase images** and press **SET**.

3) Select either **Select and erase images** or **All images on card** and press **SET**.

4) To delete all the images on the card, select **All images on card** and press **SET**. A **Cancel/OK** option appears. Press **SET** to cancel or **OK** to erase the images.

5) To delete only selected images, choose **Select and erase images** and press **SET**. Use the ⊞/⊕ and ✱/⊞•⊖ buttons to choose whether the monitor displays one, three or nine images.

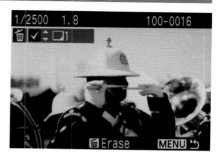

6) Press ▲ or ▼ to add a white tick above the highlighted image. Scroll through the images using the ◀ and ▶ buttons and tick all those you wish to erase.

7) When your selection is complete, press 🗑 Erase. A **Cancel/OK** option appears. Press **SET** to cancel or **OK** to erase.

Protecting images

1) Press **MENU**. Select the ▶ Playback Menu and then **Protect images**.

2) Use the ⊞/⊕ and ✱/⊞•⊖ buttons to choose whether the monitor displays one, three or nine images.

3) Select the image to be protected and press **SET**. A key symbol will be displayed above the image.

4) To remove protection, press **SET** again and the key symbol will disappear.

Understanding exposure

The topic of exposure is often best explained by means of an analogy. If you are cooking something in the oven, you know that the end product is dependent on two factors: the oven temperature and the cooking time. If you adjust one, you also need to adjust the other to obtain the same result.

Exposure is similar except that the two factors are time and aperture – the latter being the size of the opening through which light falls onto the digital camera's sensor. The time is the shutter speed, which is measured in fractions of a second: 1/60, 1/125, 1/250, 1/500, 1/1000 etc.

The aperture (opening) itself is measured in f-stops. The larger the number, the smaller the opening. Each stop represents a halving or doubling of the adjacent stop. Thus f/11 allows half as much light in as f/8 but twice as much as f/16. The sequence runs as follows: f/2.8, f/4, f/5.6, f/8, f/11, f/16, f/22.

The image shown at the bottom of this page was taken with a shutter speed of 1/250 sec and an aperture of f/8.0 using a 24–105mm zoom lens set at 47mm. From the table below you can see that any one of the corresponding shutter speed and aperture combinations would have resulted in the correct exposure, though it may not necessarily have provided sufficient depth of field.

Shutter speed/Aperture

Shutter speed:

1/60	1/125	1/250	1/500	1/1000

Aperture (f-stops):

16	11	8	5.6	4

PIGEON
There is a third exposure factor in addition to time and aperture: the ISO setting. This term originally applied to the sensitivity of film but has been retained on digital cameras. ISO 200 is half as sensitive to light as ISO 400 and needs double the exposure. This photo was taken at 1/250 at f/8 with a 100 ISO setting. At 200 ISO, the necessary exposure would have been 1/500 at f/8 or 1/250 at f/11 (twice the shutter speed or one stop less exposure).

Exposure modes – the Basic Zone

The settings on the Mode Dial fall into two groups, one on either side of the green rectangle that identifies Full Auto mode. The group which makes use of symbols, and which includes Full Auto mode, is known as the Basic Zone. The settings which make use of letters of the alphabet are known as the Creative Zone.

Photographic styles

Good images are rarely created by accident, at least not on a consistent basis. Certainly the best photographs are the product of, if not forethought and planning, then at least a sense of purpose. It is that intention, even if it is subconscious and intuitive in nature, that lies behind the concept of the Basic Zone.

The Basic Zone is primarily intended for those photographers who know what kind of images they want to achieve but do not yet have a deep understanding of the principles behind photography in general, and exposure in particular, nor breadth of experience. The latter can only be gained in time and with repeated experience of similar photographic situations.

Each symbol in the Basic Zone represents a photographic style. The Basic Zone symbols indicate automatic settings that, in general terms, will suit each of the following styles: Portrait, Landscape, Close-up, Sports, Night Portrait, and No Flash.

The settings for Full Auto mode are obviously a compromise. The Basic Zone assumes that, having determined either the nature of the subject or the style required, the user can select an appropriate mode but thereafter all the decisions will be taken by the camera. This is typified by two of the three focus modes, AI Focus and AI Servo, where AI stands for Artificial Intelligence.

A completely new feature from Canon, the Auto Lighting Optimizer, adjusts predominantly dark or low-contrast images automatically in Basic Zone modes, unless they are disabled via the Custom Functions menu. The autofocus point is also selected automatically according to the position in the frame of what the camera deems to be the main subject. Full details for each Basic Zone mode can be found in the tables on the following pages.

Full Auto mode

Full Auto mode is a blessing for the less experienced photographer in situations where there is insufficient time to think carefully about camera settings and where lighting (and therefore exposure) is changeable; a children's party or family outing, for example. Basically, the camera does the thinking for you. This is often thought of as a basic mode but there is nothing basic about it at all, as it takes into account most of the settings over which you could have some control if you chose. The panel on page 44 indicates the various settings which the camera will select and which you cannot override. The built-in flash will automatically

pop up into position if required and the AF-assist beam will be used to aid focusing in low light levels.

> **Tip**
> Full Auto mode is foolproof when photographing a scene with average tones in favourable light (see picture, left) but it cannot cope equally well with all eventualities. When you find that you want more control over your results, it is time to move on. In many ways, Program mode is the next logical step up from Full Auto mode as it selects most of the settings for you but permits you to override them.

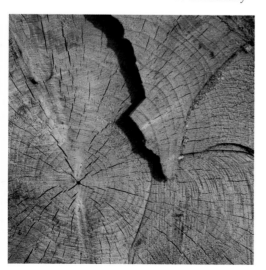

GROWTH RINGS
Full Auto mode is ideal for subjects like this, with even tones, no distinct highlights or deep shadows, and no depth-of-field requirements.

Full Auto mode

Quality setting	Large/fine JPEG
Exposure settings	Evaluative metering; shutter speed and aperture are chosen to suit the light levels and subject; Auto ISO; Standard Picture Style; Auto White Balance; Auto Lighting Optimizer
Focus settings	Automatic AF point selection in AI Focus mode (will track a moving subject as long as you keep the illuminated AF point on it and continue to partially depress the shutter button to lock focus)
Frame advance	Single frame advance; Self-timer
Flash and AF-assist settings	Automatic flash and automatic fill-in flash; red-eye reduction; AF-assist beam, effective up to 13ft (4m); first-curtain sync
Notes	Full Auto mode is easy to use and will give pleasing results in situations where the action and lighting are less challenging.

Using Full Auto mode

1) Turn the Mode Dial to ☐.

2) Aim the camera at your subject. Focusing may be easier by placing the centre AF point over the main subject. You can recompose the picture later.

3) Lightly press the shutter button to achieve focus. The In-focus Indicator ● and automatically selected AF points will illuminate briefly. Exposure settings (aperture and speed) will appear at the bottom of the viewfinder on the left; the automatically selected ISO speed and available burst settings on the right.

4) In low light levels, the built-in flash will pop up and the flash symbol ⚡ will show at the bottom left of the viewfinder. The built-in flash may also operate in bright conditions to reduce shadows.

5) Retain light pressure on the shutter button to keep the focus locked and recompose the picture before depressing the button fully to take the photograph.

6) After a very brief delay, the captured image will display on the LCD monitor for two seconds unless the review function has been adjusted or switched off.

FUNCTIONS

Portrait mode

Traditionally, portraits tend to be head-and-shoulders images with a vertical orientation (hence the term 'portrait format'). However, there are plenty of portrait situations that can benefit from landscape orientation, particularly when photographing someone in the context of their activity or profession.

Perspective and choice of lens or zoom setting are particularly important with portraits, as it is all too easy to distort the subject's features. Wide-angle lenses make the features closest to the camera look

disproportionately large, while longer telephotos tend to 'flatten' facial features. The traditional favourite for head-only portraits is a fast lens of around 85mm focal length (50mm on the 1000D/Rebel XS due to its crop factor of 1.6), with a 50mm lens (30mm on the 1000D/Rebel XS) being fine for upper-body portraits.

Tip

In portraits, the subject's eyes are critically important in terms of focus and clarity. If at all possible try to include 'catchlights' – sharp points of light created by flash, natural or reflected light.

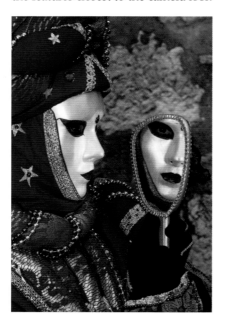

VENETIAN CARNIVAL
I chatted with this subject beforehand to make her more relaxed so that I could gently position her hands and the mirror exactly as I wanted them.

46

Portrait mode

Quality setting	Large/fine JPEG
Exposure Settings	Evaluative metering; a wide aperture is selected in order to blur the background so that the subject is given greater prominence; Auto ISO; Portrait Picture Style; Auto White Balance; Auto Lighting Optimizer
Focus settings	Automatic AF point selection in One Shot focus mode
Frame advance	Continuous shooting; Self-timer
Flash and AF-assist settings	Automatic flash and automatic fill-in flash; red-eye reduction; AF-assist beam, effective up to 13ft (4m); first-curtain sync
Notes	The camera selects a colour setting to improve flesh tones, plus a less sharp result than Full Auto to soften hair (and wrinkles!).

Using Portrait mode

1) Turn the Mode Dial to 🐾.

2) Aim the camera at your subject. Pay attention to framing and to the background which may contain distracting elements.

3) Lightly press the shutter button to achieve focus. The In-focus Indicator ● and automatically selected AF points will be illuminated in the viewfinder. The exposure settings (aperture and speed), the selected ISO and the number of burst exposures possible also appear.

4) In low light levels the built-in flash will pop up and the ⚡ flash symbol will show

bottom left in the viewfinder. (When you've finished taking the photographs that are likely to require flash, push the built-in flash unit back down manually.) The built-in flash may also operate in bright conditions to reduce shadows.

5) Retain light pressure on the shutter button to keep the focus locked and recompose the picture before depressing the button fully to take the photograph.

6) After a very brief delay, the captured image will display on the LED monitor for 2 seconds, unless the review function has been adjusted or switched off.

Landscape mode

While photos of family and friends tend to be the most popular subjects for amateur snappers, there's no doubt that those who aspire to be better photographers tend to favour scenic photography. The reasons are obvious: an unlimited supply of vistas which change according to the weather, light, season, and our own perceptions. I have never met a landscape photographer who feels he or she has run out of challenges.

A high proportion of scenic photographs are taken using wide-angle lenses (or wide zoom settings) to maximize depth of field, capture a wider scene and accentuate the foreground for a better sense of depth.

However, just as portraits aren't always shot in portrait format, scenic photographs aren't always captured in landscape format. This is probably even more true since the advent of digital cameras that offer less than

full-frame coverage, because wide-angle lens choice has become much more difficult. With a crop factor of 1.6 it is necessary to drop to an expensive 14mm or 15mm lens to obtain the equivalent of a 24mm lens on 35mm film (or full-frame digital) camera. Consequently, more portrait images of landscapes are being taken in order to improve the coverage of foreground subject matter.

Common errors
Keep an eye on the shutter speed indicated in the viewfinder. If it blinks, this indicates the risk of camera shake, so use a tripod or find an alternative form of support for the camera.

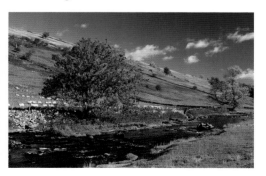

LANGSTROTHDALE, ENGLAND
Evaluative metering coped perfectly with this scene in the Yorkshire Dales and the Landscape Picture Style registered colours as vividly as the eye perceived them.

Landscape mode

Quality setting	Large/fine JPEG
Exposure settings	Evaluative metering; a narrow aperture is chosen to maximize depth of field while retaining a shutter speed sufficient to permit handheld shooting; Auto ISO; Landscape Picture Style; Auto White Balance; Auto Lighting Optimizer
Focus settings	Automatic AF point selection in One Shot focus mode
Frame advance	Single frame advance; Self-timer
Flash and AF-assist settings	Flash and AF-assist beam are switched off
Notes	Also useful for night scenes with a tripod, as the built-in flash will be automatically disabled.

Using Landscape mode

1) Turn the Mode Dial to ▲ .

2) Aim the camera at your subject. Make sure you pay close attention to framing and to the foreground, which may contain distracting elements such as litter.

3) Lightly press the shutter button to achieve focus. The In-focus Indicator ● and the automatically selected AF points will be illuminated in the viewfinder. The exposure settings (aperture and speed) will appear at the bottom of the viewfinder, on the left. The ISO selection is shown on the right.

4) If you retain light pressure on the shutter button, the focus will be locked and you can recompose the picture before fully depressing the shutter button to take the photograph.

5) After a very brief delay, the captured image will be displayed on the LED monitor for 2 seconds unless the review function has been adjusted or switched off.

Close-up mode

The terms 'close-up' and 'macro' are used differently in this book. Macro, properly speaking, means a life-size image (i.e. at a magnification ratio of 1:1) and requires the use of either a special macro lens or extension tubes. A close-up, on the other hand, is considered as an image captured at the closest focusing distance of the (non-macro) lens being used.

The table on page 172 shows the maximum magnification ratio of EF lenses. This tends to be somewhere between one-tenth and one-fifth life size, but varies between lenses, even those of similar focal lengths.

In calculating exposure, good depth of field and a higher shutter speed are traded off against each other, so any auto settings selected by the camera will always be a compromise. This is true of all

exposure modes, but the high magnification ratios involved here make it a particular concern. Good depth of field and a higher shutter speed may be necessary when shooting close-ups outdoors, but Close-up mode chooses your ISO setting for you and cannot be overridden, so you will have to rely on plenty of light, preferably diffuse light rather than strong direct light.

Common errors

For close-ups, any movement by either camera or subject must be avoided. The greater the magnification, the more important this becomes, so a tripod and remote release are invaluable tools.

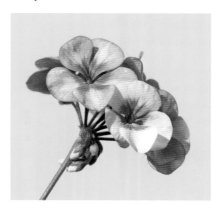

PELARGONIUM
This geranium against a contrasting background was made easier to photograph as it was well sheltered from the breeze.

Close-up mode

Quality setting	Large/fine JPEG
Exposure settings	Evaluative metering; shutter speed, aperture and ISO are chosen to suit the light levels and subject; Standard Picture Style; Auto White Balance; Auto Lighting Optimizer
Focus settings	Automatic AF point selection in One Shot focus mode
Frame advance	Single frame advance; Self-timer
Flash and AF-assist settings	Automatic fill-in flash, red-eye reduction, first-curtain sync, AF-assist beam
Notes	Autofocus will pick out the closest subject, so if you are photographing flowers, make sure that there are no wisps of grass between the lens and the subject.

Using Close-up mode

1) Turn the Mode Dial to ✿.

2) Aim the camera at your subject. Set your zoom lens to its longest focal length.

3) If using a tripod, set the frame-advance mode to self-timer or use a remote release to minimize camera shake.

4) Lightly press the shutter button to achieve focus. If the lens cannot focus, change the camera position. (If focus still proves difficult, adjust the AF/MF switch on the lens to MF and focus manually.) If the In-focus Indicator ● blinks you may be too close to the subject.

5) The automatically selected AF points will illuminate briefly in the viewfinder, accompanied by a beep (unless disabled in ✿ Shooting Menu 1).

6) In low light levels the built-in flash will pop up and the ✚ Flash symbol will appear in the viewfinder. The built-in flash may also operate in bright conditions to reduce shadows.

7) Depress the shutter. After the Auto Review image has been displayed, press ▶ to play back the image and use the ⊞/⊕ button to magnify it and check sharpness in key areas.

Sports mode

For sports, read any situation in which your subject matter is on the move: that might include festivals, children at play, your pet (unless it's a tortoise or goldfish!), school events and a host of other activities.

Like the other Basic Zone modes, Sports mode makes use of evaluative metering to select the exposure. The emphasis will be on a higher shutter speed, so unless it's very bright, you are likely to be working with a wider aperture and consequent loss of depth of field. In order to keep the moving subject in focus, the camera uses AI Servo to track your subject, provided you first focus using the centre AF point then keep the subject covered by the AF points as a whole, all the time keeping the shutter release partially depressed.

What's more, AI Servo focus mode predicts where the subject will be when the photograph is taken – a factor that is continually reassessed while focus tracking takes place. Frame advance is set to Continuous at three frames per second to help you capture that critical moment.

It is also very helpful if you can predict the action and choose a suitable vantage point accordingly. The best sports photographers are those who know in advance where they will need to be positioned to obtain the best images.

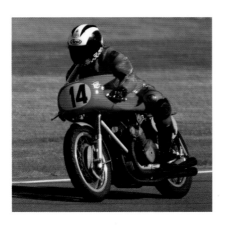

1954 MV AGUSTA 500/4
The faster the machinery, the greater the need to find the perfect spot to capture the action. When panning, try to ensure that there is a consistent and uncluttered background and that there is nothing between you and the subject to hinder the sweep of your lens.

Sports mode

Quality setting	Large/fine JPEG
Exposure settings	Evaluative metering; shutter speed, aperture and ISO are chosen to suit the light levels and subject; Standard Picture Style; Auto White Balance; Auto Lighting Optimizer
Focus settings	Automatic AF point selection in AI Servo focus mode
Frame advance	Continuous shooting; Self-timer
Flash and AF-assist settings	Flash and AF-assist beam are switched off
Notes	In this mode the camera uses the centre AF point first to acquire focus. If the subject moves away from the centre AF point, focus tracking will be acquired by one or more of the other AF points.

Using Sports mode

1) Turn the Mode Dial to 🏃.

2) Aim the camera with the centre AF point on the subject.

3) Lightly press the shutter button to achieve focus while panning to keep the subject covered by the AF points. (The AF points will not light up in red as you are accustomed to.) Maintain light pressure on the shutter release.

4) Fully depress the shutter button at the desired moment.

5) Keep the shutter button depressed to take multiple photographs, panning the camera and ensuring that the subject is covered by at least one of the AF points.

6) The number shown in the bottom right of the viewfinder indicates the number of continuous shots (known as a 'burst') that are possible depending on the file-quality setting. There may be a short delay before the images can be reviewed while the files are written to the memory card. If Auto Review is enabled, only the final frame of a burst sequence will be displayed.

FUNCTIONS

Night Portrait mode

The purpose of this mode is to achieve a well-lit subject and a well-lit background using a combination of two techniques. Exposure for the background is achieved by the camera setting a narrow aperture to create good depth of field, with a consequent low shutter speed, so that it is properly exposed for the ambient light. However, the main subject is lit by flash, which fires at a far higher speed than the shutter and freezes the subject while also providing a different quality of light. The flash itself would not reach the background and ordinarily this area of the picture would be very dark.

Night Portrait mode is especially effective with a dramatic sunset and when your subject is standing in front of an illuminated building. Floodlit backgrounds will appear very yellow/orange in comparison to the subject, because floodlights and flash have different colour temperatures and, unless you set a different colour temperature, the flash will dominate.

Common errors
In effect, two exposures are combined in this mode: a fast one using flash and a slow one without flash. Any subject movement will lead to 'ghosting', so use a tripod if possible and ensure that the subject remains quite still.

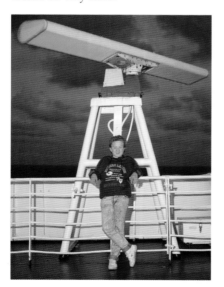

CRUISE SHIP, NORWEGIAN COAST
Position your subject about 15ft (4.5m) from the camera, or the built-in flash may not illuminate them properly. If they are still underexposed (too dark), ask them to step forward.

Night Portrait mode

Quality setting	Large/fine JPEG
Exposure settings	Evaluative metering; a narrow aperture is selected to ensure good depth of field; shutter speed and ISO are selected to suit the background; normal flash sync speed (1/200) is ignored in favour of the ambient lighting; Standard Picture Style; Auto White Balance; Auto Lighting Optimizer
Focus settings	Automatic AF point selection in One Shot focus mode
Frame advance	Single frame advance; Self-timer
Flash and AF-assist settings	Automatic flash; red-eye reduction; first-curtain sync
Notes	The red-eye reduction function can be set to either on or off via Shooting Menu 1.

Using Night Portrait mode

1) Turn the Mode Dial to ▣ and turn the red-eye reduction function on.

2) For the best results, use a tripod and either the self-timer or remote release to minimize camera shake.

3) Aim the camera at your subject and partially depress the shutter-release button. Focusing may be easier by placing the centre AF point over the main subject.

4) The In-focus Indicator ● and the automatically selected AF points will illuminate in the viewfinder.

5) The built-in flash will pop up and the ⚡ flash symbol will show at the bottom left of the viewfinder. (After taking all the photographs likely to need flash, push the built-in flash back down manually.)

6) If you retain light pressure on the shutter button, focus will be locked and you can recompose the picture before fully depressing the shutter button to take the photograph.

7) The image will be displayed on the LED monitor for two seconds unless the review function has been adjusted or switched off.

No Flash mode

No Flash mode is essentially Full Auto mode with the flash disabled, and is useful in situations where flash is not permitted or would be intrusive. With a fast maximum aperture lens such as the excellent and affordable EF 50mm f/1.4 or EF 85mm f/1.8, this mode is a very suitable option for concerts, school plays and similar situations.

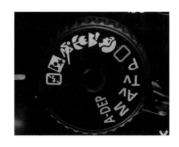

Tip

If you have chosen No Flash mode because you are in a situation where the use of flash would be inappropriate or intrusive, you may also wish to switch off the **beep** using ◌ Shooting Menu 1.

BLUES SINGER
I wanted to to fill in the shadow beneath the brim of the singer's hat, but the flash would have been intrusive. Instead, an EF 85mm f/1.8 lens was used and the image tightly cropped in Photoshop later.

No Flash mode

Quality setting	Large/fine JPEG
Exposure settings	Evaluative metering; shutter speed, aperture and ISO are chosen to suit the light levels and subject; Standard Picture Style; Auto White Balance; Auto Lighting Optimizer
Focus settings	Automatic AF point selection in AI Focus mode
Frame advance	Single frame advance; Self-timer
Flash and AF-assist settings	Flash and AF-assist beam are switched off
Notes	The AF-assist flash function is disabled, so focusing in poor light may require you to select manual focusing using the AF/MF switch on the lens.

Using No Flash mode

1) Turn the Mode Dial to [⚡].

2) Aim the camera at your subject. Focusing may be easier by placing the centre AF point over the main subject. You can recompose the picture later.

3) Lightly press the shutter button to achieve focus. The In-focus Indicator ● and automatically selected AF points will be illuminated in the viewfinder. The exposure settings (aperture and speed) will appear at the bottom of the viewfinder on the left, with the ISO speed and available burst on the right.

4) In low-light conditions it may be necessary to switch the lens to manual focusing, as the AF-assist flash function will not function in this mode.

5) Retain light pressure on the shutter button to keep the focus locked and recompose the picture before depressing the button fully to take the photograph.

6) After a very brief delay, the captured image will be displayed on the camera's LCD monitor for two seconds unless the review function has been adjusted or switched off.

A light meter is simply a gadget that measures the quantity of light falling on it (known as an incident reading) or how much light is reflected by the subject (a reflected reading). Through-the-lens (TTL) metering makes use of reflected light readings, which means that they are more likely to be fooled by highly reflective surfaces in your shot.

How helpful a meter reading is depends upon how you, or your camera, interprets the result. Any light-meter reading – from Canon's 35-zone full-frame evaluative system to that of a humble 1° spot meter – averages the readings it has taken and gives a recommended shutter speed and aperture (for a given ISO setting) that would give the correct exposure for an 18% grey card. The process works as follows:

1) The extent of the area to be metered is determined by the selected metering mode.

2) The camera's light meter 'sees' this scene in black and white and takes the meter reading.

3) The meter suggests an exposure which would give an overall tone of 18% grey.

4) The camera user adjusts the suggested reading to account for highlight and shadow preferences.

FAVERSHAM, KENT
Your camera's light meter works by 'seeing' the selected scene in black and white (left) and then calculating the correct exposure for an overall tone of 18% grey. Thankfully, real life is more colourful than that.

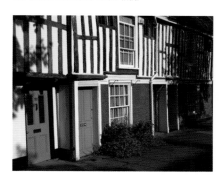
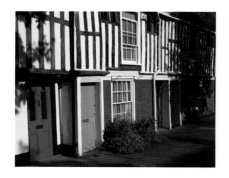

58

The AE Lock (Auto Exposure Lock) function is used when there is a difference between the area of the image that is to be metered and the area used to achieve focus, or when multiple frames will be taken using the same exposure.

1) Focus on the subject by partially depressing the shutter-release button.

2) Press the ✳/▦• 🔍 button (🕐₄). The ✳ icon is displayed in the viewfinder, indicating exposure lock. The setting will be overridden by pressing the ✳/▦• 🔍 button again.

3) Recompose the picture and depress the shutter-release button. To take a second shot at the locked exposure, continue to depress the ✳/▦• 🔍 button while depressing the shutter-release button fully.

There are two techniques which can make life a little more certain: the first is to set exposure bracketing (see page 77). The second is to be aware of constantly changing ambient light and to adjust your camera settings while you are walking around – so when an opportunity presents itself the camera is already set up to expose correctly. The latter method works best of all in Manual exposure mode.

Tips

In Partial metering and Centre-weighted metering modes, AE Lock is applied at the centre AF point.

When the lens is switched to MF (manual focus), AE Lock is also applied to the centre AF point.

In Evaluative Metering mode, AE Lock depends upon the AF point selection settings: with automatic AF point selection, AE Lock is applied to the AF point(s) which achieved focus; with manual AF point selection, AE Lock is applied to the selected AF point.

Common errors

One of the most frequent causes of badly exposed images is the tendency to shoot first and ask questions later. Often, you have a lot more time to get the shot than you think – enough to consider which metering mode is most likely to give the best result.

Exposure compensation

In most instances the exposure suggested by the camera will be quite adequate provided that there are no bright highlights and deep shadows which contain detail that you want to retain. In these cases you can use exposure compensation to shift the overall exposure and pull in additional detail. This will have the effect of making all the tones darker or lighter, depending which option you choose.

It may be beyond the capacity of the sensor to retain image detail in both bright highlight and deep shadow areas. In such cases you may wish to consider bracketing exposures to play safe (see page 77). If you are shooting RAW files, you may be able to recover some detail when the images are processed on the computer.

Exposure compensation of up to +/-2 stops in ⅓- or ½-stop increments can be set in any of the Creative Zone modes, regardless of which metering mode has been selected.

Tips

Exposure compensation can be applied in conjunction with Auto exposure bracketing.

Exposure compensation is not cancelled when you turn off the camera. Reset compensation to zero as soon as it is appropriate.

THE SUN INN
With the brightest part of the image in the centre of the frame, exposure compensation of -⅓ was used in conjunction with Auto exposure bracketing to ensure a perfect result.

Setting Exposure compensation

1) Turn the Mode Dial to any Creative Zone setting except **M** (Manual).

2) Turn the power switch to **ON**.

3) Frame your shot and partially depress the shutter-release button to obtain an exposure reading. Consider the balance between the highlight and shadow areas of the image and assess the likely level of compensation needed.

4) Check the ▬▬▬▬ Exposure level indicator at the bottom of the viewfinder, or on the LCD monitor by pressing **DISP**, to make sure that the indicator is at the centre of the exposure scale.

5) To set the level of compensation, hold down the **Av** button while rotating the ⚙ Main Dial. One direction will increase the exposure and the opposite direction will decrease it, one increment at a time. The ▬▬▬▬ Exposure level indicator will show the extent of the compensation.

6) Take the photograph and review the result. You may wish to increase or decrease the compensation accordingly and take further exposures.

7) To cancel exposure compensation, repeat step 5 and return the ▬▬▬▬ Exposure level indicator to the centre point of the scale.

Setting the Exposure compensation increment

To change the exposure compensation increment from ⅓ to ½ stop:

1) Press the **MENU** button and select ▼▼ Shooting Menu 3.

2) Highlight **Custom Functions** and press **SET**.

3) Use the ◄ and ► buttons to scroll through the Custom Functions screens until you reach **C.Fn I: Exposure/1 Exposure Level Increments**.

4) Press **SET** to highlight the existing setting.

5) Press ▲ or ▼ to change to the alternative setting.

6) Press **SET** again to save the setting. Press **MENU** to exit.

Using AF points

Automatic AF-point selection will take place in the Basic Zone and in **A-DEP** mode, and it cannot be overridden. In the Creative Zone modes (except A-DEP), you can select any one of the seven AF points, or automatic AF-point selection using all seven AF points.

Setting the AF point

1) Press the [⊡]/⊕ button. The currently selected AF point(s) will be illuminated in the viewfinder. If all seven AF points are illuminated, automatic AF-point selection is the current setting.

2) Scroll through the AF points by turning the 🗇 Main Dial.

3) Lightly depress the shutter release button to finalize your selection.

Common errors

Remember that AF-point selection can influence the meter reading (see page 59).

Tips

In auto AF-point selection, the camera will tend to focus on the nearest object in the frame.

Having pressed the [⊡]/⊕ button, pressing the **SET** button will toggle the AF-point display between auto selection and the centre AF point.

For a moving subject, select AI Servo focus mode and automatic AF-point selection. Focus using the centre AF point initially. Thereafter, the other AF points will pick up and track the moving subject.

When the lens is set to **MF**, the AF point which achieves focus will still illuminate, the beep will sound, and the ● In-focus Indicator in the viewfinder will be illuminated.

AF-assist beam

In low light conditions, when the built-in flash is deployed automatically in Basic Zone modes, or is deployed manually in Creative Zone modes, it fires a brief burst of flashes to illuminate the subject and aid focusing prior to taking the picture. The maximum effective distance for this feature is about 13ft (4m) with the built-in flash. If an external Speedlite is attached, the Speedlite will perform the AF-assist beam function instead and can be used over greater distances due to its higher guide number (see page 151).

The AF-assist beam can be enabled or disabled using **Custom Function III-6**. These settings apply to both the built-in flash and to an external Speedlite. It is also possible to make this function work only with an attached Speedlite. However, if the Speedlite's own AF-assist beam Custom Function is set to 'disabled', it will override the camera settings and the Speedlite will not fire.

AF lock

Maintaining light pressure on the shutter-release button will lock focus so that you can recompose the image, safe in the knowledge that your main subject will be sharply focused.

LOCOMOTIVE
Flash exposures of essentially dark subjects, such as this close-up of a steam locomotive in an engine shed, are made much easier with the aid of the AF-assist beam.

Exposure modes – the Creative Zone

Canon's Creative Zone modes allow the photographer absolute control over every function on the camera, creating a seemingly infinite range of permutations. What really matters, though, is that you can set up the camera for virtually any situation – from the unhurried shooting of a still life on a tripod using Live View to capturing fast-action sporting events. Most photographers stay within their comfort zones initially but gradually expand their horizons and experiment with new techniques.

(P) Program AE mode

Program AE mode automatically sets the shutter speed and aperture. The specific combination can be adjusted but only as a combination and not individually. You could change 1/250 at f/8, for example, to 1/1000 at f/4 or to any other combination giving the same effective exposure. This is referred to as Program Shift. However, full control is available over AF mode, drive mode, built-in flash and other functions, so it is still a flexible mode and is perhaps the next step up the learning curve from Full Auto.

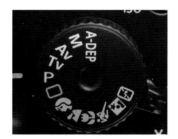

ROCK CLIMBING
This is a classic situation for Program mode with a zoom lens: one moment you want to be ready for action (left), a momentary slip resulting in a dramatic fall; the next, you want great depth of field (right). By rotating the Main Dial, a different combination of shutter speed and aperture can be selected almost instantaneously.

Program AE mode

Quality settings	RAW; JPEG (6 settings); RAW+large/fine JPEG
Exposure settings	Evaluative metering using 35 different zones; Partial metering; Centre-weighted metering; Exposure compensation; Auto exposure bracketing; Auto lighting optimizer (JPEG only)
Focus settings	One Shot; AI Servo; AI Focus; auto or manual AF point selection
Frame advance	Single frame; Continuous; Self-timer (three settings)
Flash and AF-assist settings	Flash and fill-in flash; AF-assist beam; red-eye reduction; first- and second-curtain sync; high-speed sync with selected Speedlites; flash exposure compensation; flash exposure lock; external flash function and Custom Function settings with compatible Speedlites
Notes	The least flexible of the Creative Zone modes. Flash is not possible in conjunction with Program Shift.

Using Program AE mode

1) Turn the Mode Dial to **P** and aim the camera at the subject.

2) Lightly press the shutter button to achieve focus. The In-focus indicator ● and selected AF point(s) will illuminate in the viewfinder.

3) The automatically selected shutter speed and aperture combination will be visible in the bottom left of the viewfinder. If you wish to change these settings using Program Shift, rotate the 🔆 Main Dial until the desired exposure combination is displayed in the viewfinder.

4) The built-in flash will not pop up automatically in Program mode, so keep an eye on the selected shutter speed. It can be raised manually if needed, and the ⚡ Flash symbol will be displayed at the bottom left of the viewfinder.

5) Retain light pressure on the shutter button to keep the focus locked and recompose the picture before depressing the button fully to take the photograph.

6) The captured image will be displayed on the LCD monitor for 2 seconds unless the review function has been adjusted.

(Tv) Shutter Priority AE mode

Shutter Priority mode gives the photographer the opportunity to decide on shutter speed as the single most important function. This may be in order to capture a fast-moving subject or to deliberately blur movement for pictorial effect. For the record, Tv stands for Time value.

The key factor in determining a suitable shutter speed is not the absolute speed at which the subject is travelling. What is important is the speed at which the subject is moving across the frame, and its size in relation to the area of the frame.

For example, a 1:1 magnification of a flower moving gently in the breeze is more likely to blur than an express train some distance away taken with a wide-angle lens.

Tip

For a series of high-speed shots, set a fast ISO setting. The EOS 1000D/Rebel XS still produces virtually noise-free images at 400 ISO. If your subject matter is likely to be varied but will include some high-speed shots, select Auto ISO.

RED ARROWS
With the aircraft a considerable distance away, it was possible to manually focus at infinity using an EF 85mm f/1.8 lens handheld. Using a shutter speed of 1/4000 sec at ISO 100, it was easy to freeze the action.

Shutter priority AE mode

Quality settings	RAW; JPEG (6 settings); RAW+large/fine JPEG
Exposure settings	Evaluative metering using 35 different zones; Partial metering; Centre-weighted metering; Exposure compensation; Auto exposure bracketing; Auto lighting optimizer (JPEG only). The user sets the shutter speed and the camera automatically selects a suitable aperture
Focus settings	One Shot; AI Servo; AI Focus; auto or manual AF point selection
Frame advance	Single frame; Continuous; Self-timer (three settings)
Flash and AF-assist settings	Flash and fill-in flash; AF-assist beam; red-eye reduction; first- and second-curtain sync; high-speed sync with selected Speedlites; flash exposure compensation; flash exposure lock; external flash function and Custom Function settings with compatible Speedlites
Notes	Also useful in changing light conditions to avoid camera shake

Using Shutter Priority AE mode

1) Turn the Mode Dial to **Tv** and set the desired shutter speed.

2) Lightly press the shutter button to achieve focus. The ● In-focus indicator will illuminate in the viewfinder. The selected AF point(s) will illuminate briefly accompanied by a beep (unless disabled in 📷 Shooting Menu 1).

3) The shutter speed and automatically selected aperture will be visible in the bottom left of the viewfinder.

4) The built-in flash will not pop up automatically. It can be raised manually if needed, when the ⚡ Flash symbol will show bottom left in the viewfinder.

5) Retain light pressure on the shutter button to keep the focus locked and recompose the picture before depressing the button fully to take the photograph.

6) The captured image will display on the LCD monitor for 2 seconds unless the review function has been adjusted.

(Av) Aperture Priority AE mode

This is the mode to use when you want to ensure that everything from the foreground to the background is in focus. Conversely, you can opt to use differential focus to make your subject stand out against an out-of-focus background. A wide aperture ensures narrower depth of field and a narrow aperture (larger number) will provide greater depth of field.

Many landscape photographers switch off autofocus on their lens when using this mode with a very narrow aperture. Instead, they manually focus on a point about a third of the way into the zone they want in focus. Alternatively, they may use the depth-of-field scale on the lens, if it has one.

Common errors

The viewfinder will only display shutter speeds down to 30 seconds. Any scene requiring a longer exposure will be indicated by the 30-second reading flashing – but the camera will still take the picture. Adjusting the aperture or ISO setting may be a solution.

CLIFF ARCHITECTURE
Using Aperture Priority AE mode, an aperture of f/8 on a 24mm lens was enough to keep the subject sharp from a few feet in front of the camera to infinity.

Tip
For very wide depth of field at slow ISO settings you will probably need a tripod. If you do not have a remote release, use the self-timer at its 10-second setting to minimize camera shake.

Aperture Priority AE mode

Quality settings	RAW; JPEG (6 settings); RAW+large/fine JPEG
Exposure	Evaluative metering using 35 different zones; Partial metering; Centre-weighted metering; Exposure compensation; Auto exposure bracketing; Auto lighting optimizer (JPEG only). The user sets the aperture and the camera automatically selects a suitable shutter speed
Focus settings	One Shot; AI Servo; AI Focus; auto or manual AF point selection
Frame advance	Single frame; Continuous; Self-timer (three settings)
Flash and AF-	Flash and fill-in flash; AF-assist beam; red-eye reduction; first- and second-curtain sync; high-speed sync with selected Speedlites; flash exposure compensation; flash exposure lock; external flash function and Custom Function settings with compatible Speedlites
Notes	Used to achieve maximum or deliberately reduced depth of field

Using Aperture Priority AE mode

1) Turn the Mode Dial to **Av** and set the desired aperture.

2) Aim the camera at the subject and lightly press the shutter button to achieve focus. The In-focus Indicator ● will illuminate briefly in the viewfinder. The selected AF point(s) will also illuminate briefly, accompanied by a beep (unless disabled in ◘ Shooting Menu 1).

3) The aperture and automatically selected shutter speed will be visible in the bottom left of the viewfinder.

4) The built-in flash will not pop up automatically. It can be raised manually if needed, when the flash symbol ✦ will show bottom left in the viewfinder.

5) Retain light pressure on the shutter button to keep the focus locked and recompose the picture before depressing the button fully to take the photograph.

6) After a very brief delay, the captured image will display on the LCD monitor for two seconds unless the review function has been adjusted or switched off.

(M) Manual exposure mode

This mode provides ultimate control over exposure, as the shutter speed and aperture are set independently – the camera is not involved with choosing one to fit the other. This is particularly useful in awkward lighting situations; at times when the camera's light meter may be fooled by either the luminosity or reflectivity of the subject matter; and when the desired effect is other than an averagely toned scene.

There are occasions when a particularly bright high-key image is required – for example, a soft-focus portrait of a bride in her wedding dress. Sometimes what might normally be deemed an underexposed result is needed, typically reportage images.

Another factor to bear in mind with the 1000D/Rebel XS is that it offers a monochrome option, including the simulated use of black-and-white filters. Traditionally, metering for slide film has always been based on the highlights, whereas metering for black-and-white photography has been based on the shadows. With the 1000D/Rebel XS in Manual mode you can adopt different midtones to suit different styles of photography. You can also use Picture Styles (see pages 83–7) to fine-tune your way of working.

THE AVENUE
The exposure for this shot was ½ stop greater than that suggested by the camera. If I had zoomed in further, the necessary adjustment could have been greater still. A reading from a midtone such as the grass in the foreground is useful in this type of situation.

Manual exposure mode

Quality settings	RAW; JPEG (6 settings); RAW+large/fine JPEG
Exposure settings	Evaluative metering using 35 different zones; Partial metering; Centre-weighted metering; Exposure compensation; Auto exposure bracketing. Aperture and shutter speed set independently
Focus settings	One Shot; AI Servo; AI Focus; auto or manual AF-point selection
Frame advance	Single frame; Continuous; Self-timer (three settings)
Flash and AF-assist settings	Flash and fill-in flash; AF-assist beam; red-eye reduction; first- and second-curtain sync; high-speed sync with selected Speedlites; flash exposure compensation; flash exposure lock; external flash function and Custom Function settings with compatible Speedlites
Notes	Allows ultimate control but needs understanding and experience

Using Manual exposure mode

1) Turn the Mode Dial to **M** and set the desired metering mode.

2) Lightly press the shutter button to achieve focus. The In-focus Indicator ● and selected AF point(s) will be illuminated in the viewfinder.

3) Rotate the ⚙ Main Dial to adjust the shutter speed.

4) Press the **Av** button with your thumb while rotating the ⚙ Main Dial with your index finger to adjust the aperture until the exposure-level mark is centred on the scale at the bottom of the viewfinder.

5) If metering from a selected area, take the reading and adjust as necessary to centre the exposure level mark again.

6) The built-in flash will not pop up automatically in Manual mode. It can be raised manually if needed.

7) Retain light pressure on the shutter button to keep the focus locked and recompose the picture before depressing the button fully to take the photograph.

8) The captured image will display on the LCD monitor for two seconds unless the review function has been adjusted.

(A-DEP) Automatic Depth of Field AE mode

Using the data provided by the AF points, this mode automatically selects an aperture and shutter speed that will maximize depth of field. It will attempt to give the photographer as fast a shutter speed as possible within the constraints of its objective: in other words, it won't give you f/11 when f/5.6 will do.

So what are the advantages of A-DEP mode over Aperture Priority with the depth-of-field preview button? First of all, it takes away the need to think about selecting a suitable aperture for each photograph. Secondly, it is extremely useful in situations demanding a very narrow aperture which would render the viewfinder image very dark when previewing the depth of field. Its main disadvantage is the loss of control over aperture and shutter speed.

Tips

If the automatically selected aperture produces a shutter speed that is too slow, increase the ISO setting or select Auto ISO.

If you are shooting in RAW, you can use exposure compensation to gain a couple of stops by shooting at the wrong exposure and rescuing the image on the computer later.

COUNTRY RETREAT
With the camera's array of AF points, it is easier to bring foreground elements into the picture at the sides of the image than at the bottom when using A-DEP mode.

Automatic Depth of Field AE mode

Quality settings	RAW; JPEG (6 settings); RAW+large/fine JPEG
Exposure settings	Evaluative metering using 35 different zones; Partial metering; Centre-weighted metering; Exposure compensation; Auto exposure bracketing; Auto lighting optimizer (JPEG only)
Focus settings	One Shot; automatic AF-point selection
Frame advance	Single frame; Continuous; Self-timer (three settings)
Flash	Flash can be used but the results will be the same as with Program mode (see page 64) and depth of field may be lost
Notes	Ensures that key elements are in focus but control of aperture and shutter speed is lost. Effectively acts like Program mode but without the option of Program Shift

Using A-DEP mode

1) Turn the Mode Dial to **A-DEP** and select the metering mode.

2) Aim the camera at the subject.

3) Lightly press the shutter button to achieve focus. The In-focus Indicator ● will illuminate in the viewfinder. The AF points which have achieved focus will illuminate briefly, accompanied by a beep (unless disabled in ☐˙ Shooting Menu 1).

4) If the briefly illuminated AF points do not pick out the areas of the subject that are most important to you, change your position in relation to the subject.

5) The automatically selected shutter speed and aperture combination will be visible in the bottom left of the viewfinder.

6) By retaining light pressure on the shutter button, focus will be locked and you can recompose the picture before fully depressing the shutter button to take the photograph. However, by recomposing the image you may lose focus on critical elements of the subject.

7) After a brief delay, the captured image will be displayed on the LCD monitor for two seconds unless the review function has been adjusted or switched off.

Menu options

The menu screens are displayed on the LCD monitor on the back of the camera. The seven tabs consist of two Shooting menus, one Playback menu, three Set-up menus and a customizable My Menu to access your most frequently changed options more directly. Each of these types of menu is represented by a symbol and is colour-coded to make identification easier.

The currently selected item on any menu is highlighted in the same colour as the type of menu. For example, the Playback menu symbol is blue, so menu items are highlighted in blue.

When a menu item is selected, a secondary menu is often displayed, occasionally followed by a third option or a **Cancel/OK** dialogue box.

Selecting menu options

1) Press the **MENU** button and use the Main Dial to scroll through the menus until you reach the one you need.

2) Use the ▲ and ▼ button to highlight the desired menu item. To select it, press the **SET** button.

3) If secondary menus or confirmation dialogue boxes are displayed, you may need to use the □□□□ buttons, the **DISP** button or **SET** in different ways.

4) Once a setting has been changed, press **SET** to save the new setting.

5) To exit at any stage, press the **MENU** button to go back one level and repeat the process if necessary.

Shooting menu 1

The 1000D/Rebel XS has two Shooting menus, which use red highlighting to differentiate them from other menus. The two Shooting menus control all the basic shooting-related functions including the quality of the files recorded, auto exposure bracketing, white balance and colour options, and Picture Styles.

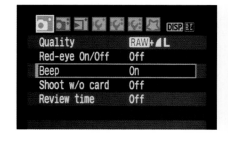

74

Setting file quality

The 1000D/Rebel XS has eight different file-quality settings. Six are in JPEG format, but there is also a RAW setting. It is also possible to record both RAW and large/fine JPEG files simultaneously.

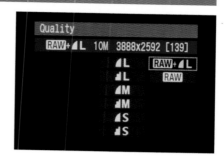

JPEG files, especially the smaller JPEG options, will take up much less space on your memory card, but will be of lower quality. They will also write faster so you won't need to wait while the buffer empties, as may happen when shooting RAW files. The burst size (the maximum number of shots you can take before the buffer is full) is also significantly increased. As the camera performs a number of processing tasks on JPEGs compared with RAW files, far less post-processing is required. The disadvantage of shooting JPEGs is that you have far less control over the recorded image than is the case with a RAW file. JPEG is also a compressed format, which means that there is some

loss of quality. The smaller the file, the greater the compression and the greater the loss of picture quality.

Using RAW files suits those who require the highest-quality images and are prepared to use computer software to bring those images to fruition. With the advent of Picture Styles, however, some of the post-processing can be avoided, which makes shooting RAW a much more viable option for those who are less interested or less skilled in post-processing techniques.

Red-eye on/off

This feature can be used in any mode except Landscape, Sports and Flash Off modes in the Basic Zone.

To select this function, follow the instructions on page 74.

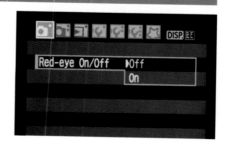

Beep

The beep is very useful to confirm focus, especially if you wear spectacles and have difficulty getting your eye right up to the viewfinder. However, the beep can also be an unwelcome distraction in situations such as a church or museum, so you can choose to turn it off.

To select this function, follow the instructions on page 74.

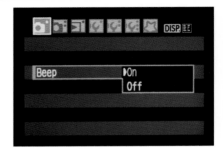

Shoot without card

With this function you can choose to allow the camera to function without a memory card installed. This facility might be used when capturing a large number of images direct to your computer.

To select this function, follow the instructions on page 74.

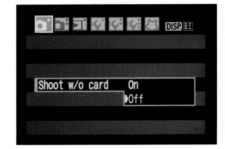

Review time

After shooting, the camera will display the image on the monitor for 2, 4 or 8 secs, or for as long as you like if you select **Hold**. Alternatively, if want to conserve battery power and review images later, you can turn the review function off.

To select this function, follow the instructions on page 74.

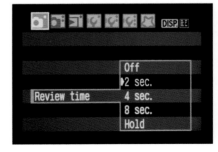

76

Shooting menu 2

Shooting menu 2 gives access to settings which control exposure, colour, contrast and sharpness. As with Shooting menu 1, selected items are highlighted in red. The process for selecting menu options is described on page 74.

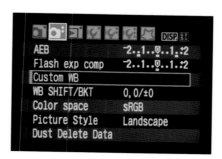

> **Note**
> This menu cannot be accessed in Basic Zone modes.

Auto exposure bracketing (AEB)

This function is useful when you're not sure how the balance between highlights and shadows will work out.

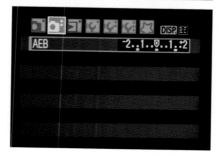

Three bracketed exposures will be taken at ¹/₃ or ½ stop apart, depending on the increment set in **Custom Function 1**. The ▒▒▒▒▒ scale in the viewfinder shows additional indicator marks either side of the central indicator to show the level of over- and under-exposure. This information is also shown on the Display screen. The order in which the shots are taken is as follows: normal, under-exposed, over-exposed.

To cancel AEB, follow the same procedure but return the indicator on the ▒▒▒▒▒ scale to its central position.

> **Tip**
> AEB can be used with both single and continuous drive modes. However, it cannot be used with flash or bulb exposures.

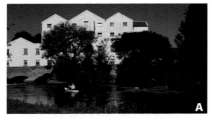

AUTO EXPOSURE BRACKETING

This water mill scene contains a full range of highlights and shadows. Image C is the 'correct' exposure. Images A and B are underexposed by 1 stop and ½ stop respectively. Image D is overexposed by ½ stop and image E by 1 stop. It is clear that bracketing by ⅓ or ½ stop would be sufficient to achieve a successful result.

Tips

The Auto exposure bracketing function is cancelled when the camera is turned off.

AEB can be combined with Auto exposure compensation, with the compensated setting being the 'normal' exposure of the three shots taken.

If the Auto Lighting Optimizer function is enabled, AEB may not prove effective.

AEB is not available in Basic Zone modes. Once selected in a Creative Zone mode, it will be retained when you change to any other Creative Zone mode. If **Bracketing auto cancel** is not enabled, the camera will also retain the bracketing setting even when it is turned off.

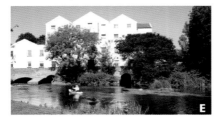

Flash exposure compensation

Flash exposure compensation can be set for both the built-in flash and for external EX-series Speedlites. When flash exposure compensation has been set and the shutter button is partially depressed, the viewfinder will display both the flash-ready symbol **⚡** and the flash exposure compensation symbol **⚡**.

The latter symbol will also be shown on the Display screen with the amount of compensation also indicated.

Tip
Flash exposure compensation may not prove effective if the Auto Lighting Optimizer is enabled.

Common problems
Flash exposure compensation is not cancelled when the camera is switched off. Reset it to zero after use.

White balance (WB)

White balance is set via the **WB** button on the back of the camera, except in Basic Zone modes where **AWB** is mandatory.

In order for colours to be rendered accurately, it is necessary to ensure that white is represented exactly as desired. In most cases this means obtaining a pure white, without the colour cast that comes with different artificial light sources, and from natural lighting at different times of the day, or in shade. These variations are measured according to what is known as

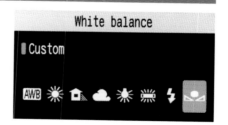

colour temperature, which is shown in degrees Kelvin, commonly abbreviated to °K. This figure is indicated above each preset WB setting accessed via the **WB** White balance button (see page 38).

FUNCTIONS

Setting Custom white balance

Shooting menu 2 also enables you to determine a Custom white balance setting ⌧ to suit a particular shooting situation in which you are unable to gauge the precise colour temperature.

1) To set Custom white balance, first photograph a plain white object using manual focus and the exposure indicated, without any compensation or bracketing. Ensure that it fills the area covered by the four central AF points. Any white-balance setting can be used at this stage.

2) Select ◘ Shooting Menu 2, highlight **Custom WB** and press **SET**. A captured image will appear on the LCD monitor.

3) Rotate the ⌧ Main Dial or use the ◄ and ► buttons until the image you just captured appears, then press **SET**.

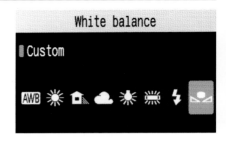

4) A dialogue box appears, reading **Use WB data from this image for Custom WB**. Select **OK**. The data will be imported.

5) You will be prompted to set the WB to ⌧.

6) Exit the menu by pressing **MENU**.

7) Next time you wish to use your Custom WB setting, press the **WB** button and select ⌧.

Common errors

If the exposure obtained in step 1 above is significantly underexposed or overexposed, a correct white balance may not be obtained.

If the image captured in Step 1 was taken while Picture Style was set to Monochrome, it cannot be imported in Step 4.

Tips

If you have registered a personal white-balance setting using the software provided with the camera, it will be replaced by any new Custom white-balance setting ⌧.

80

White-balance shift/bracketing

These two functions are incorporated into the same menu screen, which provides a simple graphic representation of a complex process. Adjusting the colour settings is not unlike using colour-correction filters, except that here, nine levels of correction are possible. Each increment is equivalent to a five mired shift.

This facility can be applied to any white-balance setting, including custom and preset white-balance settings. It is only available in Creative Zone modes.

To set White-balance shift:

1) In ○ Shooting Menu 2, highlight **WB SHIFT/BKT** and press **SET**.

2) Use the □□□□ buttons to move the white cursor ■ from its central position to the new setting. The bias can be towards Blue, Amber, Magenta or Green and the blue panel at the top right displays the new coordinates using the initial letter of the colour plus a number from 0–9.

3) Press **DISP** at any time to reset the bias to 0,0.

4) Press **SET** to finalize your setting.

5) The **BW+/-** symbol will be shown in the viewfinder and on the LCD monitor.

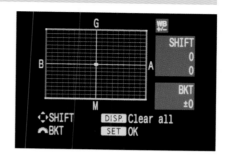

White-balance bracketing can be used in conjunction with White-balance shift to capture three versions of the same image, each with a different colour tone. The primary image will use the cursor location as set opposite. Either side of this, two further images will be captured with a difference of up to three levels in single-level increments, each increment being five mireds. You can bracket with either a Blue/Amber bias or a Magenta/Green bias.

> **Tip**
> It is only necessary to press the shutter release once with White-balance bracketing selected in order to capture the three images. However, both the total number of shots available on the memory card and the number of burst images available will be reduced by three.

To set White-balance bracketing:

1) In ◘ⁱ Shooting Menu 2, highlight **WB SHIFT/BKT** and press **SET**.

2) Rotate the ⚙ Main Dial clockwise to set a Blue/Amber bias with one, two or three levels' difference. The increment is shown in the blue panel (bottom right). Alternatively, rotate the ⚙ Main Dial anti-clockwise to set a Magenta/Green bias with one, two or three levels' difference.

3) Press **DISP** at any time to cancel bracketing (the cursor will be reset to 0,0).

4) When bracketing is selected (but before **SET** is pressed) it is still possible to move the cursor around the screen to adjust the colour bias.

Tips
White-balance bracketing can be combined with Auto Exposure Bracketing. Pressing the shutter release three times will result in nine images being captured.

The bracketing sequence will be as follows: standard white balance, blue bias, amber bias or standard white balance, magenta bias, green bias.

5) Press **SET** to finalize your settings and return to ◘ⁱ Shooting menu 2.

Colour space

The term 'colour space' is used to describe the range of colours that can be reproduced within a given system. The 1000D/Rebel XS provides two colour spaces: sRGB and Adobe RGB. The latter offers a more extensive range and is likely to be used by those for whom the final image is to be converted to the CMYK colour space for commercial printing in books, magazines or catalogues. Canon recommend sRGB for what they classify as 'normal use'.

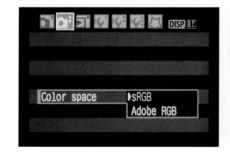

To select this function, follow the instructions on page 74.

Picture Style

In the Basic Zone modes, the appropriate Picture Style is selected automatically – for example, in Portrait Mode the Portrait Picture Style is selected. In the Creative Zone, however, each Picture Style preset can also be tweaked according to your personal needs and preferences.

To change to a different Picture Style without changing parameters, a simple menu can be accessed by pressing the ⚬⚬ Picture Style selection button on the back of the camera. To change an individual Picture Style's parameters you must access the Picture Style menu via the **MENU** button and **◻ᵢ** Shooting Menu 2.

Picture Style	❶, ❶, ⚬, ❶
S Standard	3, 0, 0, 0
P Portrait	2, 0, 0, 0
L Landscape	4, 0, 0, 0
N Neutral	0, 0, 0, 0
F Faithful	0, 0, 0, 0
M Monochrome	3, 0, N, N
DISP. Detail set.	SET OK

All the Picture Style options discussed on pages 84–7 apply equally to both JPEG and RAW files, but if you are shooting RAW you also have the option of resetting or changing the Picture Style parameters afterwards on your computer using dedicated Canon software.

FUNCTIONS

Standard

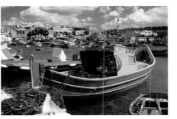

Portrait

PICTURE STYLES
These images show the camera's five preset Picture Styles for colour images. The Monochrome Picture Style is discussed separately on pages 86–7.

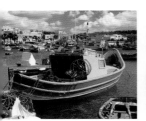

Landscape

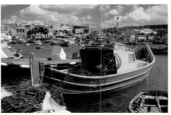

Neutral

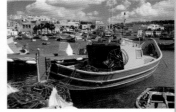

Faithful

Picture Style parameters

For each Picture Style there are four sets of parameters, as follows: ◐ Sharpness, ◑ Contrast, ⬥ Saturation and ● Colour tone. With the exception of ◐ Sharpness, the settings for which range from 0 to +7, all the settings range from -4 to +4. Their effects are self-explanatory, with the exception of Colour tone. With the Colour tone parameter, a lower setting (-4, for example) produces a reddish skin tone, while a higher setting (such as +4) produces a yellower skin tone.

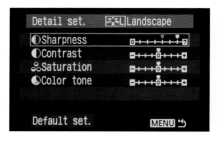

Changing Picture Style parameters

1) Press the **MENU** button. Select ◘ Shooting Menu 2, then **Picture Style** and press **SET**.

2) Use the ▼ button to scroll down to the desired Picture Style and press the **DISP** button to display the **Detail set.** screen for that Picture Style.

3) Use the ▲ and ▼ buttons to highlight the parameter you wish to change and press **SET**.

4) The chosen parameter will now appear on a screen on its own. Use the ◄ button to decrease the setting or ► to increase it. The white indicator will move along the scale accordingly, leaving a grey indicator showing the default setting.

5) Press **SET** to finalize the parameters. The **Detail set.** screen appears.

6) Repeat steps 3–5 as necessary.

7) Press **MENU** to return to the Picture Style screen, then press **SET** to finalize your choice of Picture Style and return to the Shooting Menu.

Tip

If you change a setting, you will see that the new setting is indicated by a white marker. The original setting also remains in view as a grey marker, so it is easy to return to the default settings.

84

Registering User-defined Picture Styles

You can adjust the parameters of a Picture Style and register it as one of three User-defined styles, while keeping the default settings for the base style.

1) Press the **MENU** button. Select 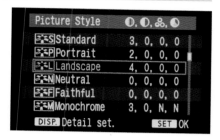 Shooting Menu 2 then **Picture Style** and press **SET**.

2) Use the ▼ button to scroll down to the desired User-defined Picture Style and press the **DISP** button to display the **Detail set.** screen for that Picture Style.

3) The top line of the menu will show the preset Picture Style currently used as the base style for the selected User-defined style. To amend this base style, press **SET** and use the ▲ and ▼ buttons to scroll through the preset styles. Select the desired preset and press **SET**.

4) Use the ▼ button to scroll down to the Picture Style parameter you wish to amend and press **SET**.

5) The chosen parameter will now appear on a screen on its own. Use the ◄ button to decrease the setting or ► to increase it. The white indicator will move along the scale accordingly, leaving a grey indicator showing the default setting.

6) Press **SET** to finalize the parameters. The **Detail set.** screen appears.

7) Repeat steps 4–6 as necessary.

8) Press **MENU** to return to the Picture Style screen, then press **SET** to finalize your choice of Picture Style and return to the Shooting Menu.

Setting a Monochrome Picture Style

The procedure for setting or adjusting the parameters for Sharpness and Contrast is exactly as outlined on page 84. The procedure for setting Filter or Toning effects is the same up to the point where a single parameter is shown on screen.

Instead you are presented with a menu from which to choose. The Filter effects menu offers a choice of yellow, orange, red or green filter effects or none. The Toning effects menu offers a choice of sepia, blue, purple, green or none.

Monochrome parameters

As well as ◖ Sharpness and ◖ Contrast there are two monochrome-only settings, ◔ Filter effect and ⊘ Toning effect, the

symbols for which replace those for Saturation and Colour Tone as soon as Monochrome is selected.

Monochrome filter effects

Four filter effects can be applied to monochrome images, as follows:

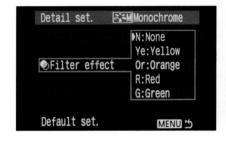

Yellow Blue sky looks less washed out and clouds will appear crisper.

Orange Blue sky will be darker and clouds more distinct. Good for stonework.

Red Blue sky will appear very dark, clouds very white; high contrast.

Green Good for lips and skin tones. Foliage will look crisper.

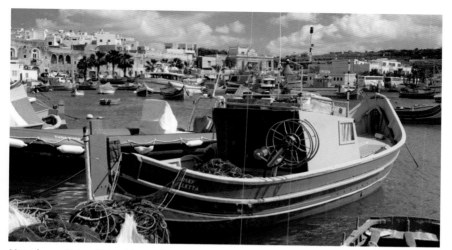

Monochrome Picture Style without adjustment.

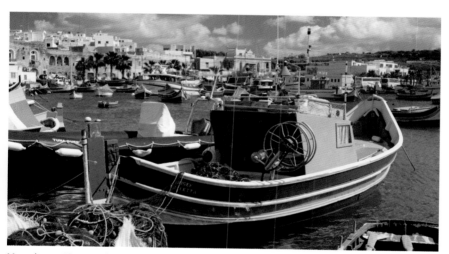

Monochrome Picture Style with Red filter applied. The effect is not as marked as when using a red filter with black-and-white film at a similar ISO.

Dust Delete Data

Under normal circumstances the camera's self-cleaning sensor unit will eliminate most of the dust specks that show up on your images. When visible traces remain, however, you can append the Dust Delete Data to the images to erase the dust spots automatically at a later stage in the Digital Photo Professional software provided. Once obtained, the data is appended to all the images, both RAW and JPEG, captured subsequently, but it has no significant impact on file size.

To obtain the Dust Delete Data:

1) Using a solid-white subject, set the lens focal length to 50mm or longer.

2) Set the lens to **MF** manual focus and rotate the focusing ring to the infinity setting.

3) In ◻️ Shooting Menu 2, select **Dust Delete Data** and press **SET**.

Tip
Update the Dust Delete Data before an important shoot – especially if you will be working with narrow apertures, which show up dust spots more clearly.

4) Select **OK** and press **SET**.

5) After automatic sensor cleaning is completed, the following message will appear: **Press the shutter button completely when ready for shooting**.

6) Photograph the solid-white subject at a distance of 8–12in (20–30cm). Ensure that the subject fills the viewfinder.

7) The resulting image will be captured automatically in **Av** Aperture Priority mode at an aperture of f/22. This image will not be saved but the Dust Delete Data will be retained. A message screen appears reading **Data obtained**. Press **OK**.

8) If the data was not obtained, another message will advise you of this. Make sure you follow the preparatory steps carefully and try again.

Playback menu

The Playback menu is identified by blue highlighting, and it covers the protection, deletion and rotation of selected images. It also enables you to choose images for the purposes of printing or transferring to computer.

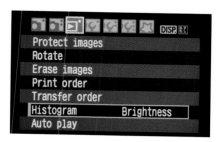

Protect images

In order to avoid accidental deletion, you can protect selected images. These, once protected, will display the 🔣 key symbol.

1) Press the **MENU** button and use the 🎛 Main Dial or ■■ buttons to scroll through the menus until you reach ▶ Playback menu.

2) Select **Protect images** and press **SET**.

3) Using the ◀ or ▶ buttons, select the image to be protected and press **SET**. The 🔣 key icon will appear above the protected image.

4) To cancel protection for an image, select it and press **SET**. The 🔣 key icon will disappear.

5) To protect another image, repeat Step 3.

6) To exit image protection, press the **MENU** button.

Warning!
Protected images will still be deleted when you format a memory card.

Tip
To delete protected images, you must cancel the protection individually for each image.

Rotate images

This facility enables you to rotate individual images, as opposed to the Auto Rotate function which will automatically rotate all portrait-format images to the correct orientation if selected.

1) Select **MENU** on the power switch.

2) Press the **MENU** button and then use the 🖰 Main Dial to scroll through the nine menus until you reach ▶ Playback menu 1.

3) Rotate the ○ Quick Control Dial to select **Rotate** and press **SET**.

4) Rotate either the ○ Quick Control Dial or the 🖰 Main Dial to select the image to be rotated, and press **SET**.

5) To rotate another image, repeat Step 4.

6) To exit, press the **MENU** button.

> **Tip**
> By using the ✶/📼•🔍 and 📼/🔍 buttons you can toggle the monitor between a single image, four images or nine images shown simultaneously.

Erase images

The Erase facility enables the deletion of either selected individual images or all the images on the memory card, with the exception of any protected images in both cases. There is a distinct advantage to erasing individual images via this menu as opposed to simply using the 🗑 button during review. This is that images are selected for deletion (marked with a tick) but not actually deleted until you press the 🗑 button to delete all selected images at once. Consequently, you can scroll backwards and forwards through similar images to make comparisons and can uncheck an image if necessary.

To erase selected images:

1) Press the **MENU** button and then use the ⚙ Main Dial or ■■ buttons to scroll through the menus until you reach ▶ Playback menu.

2) Select **Erase images** and press **SET**.

3) Select **Select and erase images** and press **SET**.

4) Use the ◄ and ► buttons to scroll through the images.

5) Use the ▲ button to select an image for deletion. A white tick will be displayed in a small box at the top left of the displayed image. Next to the tickbox the total number of images selected for deletion will be displayed. To remove the tick, press ▼.

6) To select another image for deletion, repeat steps 4–5.

7) To exit, press the **MENU** button.

Print order

The Print Order function allows you to select images for printing direct from the memory card. You can also specify which settings will be applied and the information to be printed with each image. Index printing enables you to print thumbnail images. This topic is explained fully in Chapter 8, Connection.

Transfer order

The Transfer Order function operates in a similar way to the Print Order function but relates to the transfer of images from the memory card to your computer. This topic is covered in Chapter 8, Connection.

Histogram

During playback, pressing the **DISP** button will bring up the Shooting Information display, which shows the image at a smaller size but with useful shooting information, including a histogram. The **Histogram** menu option allows you to choose between displaying a Brightness histogram or an RGB histogram. Pressing the **DISP** button a second time during playback will bring up a second display which incorporates both Brightness and RGB histograms, but with less shooting information, owing to the reduced display area available.

Using the Brightness histogram

The Brightness histogram is a graph that shows the overall exposure level, the distribution of brightness and the tonal gradation. It enables you to assess the exposure as a whole and also to judge the richness of the overall tonal range. With the ability to interpret these histograms comes the skill needed to fine-tune the exposure that is required.

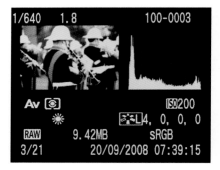

The horizontal axis on the histogram shows the overall brightness level of the image. If the majority of the peaks appear on the left of the histogram, it indicates that the image may be too dark. Conversely, if the peaks are largely on the right, the image may be too bright. Why 'may be' as opposed to 'will be'? The reason I have qualified the wording is that the answer all depends on the result you are seeking. You might actually want a very 'heavy' result, or perhaps a high-key, soft-focus image which is bright and ethereal in quality.

The vertical axis shows how many pixels there are for each level of brightness. Too many pixels on the far left suggests that shadow detail will be lost. Too many on the right suggests that highlight detail will be lost. The Highlight Alert function will cause these areas to blink on the image displayed.

In particularly contrasty situations, you may be in danger of losing both shadow and highlight detail in an image, in which case you must judge which you want to sacrifice in favour of the other.

92

Using the RGB histogram

The RGB histogram is a graph showing the distribution of brightness in terms of each of the primary colours – Red, Green and Blue. The horizontal axis shows each colour's brightness level (darker on the left and lighter on the right). The vertical axis shows how many pixels exist for each level of brightness in that particular colour.

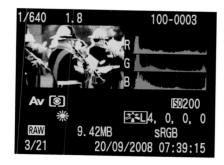

The greater the number of pixels on the left, the darker and less emphatic that particular colour will appear in the image. Conversely, the greater the number of pixels shown on the right, the brighter

that colour will be, possibly to such an extent that the colour is far too saturated and won't hold detail.

Auto play

Auto Play initiates a slide show which works in conjunction with the Shooting Information display described on page 92. You can press **DISP** during the slide show to change the display from image-only to a display with the histogram that has been set in the Playback menu ▶ or to a display that shows both types of histogram. You can also pause and restart the slide show by pressing **SET**.

Tip
Use the RGB histogram rather than the Brightness histogram. Because it provides both colour and brightness information in a single graph, you can avoid having to learn how to use both histograms at the same time.

FUNCTIONS

Set-up menu 1

This is the first of three menus that cover settings which, in most cases, you will determine once and need not return to often, except in special circumstances. Highlighting for all Set-up menus is in yellow.

To set options in ✨ Set-up menu 1:

1) Press the **MENU** button and use the 🎛 Main Dial or ▢▢ buttons to scroll through the menus until you reach ✨ Set-up menu 1.

2) To change the highlighting to a different item on the menu use the ▲ and ▼ buttons.

3) To select an item once it is highlighted, press the **SET** button.

4) If secondary menus or confirmation dialogue boxes are displayed, you may need to use the ▢▢▢▢ buttons, the **DISP** button or **SET** in different ways.

5) Once a setting has been changed, press **SET** to save the new setting.

6) To exit at any stage, press the **MENU** button to go back one level and repeat if necessary.

Auto power-off

With the Auto power-off setting, you can save battery power while keeping the camera ready for action. You can instruct the camera to turn itself off after a set interval ranging from 30 seconds to 15 minutes of inactivity, but power will be restored immediately when you partially depress the shutter-release button. If you wish the camera to remain switched on you should select the **Off** option.

File numbering

Each time you record an image, the camera allocates a file number to it and places it in a folder. The file numbers and folder names can be changed when they are on your computer, but not in camera.

Images are assigned a sequential file number from 0001 to 9999 and are saved in one folder. The prefix IMG_ is used regardless of file type but the suffix will be either .JPG or .CR2 for RAW files. When a folder is full and contains 9999 images, the camera automatically creates a new folder. The first image in the new folder

will revert to 0001, even if **Continuous** is selected in the File numbering menu. The camera can create up to 999 folders. A new folder is also created for each new shooting date.

Continuous

If you select this option, when you change a memory card, the file number of the first image recorded on the new card will continue from the last image on the card you removed. So, if the last shot taken on a card was IMG_0673.JPG, the first shot on the new card will be IMG_0674.JPG. As soon as the file number reaches 9999, a new folder will still be created and the file number will revert to 0001.

Auto reset

Each time you replace a memory card, file numbering automatically starts from 0001.

Common problems

Continuous file numbering is sometimes assumed to be a mechanism for counting the number of shutter actuations, but in fact it relates only to the file-numbering sequence that continues when you replace the camera's memory card.

Even when Auto reset is selected, if you insert a memory card that contains previously captured images, the camera is likely to continue the sequential file numbering from the last image shot on that card. To avoid this you should format the card to delete all previous images – provided, of course, that you have already downloaded them to your computer or another storage device.

Manual reset

When you reset the file numbering manually, the camera creates a new folder immediately and starts the file numbering in that folder from 0001. This is convenient if you are shooting similar images in a variety of different locations or at different times and want to keep each set of images separate. This can be extremely helpful when renaming files or adding captions at a later date. After a manual reset, the file-numbering sequence will return to Continuous or Auto reset.

Auto rotate

If Auto rotate is enabled, all vertical images will be rotated automatically so that they are displayed with the correct orientation. This can be applied to either the camera monitor and computer ◘▣ or just the computer ▣, or it can be disabled altogether.

Format

If the memory card is new, or has been in use in a different camera, the Format function will initialize the card ready for use in the current camera. Formatting a card removes all images and data stored on that card, including images which have been protected through the **Protect images** function in the ▶ Playback menu (see page 89).

LCD on/off button

The LCD monitor displays menus and secondary dialogue boxes, images captured, and shooting information. The default setting is for the Shooting settings screen to be displayed when the camera is switched on. When you partially depress the shutter-release button, this display is temporarily turned off. The Shooting settings screen can also be turned off by pressing either the **DISP** or **SET** buttons. Other default settings include the display of menus when you press **MENU** or image playback when you press ✳, the display in each case being switched off again when you press the same button.

The **LCD on/off button** menu allows you to choose how the Shooting settings screen is activated or deactivated (menu and image playback displays are not affected).

Shutter btn. (default): Display turns off temporarily while the shutter-release button is depressed.

Shutter/DISP: Display turns off when the shutter-release button is depressed but then remains off. To switch the display on again, press **DISP** or **SET**.

Remains on: display remains on, even when the shutter release is depressed. To switch it off, press **DISP** or **SET**.

> **Tip**
> Unnecessary use of the LCD monitor should be avoided to conserve the battery.

Screen colour

Four different colour schemes can be selected for the Shooting settings display. Menu screens are not affected.

Set-up menu 2

As with Set-up menu 1, you will visit most of the settings in Set-up menu 2 when you first acquire the camera, but rarely afterwards – with the possible exceptions of the Live View and Flash control functions.

To set options in ʦ Set-up menu 2:

1) Press the **MENU** button and use the Main Dial or □□ buttons to scroll through the menus until you reach ʦ Set-up menu 2.

2) To highlight a different item, use the ◄ and ► buttons. To select it, press the **SET** button.

3) If secondary menus or confirmation dialogue boxes are displayed, you may need to use the □□□□ buttons, the **DISP** button or **SET** in different ways.

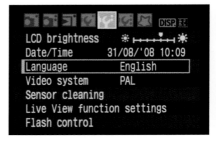

4) When a setting has been changed, press **SET** to save the new setting.

5) To exit at any stage, press the **MENU** button to go back one level at a time.

> **Note**
> The Live View and Flash control menus will not be displayed when using a Basic Zone mode.

LCD brightness

When this function is selected, three items are displayed on the monitor: the last image recorded, a greyscale and a slider control. If no images are stored on the memory card, just the greyscale and slider are displayed.Use the ◄ and ► buttons to change the setting. The arrow on the slider moves along the scale and all the bands of the greyscale graphic become darker or lighter, as does the displayed image.

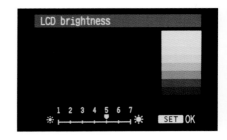

Date/Time

To set or amend the Date/Time:

1) Use the ◀ and ▶ buttons to highlight the item to be changed.

2) To change a setting, highlight it and press **SET**. Press either ▲ or ▼ (repeatedly when necessary) to increase or decrease the setting.

3) Press **SET** to confirm the change.

4) Repeat steps 1–2 for each setting you wish to change.

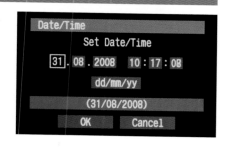

5) To save your changes, highlight **OK** and press **SET**.

Language

Twenty languages are programmed into the camera. Use the Language menu option to choose the one you prefer.

Video System

You can connect the camera to a TV set using the cable provided, making it easy to share your images with family and friends. This topic is covered in detail in Chapter 8, Connection. However, you must first use this menu to establish the correct video format. The choice is between **NTSC** (common in North America) and **PAL** (the format usually used in Europe).

Dust specks on the camera sensor are one of digital photography's major irritations, and they are virtually impossible to avoid. They show up particularly in areas of plain colour, such as expanses of blue sky, and when using narrow apertures – assuming the image is magnified sufficiently for them to be noticeable. To minimize the problem, avoid changing lenses frequently, especially in a dusty or windy environment, and don't use f/22 when f/8 will do!

The Integrated Cleaning System of the 1000D/Rebel XS is designed to shake off particles of dust, but it may still be necessary to have your camera's sensor professionally cleaned occasionally by an authorized Canon service centre.

If you enable **Auto cleaning** in the Sensor cleaning menu, the Self-cleaning sensor unit, which is attached to the sensor's front layer, will operate for approximately one second each time you turn the camera on and off. During this brief period the LCD monitor displays a message indicating that cleaning is taking place. Auto cleaning can also be disabled using the same menu.

Selecting the **Clean now** option in this menu will instruct the camera to operate the sensor-cleaning operation immediately. This will initiate a single cleaning cycle which may take slightly longer than the

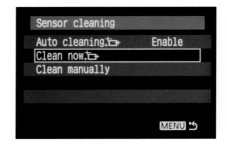

automatic operation. The sound of a single shutter operation will be heard but no image is recorded.

Tips
Consecutive cleaning operations will not necessarily be more effective than a single cleaning cycle.

For best results, stand the camera on its base on a firm surface while cleaning is taking place.

The Auto cleaning process can be interrupted by partially depressing the shutter-release button as a prelude to shooting.

The **Clean manually** setting is for use only by service technicians.

100

Live View function settings

When Live View is enabled it is activated by pressing the **SET** button, which is normally used for adjusting a wide range of menu settings. Consequently it is necessary to disable Live View when not in use.

Note
Live View is not available in Basic Zone modes.

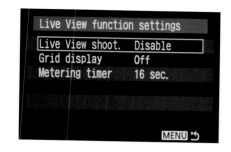

For further details on using the Live View function, see pages 111–7.

Flash control

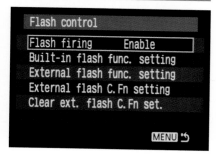

This secondary menu permits changes to a variety of settings for both the built-in flash and an external flash, provided the latter is a Canon EX Speedlite model that permits the setting of functions on the camera.

Flash firing

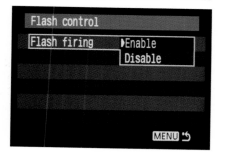

The first option in the Flash Control menu is simply to enable or disable flash firing. If flash firing is disabled, then neither the built-in flash nor an external flash will fire. They will continue to provide an AF-assist beam as long as this is not disabled too.

FUNCTIONS

Built-in flash functions

On this screen you can adjust the settings for shutter synchronization, flash exposure compensation and flash metering mode within E-TTL II. The top line, shown in pale grey to indicate that it cannot be changed, indicates the Flash mode.

Synchronization can be set to **1st curtain** or **2nd curtain** (see pages 156–7). The default setting, considered 'normal' flash exposure, is 1st curtain flash.

Flash exposure compensation works in exactly the same way as exposure compensation for the camera. Highlight the **Flash exp.comp.** setting and use the ◄ and ► buttons to adjust the exposure. A white marker indicates the level of compensation while a blue marker remains at the original setting. Compensation can be set in either ½- or ⅓-stop increments, depending on the increment set in the Custom Functions menu (see page 105).

E-TTL II metering can be set to either **Evaluative** or **Average**.

Evaluative metering compares the data obtained by the metering burst with the exposure levels under ambient lighting in order to extrapolate the best flash exposure. Readings are taken from the entire frame without bias towards any AF points covering the main subject. Distance

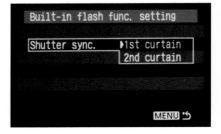

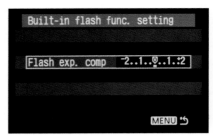

information, provided by compatible lenses, is factored into these calculations. Average metering simply calculates the flash exposure based on readings across the frame, without taking into account the ambient lighting, and may require some flash exposure compensation.

External flash functions & External flash custom function settings

Which of the above you need to choose will be determined by the model of the Speedlite attached and the functions the camera will support. The External flash functions screen allows you, depending on the external flash fitted, to change the settings for flash mode, 1st or 2nd curtain synchronization, flash exposure bracketing, flash exposure compensation and flash metering mode. If any of these functions are displayed in pale grey, they have to be set on the flash itself.

To change any external flash settings, follow the instructions on page 98.

To clear all Speedlite settings, press the **DISP** button.

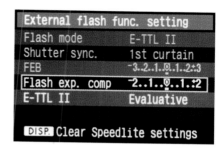

Warning!
Clearing the Speedlite settings will return all built-in flash settings to their default values.

External flash & Clear external flash custom functions

These functions operate in much the same way as the external flash settings except that you have direct access to the Speedlite's custom functions, assuming you are using a compatible model such as the 580EX II.

Common problems
Lenses equipped to transmit distance data to the camera will provide the most accurate exposure. However, distance data is not transmitted when the Speedlite is used in bounce mode or when multiple Speedlites are used. With EX Speedlites which are set to TTL, or EZ/E/EG/ML/TL Speedlites which are set to TTL or A-TTL, the flash will fire at full output only.

Set-up menu 3

This menu includes the 12 Custom Functions. It is also used to clear all camera settings and all Custom Functions back to their default values, so care needs to be taken not to do this accidentally. Set-up menu 3 ⁀Tᶦ also identifies the firmware installed on the camera.

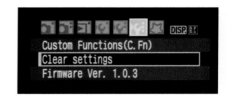

Custom Functions

Custom Functions are divided into groups primarily concerned with Exposure, Image, Autofocus and Drive, with a final group called Operation/Others. These groups are abbreviated using Roman numerals to C.Fn I, C.Fn II and so on. On the EOS 1000D/Rebel XS all Custom Functions are accessed from a single Custom Functions menu and are numbered from 1–12 consecutively, despite their sub-category.

The procedure for accessing each menu item is the same, as follows:

Note
This menu cannot be accessed in Basic Zone modes.

1) Press the **MENU** button and use the Main Dial or the ◄ and ► buttons to scroll through the menus until you reach Set-up menu 3 ⁀Tᶦ.

2) Select **Custom Functions** and press **SET**.

3) Use the ◄ and ► buttons to scroll through the options until you reach the appropriate one. Press **SET**.

4) Use the ▲ and ▼ buttons to choose the desired setting and press **SET**. The current setting will be highlighted in blue.

5) Repeat steps 3–4 to change other Custom Function settings.

6) Press **MENU** to exit to the main Custom Functions menu.

7) Press **MENU** to exit.

C.Fn I: Exposure

C.Fn-1 Exposure level increments

This provides a choice between ⅓- or ½-stop increments for both normal and flash exposure settings.

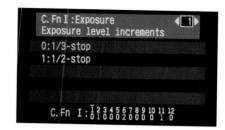

C.Fn-2 Flash sync speed in Av mode

This function applies solely to Aperture Priority (Av) mode and the use of flash. The flash sync speed can be set to a fixed 1/200 sec or can be left on **Auto** when it will set a suitable speed to match the ambient light, up to a maximum of 1/200 sec.

High-speed flash synchronization is also possible with compatible Speedlites.

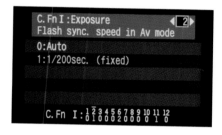

C.Fn II: Image

C.Fn-3 Long exposure noise reduction

The default setting for this function is **OFF**. When changed to **Auto**, the camera will automatically apply noise reduction to exposures of 1 sec or longer provided it detects noise in the image just captured. When switched to **On**, this function will apply noise reduction to all exposures of 1 sec or longer.

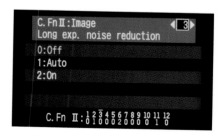

Tips

The noise-reduction process is applied after the image is captured and will effectively double the time taken to record the image.

If set to **On** and shooting with Live View, the LCD monitor will be disabled while noise reduction is applied.

The size of the maximum burst for continuous shooting will be drastically reduced when noise reduction is applied.

C.Fn-4 High ISO speed noise reduction

This function will reduce noise at all ISO settings, not just high ISO speeds as the name seems to suggest. When used with lower ISO speeds, a reduction in shadow noise may be obtained.

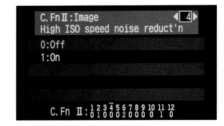

C.Fn-5 Auto Lighting Optimizer

This feature enables dark or low-contrast images to be corrected automatically, though in some situations there can be an increase in noise. The feature is applied automatically in all Basic Zone modes and cannot be disabled. In Creative Zone modes it can be enabled or disabled, but it will not work in Manual mode, nor with RAW or RAW+JPEG images.

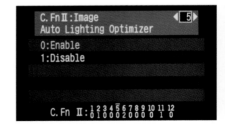

106

C.Fn-6 AF-assist beam firing

Both the built-in flash and EX Speedlites can assist with focusing in low light situations using this facility. If **Enable** is selected, both the built-in flash and an EX Speedlite, whichever is being employed, will use the AF-assist beam. If **Disable** is selected, neither will be able to use it. Finally, it is possible to enable only an external flash's AF-assist beam, as long as this function is not disabled on the Speedlite, the settings of which will override the settings on the camera.

C.Fn-7 AF during Live View shooting

During Live View operation it is possible to use one of two different AF modes to acquire focus, as well as a manual focus option. Manual focus is recommended for precision, with **AF during Live View shooting** disabled.

For a detailed description of the different focusing modes see pages 34–5.

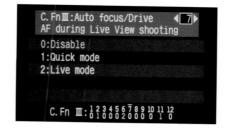

C.Fn-8 Mirror lock-up

To prevent the slight vibration that can be caused by the reflex mirror operation, the mirror can be locked up as soon as your focusing, framing and exposure-setting procedures have been completed. When the Mirror lock-up function is enabled, fully depressing the shutter-release button once swings the mirror up and locks it in place. This operation sounds like shutter actuation but is not. The shutter-release button is then pressed a second time to take the exposure and release the mirror afterwards.

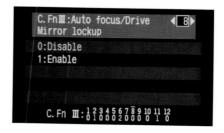

It is recommended that the remote release RS-60 E3 is used to further reduce the risk of vibration.

C.Fn IV: Operation/Other functions

C.Fn-9 Shutter/AE lock button

This menu offers several combinations for the shutter release and ✳/⊞• ⊖ AE lock button, all involving auto exposure lock and autofocus. There are handling implications for each combination and any reprogramming should be thought through carefully.

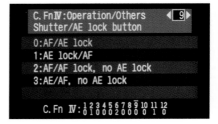

C.Fn-10 SET button when shooting

The **SET** button can be programmed to perform various functions, any of which you may like to access quickly. It can be used to control the LCD monitor display, bring up the image-quality screen, set flash exposure compensation, or access the Menu system. It can be used in conjunction with My Menu (see page 110) to access frequently used functions.

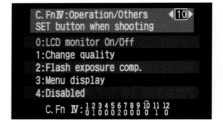

C.Fn-11 LCD display when power ON

When **Display** is enabled, the Shooting Information screen will be displayed when the camera is switched on.

If **Retain power OFF status** is enabled, the camera will not display the Shooting Information screen when the camera is turned on, provided the display was turned off prior to switching the camera off.

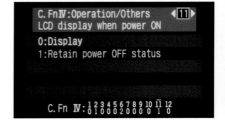

108

C.Fn-12 Add original decision data

When this function is **On**, data is added to all subsequently captured images to confirm their originality. For anyone to verify originality they must purchase the Original Data Security Kit OSK-E3.

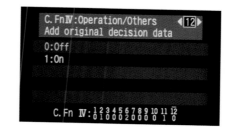

Clear settings

The **Clear all camera settings** function changes all shooting functions back to their default settings. Note that this will also delete both Custom WB information and Dust Delete Data. Custom Function settings are not affected.

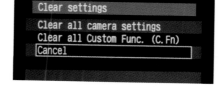

Clear all Custom Func. restores just the Custom Function settings to default values.

Firmware version

Set-up menu 3 displays the firmware version currently installed on the camera, provided one of the Creative Zone modes is selected. Canon periodically update the camera's firmware; check their website for new versions and installation instructions. Alternatively, you can have the updated firmware installed for you at a Canon Service Centre.

My menu

For faster access, you can register a combination of up to six menus and Custom Functions that you use on a regular basis, and choose the order in which they are displayed.

1) Press the **MENU** button and select ⚏ My Menu. Press **SET**.

2) Select **Register** and press **SET**.

3) Using the ▲ and ▼ buttons, scroll through the list of features to an item you wish to include. Press **SET**, then **OK** when the dialogue box is displayed.

4) Repeat the process for up to six items and press the **MENU** button to exit to My Menu settings.

5) To change the order in which the menu items are listed, select **Sort**.

6) Use the ▲ and ▼ buttons to highlight an item and press **SET**.

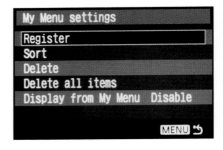

7) Change its position using the ▲ and ▼ buttons and press **SET**.

8) Repeat steps 6 and 7 as necessary and press **SET** to exit to My Menu settings.

You can easily delete a single item or all items registered to My Menu from the My Menu settings screen.

The final item on the My Menu settings screen is **Display from My Menu**. If this is enabled, My Menu will be displayed every time you press **MENU** rather than the last menu viewed.

110

Live View functions

Live View allows you to view the subject on the LCD monitor rather than through the viewfinder, but it will only function in Creative Zone modes. Live View shooting can be also carried out with the image displayed on the computer screen and camera functions operated remotely (for further information, refer to the software manual provided with the camera).

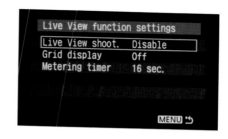

Live View: preparation

1) Set up your subject, tripod, lighting and camera using the viewfinder.

2) Select a Creative Zone shooting mode.

3) Select ꝑ Set-up Menu 2 and highlight **Live View function settings**. Press **SET**. Select **Live View shoot** and press **SET**.

4) Select **Enable** and press **SET**. Select and enable **Grid display** if desired.

5) Adjust the Metering timer. Six settings from 4 secs to 30 mins are available.

6) Press **MENU** to exit to the main menu and again to exit all menus.

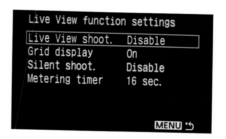

Warning!
Do not point the camera directly into any light source, especially the sun.

Warning!
Prolonged use of Live View may lead to high internal camera temperature, which may degrade image quality. If enabled, Auto power-off will operate as normal if the camera is not used. If Auto power-off is disabled, Live View will switch itself off after 30 mins if the camera is not used, though camera power will remain on.

Live View: display image

Enabling Live View shooting temporarily reassigns the **SET** button for all the Creative Zone modes, which will cause the subject image to appear on the LCD monitor in real time when pressed. If you press **SET** again, the Live View image will be switched off. Each time the display is turned on or off, the sound you hear is the mirror, not the shutter.

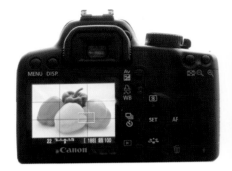

7) Press **SET** to enter Live View mode. The mirror will be raised and the subject displayed on the LCD monitor.

8) The brightness of the image displayed will be indicative of the brightness of the recorded image.

9) In Manual mode the image will appear darker or lighter when you adjust the shutter speed or aperture. Rotate the ⚙ Main Dial to adjust the shutter speed. Adjust the aperture by holding down the **Av+/-** button while rotating the ⚙ Main Dial.

Tips
You can display Live View images on your TV set using the video cable provided with the camera.

If lighting conditions change suddenly, the Live View monitor image may be destabilized. Don't take the picture until the image appears stable on the monitor.

If LCD brightness is at a higher setting, chrominance noise may be visible in the displayed image but will not be apparent in the recorded image.

Taking the picture while the image display is magnified will result in an unmagnified image but may adversely affect the recorded image quality.

Live View: magnification

10) A white rectangle (landscape format) is superimposed on the displayed image. This indicates the area which will be magnified so you can check detail or focus. Use the □□□□ buttons to move the white rectangle to the section of the image you wish to magnify.

11) Press the ⊡/⊕ Enlarge button once for 5× magnification. The □□□□ buttons can still be used while the image is magnified.

12) Press the ⊡/⊕ Enlarge button a second time to achieve 10× magnification. Press the ⊡/⊕ Enlarge button a third time to restore the unmagnified image.

13) You can also use the depth of field preview function to check focus while an image is magnified.

> **Tip**
> If the image is magnified first, the ✳/☐・⊕ AE Lock button will not lock the exposure settings. If the ✳/☐・⊕ AE Lock button is used before magnifying the image, the locked exposure settings will be retained during magnification.

Live View: shooting functions

Picture Style, Drive mode, AF mode, and choice of AF point cannot be changed without temporarily quitting Live View.

The Mode Dial can be used to change shooting mode during Live View operation, but A-DEP mode will function only as Program mode (P).

To adjust white balance, press **WB** and use the ◀ or ▶ buttons to select the desired setting, then press **SET**.

To adjust ISO, press **ISO** and either rotate the **SET** Main Dial or use ▲ and ▼ to change setting. To confirm and return to shooting readiness, press **ISO** or **SET** or partially depress the shutter release.

To adjust exposure compensation, hold down the **Av+/-** button and rotate the ⌢ Main Dial.

Evaluative metering mode will be used regardless of setting.

If you choose to change shooting functions via the menus, Live View will quit while you do so. Press **MENU** to exit the menus and **SET** to restore the Live View display.

Tips

If you usually use the **SET** button for one of the purposes specified in Custom Function 10 (see page 108), you must disable Live View in Set-up menu 2 **Live View function settings** before you return to normal shooting. If you do not, when you press **SET** you will bring up the Live View monitor image instead of the expected menu.

If the Auto Lighting Optimizer function is enabled (see page 106), the image displayed in Live View may appear brighter than intended.

Battery life will be reduced significantly when using Live View, providing approximately one third of the usual number of exposures.

Live View and DISP

With the Live View image displayed, pressing the **DISP** button will display the following shooting information: Drive mode, White balance, Picture Style, Image quality, Exposure simulation, AE lock, Flash ready, Shutter speed, Aperture, Exposure compensation, Flash exposure compensation, Exposures left on memory card, ISO, and Battery level.

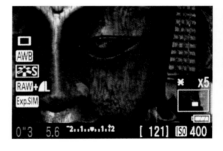

When **ExpSIM** is displayed, it indicates that the brightness level of the displayed image is a good indicator of the brightness of the image to be recorded. If **ExpSIM** blinks, it indicates that Live View is finding it difficult to display the image with a suitable level of brightness, but the recorded image will follow the exposure setting rather than the displayed image.

When **DISP** is pressed a second time, either the Brightness or the RGB histogram will be added to the display, depending on which option has been set in the ▶ Playback menu.

If either a time exposure (bulb) or flash is to be used, both the **ExpSIM** symbol and the histogram will be greyed out.

114

Live View with flash

There are several points to remember when using Live View with flash. First, only Canon flash units can be used.

When flash is used in Live View it sounds as if two exposures are recorded when you press the shutter release and take a picture, but in fact it is only one.

Built-in flash can be used but close proximity to the subject may result in uneven illumination.

Flash exposure lock is not possible with either the built-in flash or external Speedlites. Modelling flash with an external Speedlite does not function.

Live View: manual focus

You can use autofocus in Live View but there is much to be said for manual focus, especially using the magnification facility.

14) Exit Live Mode by pressing **SET**.

15) Press **MENU** and select Set-up Menu 3.

16) Select **Custom Functions** from the menu and press **SET**.

17) Use the ◄ or ► buttons to navigate to C.Fn 7 **AF during Live View shooting** and press **SET**.

18) Select **Disable** and press **SET** again.

19) Press **MENU** twice to come out of the menu screens. Then press **SET** to bring up the Live View image again.

20) Switch the lens to **MF** Manual focus and focus on the key part of the subject.

21) Use the □□□□ buttons to move the white rectangle to the key part of the subject, then press ⊡/⊕ to magnify the image. Fine-tune the focus.

22) Press ⊡/⊕ twice to return the image display to the full image.

> **Tip**
> Pressing the 🗑 Delete button will return the white rectangular focusing frame to the centre.

Live View: shooting

23) If necessary, press the ⊟/⊕ Enlarge button to return to the unmagnified image.

24) Fully depress the shutter-release button. The image is recorded and displayed on the monitor.

25) After the specified review time (set in ◯ Shooting Menu 1) the monitor display will revert to the Live View display.

26) To cease shooting in Live View, press **SET** while the Live View image (as opposed to the review image) is displayed.

Live View: autofocus

Two forms of autofocus are available in Live View: Quick Mode and Live Mode. However, manual focus is recommended for critical accuracy (see page 115).

Quick Mode AF: this mode functions just like autofocus in a normal shooting situation. Live View will be temporarily switched off during the focusing operation and while you adjust the menu settings.

1) Press **MENU**. Live View will be switched off. You will hear the mirror return to its normal down position.

2) Select ♈ Set-up menu 3, then Custom Functions. Press **SET**.

3) Use ◄ and ► to select C.Fn 7 **AF during Live View shooting**.

4) Press **SET** again and select **Quick Mode**. Press **SET** again.

5) Press **MENU** to exit.

6) Adjust the AF point selection as desired, using the ⊟/⊕ AF point selection/Enlarge button and the ⬯ Main Dial.

7) Select **One shot** AF mode and ensure that the lens is set to **AF**.

8) Press **SET** to display the Live View image. The selected AF point will be shown as a small white square (not to be confused with the larger white focusing frame which is also displayed). Aim the camera so that the AF point is over the key part of the subject.

9) Hold down ✱/⬛•⊕ button. The Live View image will be switched off, the mirror will return to its down position, and a beep will confirm that focus has been achieved.

10) When you release the ✱/⬛•⊕ button, the mirror will be raised and the Live View image will be displayed again.

116

11) Depress the shutter release.

12) The recorded image will be played back for review according the settings in ◘ Shooting Menu 1. If you press the ▶ Playback button, you can review images but Live View will switch off. It can be restarted by pressing **SET**.

Live Mode AF: this mode uses the sensor to achieve focus. While AF can be achieved with the Live View image still displayed, focusing may be slower than normal.

1) Press **MENU**. Live View will be switched off. You will hear the mirror return to its normal down position.

2) Select ↑↑⁵ Set-up menu 3, then Custom Functions. Press **SET**.

3) Use ◀ and ▶ to select C.Fn 7 **AF during Live View shooting**.

4) Press **SET** again and select **Live Mode**, then press **SET** again.

5) Press **MENU** twice to exit all menus.

6) Select **One shot** AF mode and ensure that the lens is set to **AF**.

7) Press **SET** to display the Live View image. A superimposed white rectangle (portrait format) is displayed. This serves as both focusing frame and AF point, rather than the two separate frames

used in Quick Mode. The AF point in Live Mode can be moved around the frame using the ☐☐☐☐ buttons, though not right to the edges.

8) Aim the camera and move the AF point so that the AF point is over the key part of the subject.

9) Hold down the ✱/◲• ⊖ button. When focus is achieved, a beep will sound and the AF point will turn green. (If focusing proves difficult, the AF will 'hunt' for focus and the AF point will eventually turn orange.)

10) Depress the shutter release, and release the ✱/◲• ⊖ button.

11) The recorded image will be played back for review according the settings in ◘ Shooting Menu 1. If you press the ▶ Playback button you can review images but Live View will switch off. It can be restarted by pressing **SET**.

> **Note**
> Autofocus in Live View is not compatible with the Remote Switch RS-60E3.

Chapter **3**

In the field

Every photograph is a snapshot in so far as it records a moment in time, usually measured in hundredths, if not thousandths, of a second. But not every photograph is worth a thousand words, as the old adage goes. So what makes the difference?

Leaving technical competence aside for a moment, the four most important factors are, firstly, the intentions of the photographer, and finally, the impact the image has on the viewer. In between those two factors lie the content of the image and its treatment, both of which have to be considered in the light of what doesn't take place within the frame as much as what does.

The simplest approach for the aspiring photographer is to visualize the end result before even picking up the camera. Once the end product is envisaged, the other considerations can fall into place quite quickly when one has a degree of experience. But this is an equally valid approach for the novice: how can you judge your degree of success if you don't know what you were setting out to achieve? Anything else is just a happy accident.

The reference to what doesn't take place is also an aspect of photography that professionals deal with instinctively but beginners rarely consider. It's important to step back from the scene in front of you and look for distracting elements, whether it's a discarded crisp packet in the foreground or someone with a bright red jacket in the background.

BURE VALLEY RAILWAY

Photography can demand a much wider range of skills than just handling a camera. To capture this image and get it published, liaison with the operators of this narrow-gauge line took place months beforehand. On the day, it was necessary to stay in mobile phone contact with the signal box staff; safety issues had to be addressed and appropriate high-visibility clothing worn. All of these factors were as crucial as my photographic experience in making this a successful shot.

Depth of field

No lens has two clearly defined zones – in focus and out of focus. What it does have is a single plane of sharp focus with a gradual transition, both in front of and behind that plane, towards being out of focus. There comes a point in that transition where relative sharpness ceases to be acceptable. This point will occur twice: both in front of and behind the plane of sharp focus – unless the far point is deemed to be so far away that it reaches infinity. The term 'depth of field' is used to identify this zone within the image which is deemed to be in acceptable apparent focus.

Circle of confusion

The term 'acceptable apparent focus' sounds subjective, rather than absolute, and that is indeed true. While a lens on a test bench can have all sorts of tests performed to determine absolute measurements, depth of field is not one of them. Depth of field depends in particular on the intended magnification of the image and on the chosen size of the circle of confusion, the latter being the size of an area of the image at which a point ceases to be a point and becomes a small circle. For 35mm cameras and their digital counterparts, this is generally in the order of 0.001in (0.035mm) and assumes an average magnification of ×5, resulting in a 5 × 7in (13 × 18cm) print. With these factors in mind, lens manufacturers mark their lenses with a depth-of-field scale that indicates this zone of acceptable sharpness.

However, both professional and keen amateur photographers are likely to want enlargements greater than 5 × 7in. Many professionals choose to use an aperture at least one stop smaller than the depth-of-field scale on the lens indicates for the distances required (i.e. the closest and furthest points in focus).

FLOWER ARRANGEMENT
Despite an aperture of f/8, the zone of sharp focus in this image is very shallow. Close examination of the sheet music reveals marked differences in focus, even within a particular scroll.

Many lens manufacturers have reduced the depth-of-field scales (or omitted them entirely) on their lenses until they are so cramped or lacking in aperture markings as to be almost meaningless. The reason for this seems to be the reduced arc through which the lens travels in order to achieve focus, so that autofocus speeds can be faster and faster.

It could be argued that autofocus systems are so sophisticated now, especially with the A-DEP mode, that there isn't the need to be so concerned about depth of field. Serious landscape photographers, however, will always see depth of field as a matter of prime importance and it is they who plead for the retention of decent depth-of-field scales on lenses – mainly as a result of their frequent use of the hyperfocal distance focusing technique.

DEPTH OF FIELD SCALE
The depth of field scale on older lenses like this EF 28mm f/2.8 is much easier to use those featured on more recent designs.

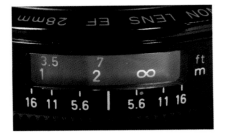

Using hyperfocal distance

The hyperfocal distance at a given aperture is the closest point of focus at which infinity falls within the depth of field. The hyperfocal distance varies according to aperture.

This is the point on which you would focus the lens to ensure that everything from that point to infinity is in focus, along with a significant zone in front of it. You do not even need to look through the viewfinder to do it: simply switch the lens to manual focus and manually turn the focus ring so that the infinity mark is just inside the mark for the selected aperture on the depth-of-field scale. The equivalent mark at the other end of the scale shows the closest point that will be in focus.

Sensor confusion

There is a need to comment here on cameras which use a less than full-frame sensor – like the EOS 1000D/Rebel XS, which has a 1.6× crop factor. What this means in effect is that if you placed a 1000D/Rebel XS side by side with a full-frame camera

and fitted them both with identical lenses, the field of view of the full-frame camera would be 1.6× greater.

The image projected by the lens onto the film or sensor is circular rather than rectangular. In the first illustration below, you can see that a full-frame sensor (left) is large enough to accommodate the maximum amount of the projected image circle. However, the smaller APS-C sensor (centre) covers a smaller proportion of the image circle projected by a lens designed for 35mm or a full-frame sensor. Finally, an EF-S lens, designed solely for use with an APS-C sensor, has a smaller image circle, once again maximizing the sensor area (right).

In the second illustration, the triangles represent a main subject within the image as a whole, assuming an identical camera-to-subject distance and the same focal-length lens. Note that the main subject as projected onto the sensor is identical in terms of absolute size

in both cases, but the smaller sensor has cropped away a lot of the area around the main subject.

There is a great deal of confusion about the implications of this as regards lenses. Some people insist on making comparisons such as saying that a 50mm lens on a camera with the smaller APS-C sensor is equivalent to an 80mm lens (i.e. 50mm × 1.6) with a full-frame sensor. Not true. A 50mm lens behaves like a 50mm lens no matter what camera it is on, and the size of the projected image will always be the same, assuming identical camera-to-subject distance. The only thing that changes is the field of view.

In summary, assuming that the four key factors of focal length, circle of confusion size, aperture, and camera-to-subject distance are identical, there is no difference in depth of field between full-frame and less than full-frame sensor cameras. Any claim to the contrary is not comparing like with like.

Subjects in motion

Capturing movement is one of the more difficult skills to master. It demands quick reflexes, a good grounding in basic photographic techniques, and an ability to predict the best vantage point from which to capture the action.

Freezing the action
In order to capture a pin-sharp image of a fast-moving subject, three things must be considered: a fast shutter speed, a firmly held or supported camera position, and an understanding of the nature of what I call 'apparent speed'.

Ignore the actual speed of travel at this point: what really matters is the speed of movement across the frame. A moving subject that passes at right angles to the camera has the highest apparent speed. A subject that is approaching head-on seems to move much more slowly. Very often the best compromise is a vantage point which has the subject moving towards you at an angle of around 45 degrees. Compared with a subject crossing at right angles, you will probably need less than half the shutter speed and can more easily control just the right amount of blur.

Tips
Avoid shooting subjects that are moving away from you. Subjects photographed from the rear are usually far less interesting.

Camera support is a matter of personal choice, but the single most useful tool for action shots is the monopod, which provides support while allowing mobility.

BATTLE OF BRITAIN MEMORIAL FLIGHT
Freezing the subject isn't always the best approach. A degree of blur in this Lancaster bomber's propellers would have added a greater sense of movement.

Panning

If you stand perfectly still and photograph a fast-moving subject, the likely result is that the subject will be blurred and all the stationary elements of the image will be sharp. Panning the camera (i.e. moving the camera through a single plane, usually horizontal, while keeping the subject in the viewfinder) can produce the opposite result: the moving object is sharp and the stationary elements are blurred.

The result depends largely on the selected shutter speed. An extremely fast shutter speed may even freeze the background if panning slowly. Conversely, a slow shutter speed may create a blurred background and a blurred subject – this can be quite effective if the degree of blur differs between the subject and the background. The use of flash, especially second-curtain flash, in conjunction with the latter technique can be very effective.

Blurring for effect

The most popular subject for this technique is undoubtedly water. As with fast-moving subjects, the scale and speed of travel across the frame are the key issues. It is helpful if the water's direction of travel is across the frame – the opposite of fast-moving subjects. To obtain a slow shutter speed in bright conditions, a slow ISO and small aperture will be required. In very bright conditions a neutral density filter or polarizing filter can also be useful in reducing shutter speed by two stops or more. The precise shutter speeds needed to blur water will vary according to the situation.

WATERFALL
Water is a perenially popular subject for motion-blur photographs. A shutter speed of at least half a second will usually produce the best results.

Composition

Personal preferences and intuition are all-important in relation to composition, but it is always worth learning from other photographers. It is also worthwhile experimenting with different approaches to cropping, using your own work.

Balance

Every photograph includes a number of elements and they all contribute to its overall impact. Balance must be considered in terms of not just shape but colour, density, activity, mood, light and perspective. Once again, this is a matter of personal preference, but it also has a great deal to do with the dimensions of the final photograph as well as the subject matter and its treatment. In order to achieve balance, you must think in terms of the essence of the image. If the shot is highly dynamic, you will want it to have a 'busy' feel, which can be achieved with striking angles, vivid colour, blurred motion and lots of detail. Conversely, if you want an image that is restful to the eye, all of its components should be in harmony: keep it as simple as possible and avoid 'hard' shapes, straight lines and vibrant colours like red and yellow.

Often the photographer has little or no control over the positioning of the subject and its component parts.

WROXHAM, UK
These two images depict one of the most frequently photographed scenes in Norfolk. The shot on the left was taken from Wroxham's famous bridge, the easiest and most obvious viewpoint, but composition is poor. By taking a few minutes to find a better viewpoint off the bridge, the second image is vastly improved.

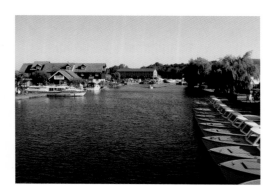
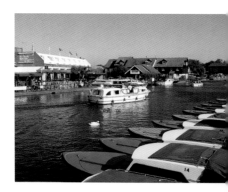

TIGER MOTH
Don't be afraid of flouting convention when composing your images. This can often result in a far more interesting photograph than the more obvious 'bigger picture'.

To circumvent this problem, it is often possible to adjust your own position in relation to the subject, as demonstrated by the pair of images shown opposite.

When it comes down to simple composition, one might say that a symmetrical photo is one which has absolute balance, but symmetry can make a composition seem far too anchored, so use it sparingly. Trust your instincts, don't try to follow set rules and shoot from a variety of viewpoints. The great thing about digital photography is that it will cost you nothing to experiment.

Directing the eye

It is generally accepted that an image will first have an immediate impact as a whole on the viewer.

After that, there are a number of natural processes that can be harnessed to direct the viewer's eye to specific points in the image and also to lead the viewer through the image in the way you would like. For instance, the eye will naturally be drawn towards colours which stand out, especially reds and yellows, and along strong lines.

Of particular importance are converging lines. These tend to create triangles which act as arrows and, as has already been noted, a great deal of dynamism is derived from diagonal lines in a composition. These points of convergence can also act as 'stoppers' that temporarily arrest the viewer's eye movement while they linger on a specific area of the image.

Lighting

Light, or sometimes the absence of it, is crucial to effective photography. Even the word 'photography', derived from Greek, means 'drawing with light'. But light possesses qualities above and beyond its mere presence and it is the manipulation of these qualities that sets a good photograph apart from a mediocre one. True, there are occasions when the subject is powerful enough to stand alone, as with reportage photography, but even then a dramatic picture can be further enhanced by the use of colour, light direction or contrast. These are the attributes of light which most frequently concern photographers.

Light sources

Light always comes from a specific source. Photography commonly makes use of two types of light source: direct and reflected. The most commonly used direct source is the sun. That doesn't mean that it has to be visible: even on a dull winter's day thick with cloud, any available light is still coming from that orb in the sky. The second source commonly used is flash, with artificial light sources such as domestic lighting, street lighting and studio lighting following behind. Each of these has particular qualities that can be harnessed to good effect, notably its inherent colour, which is known as its colour temperature.

Colour

Photography makes use of three types of colour. There is the colour which a subject appears to have in its own right (but which is actually just a function of reflected light). Then there is the colour of the light falling on the subject, and finally the colours used for printing or displaying the image. The last two, in particular, are ones which we can exercise a lot of control over, even removing colour from an image to render it as a set of grey tones. One might argue that there is also a fourth category of colour, taking into account the way that specialist films such as infra-red record colour. The 1000D/Rebel XS has the ability to select white-balance options in order to correct the colour temperature of the light emanating from various sources in different circumstances.

Direction of light

This plays a much more important role than most people realize and it affects far more than just the direction in which the shadows fall. It affects the overall appearance of the subject: frontal lighting produces little shadow

and a more colourful appearance; side lighting can increase shadow, which can mean less colour but more interesting shapes; back-lit subjects may appear as silhouettes or possess an ethereal, translucent quality.

There is always a temptation to shoot with the sun behind us on a sunny day, but it is always worth exploring additional options. Take the time to 'stalk' a subject, exploring it for different possibilities and from different angles. If you have control over the direction of light – when using flash, for example – try out different set-ups with direct, diffused and reflected light. Similarly, if you can't control the light direction but have the option of moving the subject in relation to it, you can position the subject in different situations to achieve varying results.

NOTRE DAME LA GRANDE, POITIERS, FRANCE
Side-lighting is useful for picking out texture or architectural details such as those on this church façade.

CRUISING
Careful metering of a mid-tone and use of Manual (M) exposure mode is often necessary for high-contrast scenes such as this.

Contrast

Contrast is the term given to the difference between light and dark areas in an image. Ideally, we manage to render some detail in both of these, but it is possible to have too much of a good thing and strong lighting is one such example.

Extensive highlight areas require a methodical approach to metering and exposure, combined with a decision-making process regarding which areas of the image are most important in terms of recording detail. In the image above, the trees were of secondary importance and detail was sacrificed in this area to stop the white boat from burning out completely. A meter reading of an average-toned subject near at hand was taken in advance and Manual exposure mode selected.

Dynamic range

This is the full range over which detail can be recorded in an image, from the lightest highlights to the deepest shadows. While digital cameras are able to record a far wider dynamic range than, say, transparency (slide) film, they still fall a little short of the full range that the human eye can distinguish.

Tips

Bracket your exposures in difficult situations as even ½ stop can make a significant difference.

The sensor's dynamic range is greater with a lower ISO rating, so use the lowest possible ISO in high-contrast situations.

CANON EOS 1000D/REBEL XS

TWISTED TREE

This image has been compressed using the Levels tool in Photoshop, creating a near-silhouette while retaining just enough mid-tone to register some colour in the foliage.

> **Tip**
>
> The 1000D/Rebel XS includes two features that can be very useful when low-end clipping is an issue: Long exposure noise reduction and High ISO speed noise reduction. Both can be accessed via the Custom Functions menu.

As a result, in many high-contrast situations the photographer is faced with three options: favouring the highlights and allowing the deepest shadow tones to merge; favouring the shadows and allowing the highlights to burn out; or aiming somewhere between the two and allowing some clipping at both ends of the range (see page 133).

The choice is usually determined by the intended end product. For instance, when producing images for magazine or book use, the quality of the paper to be used by the intended publisher can play a

part, and photos for screen display depend more on screen calibration than dynamic range.

Sometimes it is desirable to compress the tones in an image rather than attempt to extend them as far as possible. Using the Levels tool in Photoshop, one can use the sliders to compress just the darker tones, just the highlights, or to use the middle slider to shift the balance of the whole image.

Another option is to use high dynamic range (HDR) software, which extends the dynamic range by combining bracketed exposures.

Image properties

One aspect of digital photography that perplexes newcomers and recent converts from film is the fact that digital images can suddenly appear to take on a life of their own, displaying some rather strange effects which the photographer definitely hadn't intended.

Flare

This is one aspect with which former film users will be familiar. Flare occurs due to the scattering of light waves within the lens and manifests itself in the form of diffuse rays emanating from a pronounced highlight, with odd coloured shapes along their path. While image-manipulation software can remedy many problems, flare isn't generally one of them, though if it is only minor it may be possible to copy sections of the image and paste them over the offending signs of flare. The best solution is to avoid the flare in the first place by using an appropriate lens hood and not shooting directly into a light source.

Noise

Noise occurs in digital images due to missing information at pixel level. Images are composed of millions of pixels, some of which may function poorly or even fail to function at all, in which case they may appear white or lacking the correct colour. These pixels blend into the image creating undesirable flecks of random colour, especially noticeable in darker areas of smooth colour such as shadows.

The appearance of noise can be exacerbated by a number of factors such as temperature, long exposures and a high ISO setting. When two or more factors are present, noise is more likely. A white speck in a constant position in images may indicate a 'hot' pixel due to failure of one of the pixels on the sensor, in which case the camera will need to be serviced to remedy the problem.

FOREST FLARE
Flare is often used for creative effect but is actually a product of the shortcomings of lens technology. It is hard to remove after shooting but can be avoided by changing the camera position.

IN THE FIELD

Clipping

As we've seen, dynamic range is the spread of tones, from the darkest to the lightest, that can be recorded in an image. If the tones exceed this range, detail will be lost, whether it is in the highlights or in the shadows, or both. This loss of detail is referred to as 'clipping'.

The top of the dynamic range is reached when a pixel records the brightest tone possible without being pure white. At the opposite end of the scale the reverse is true, with a pixel recording detail just short of being black. The extent of this range is determined by the ISO setting, with lower ISO settings providing the greatest range. Lower ISO settings will also give a smoother transition between tones.

Camera manufacturers are rumoured to be working on a way of applying different ISO settings to different parts of a single image, which would help to eliminate clipping entirely.

Aliasing

This term is used to describe the process by which individual pixels are visible in an image at normal levels of magnification. It tends to be more apparent in low-resolution images and those with diagonal or curved lines – telephone lines are a common example. Part of the answer is prevention rather than cure: as often as possible shoot in RAW or large/fine JPEG. It is far easier to create a quality small image from a larger one than the other way round.

A common cause of aliasing is the overzealous use of sharpening, especially in images with smaller file sizes. If you are shooting JPEGs and know that your images are only going to be used as thumbnails or low-resolution images for use on screen, you can use the Picture Style options to reduce the setting for the sharpening parameter. You will only be able to do this if you work in one of the Creative Zone modes. If you use a Basic Zone exposure mode, you lose control over sharpening and other parameters.

Sharpening images

One issue that film users find it hard to get used to is the need to sharpen digital images, not because they are out of focus or blurred, but because digital images are inherently unsharp to a degree. Most casual amateur photographers remain blissfully unaware of this because they shoot in JPEG format, which is sharpened in-camera long before the results are printed or displayed on screen. However, anyone who shoots RAW files quickly realizes that most images need some degree of sharpening, certainly if they are to be enlarged or used commercially.

Generally speaking, sharpening images works fine as long as the image is to be used at its original size or larger. However, sharpening images and then reducing them in size significantly can result in an over-sharpened appearance, which is true relative to the image size. If you want to produce thumbnails or other small images for any reason, it is better to do this before sharpening takes place. Sharpening JPEGs can always be carried out later on the computer. However, once it has been carried out, either in-camera or on the computer, it cannot be undone.

The computer software and precise mechanism used to sharpen your images is a matter of personal choice. However, one choice which has previously eluded photographers has been the ability to sharpen RAW images in-camera – an option which is now extended to 1000D/Rebel XS users for both RAW and JPEG files using the Picture Style parameters.

With RAW files, the original image data is always retained. If you make changes to the originals in post-processing, those changes can be undone. If you make changes and then convert the RAW file to a different file format, you will not be able to undo those changes in the new file format. But you can go back to the original RAW file, undo the changes or make corrections, and convert the file again.

Any sharpening which has been programmed in-camera using the Picture Style parameters

134

when shooting RAW files can also be undone later using Digital Photo Professional. However, it is important to remember that the scales used in-camera and by the Digital Photo Professional software are not the same. The in-camera sharpening parameter uses a scale of 0–7, while the scale used in Digital Photo Professional runs from 0–10.

While this seems strange, it does offer an advantage. If the Picture Style sharpening parameter is set in-camera to its maximum setting of 7, when you open the captured image in Digital Photo Professional the sharpness will still indicate a setting of 7. This means that not only can you undo or reduce the sharpening in post-processing, you can also increase it beyond the maximum level that was possible at the time of shooting.

GLASGOW GLASS
Images like this must be pin-sharp to be effective, but you should consider the intended print size when sharpening in order to avoid giving the straight lines a jagged appearance when the image is reduced in size.

135

Using exposure compensation

All light meters, no matter how sophisticated and regardless of their angle of view, work the same way: they average what they see and give a reading based on the assumption that you are looking at an 18% grey card.

Scenes such as this will fool a meter into giving a reading that won't actually give you the best result. The combined expanse of pale tones and glass suggested a reading half a stop lower, on a dull day. Had the sun been shining, the difference between the meter reading and the settings required would have been even greater.

Exactly how much exposure compensation is needed is a matter of experience, trial and error, educated guesswork, or bracketing. Using either ½- or ⅓-stop increments, three exposures can be taken with or without additional exposure compensation. The large monitor of the 1000D/Rebel XS is ideal for reviewing the results.

Settings
Aperture priority (Av) mode
ISO 100
f/5.6 at 1/160 sec
Exposure compensation +½
Evaluative metering
White balance: 5200°K
Manual focus

BOLD DESIGN
This rather gaudy building in central Glasgow is nevertheless an eye-catching sight and an ideal subject for a book I was shooting on the city.

A sense of depth

A popular technique in landscape photography is to use a river, road, or other strong line to lead the eye into the picture. Such lines may also be used to direct the eye from left to right, the usual way in which we assimilate visual information in the western world. Features such as gates and arches also offer an 'invitation' to the viewer to proceed further into the image.

Another, more subtle, technique is to make use of foreground and middle-distance features which are on different planes, often running parallel across the image. These methods all help to create a feeling of depth in the image.

LIMESTONE SCENERY
This simple landscape image makes use of all the techniques described opposite. The track leads the viewer from left to right and further into the image. In addition, there are four identifiable planes: the track in the bottom left corner, the sheep and lambs, the dry stone wall, and finally the limestone crags in the distance. The gate is perhaps too far to the right to be particularly inviting but the sheep refused to move into the ideal position.

Settings
Aperture Priority (Av) mode
ISO 200
f/8 at 1/640 sec
Evaluative metering
Picture Style: Landscape
White balance: 5200°K
One Shot AF mode

IN THE FIELD

Photo essays

The great thing about digital photography is that you can fire off as many shots as you like at no extra cost. This makes it ideal for what I refer to as 'stalking the subject' when I am compiling a group of images on a single theme. When a number of images are used together, whether framed as a group on a wall in your home or published in a magazine, they are described as a photo essay.

When I come across a good photographic situation I always want to make the most of it and produce a variety of usable images. But I also find that stalking the subject gradually hones my ideas and the shots obtained usually get better as I go along. However, it is usually still necessary to obtain a straightforward 'establishing shot'

CROPPING
The landscape-format image (top) captures the details of the team dealing with a rescue victim, but it all looks too relaxed. I achieved a greater sense of urgency by careful cropping into portrait format – note how each rescuer's line of sight of focuses on the victim's face, increasing the intensity. The vital oxygen bottle also achieves more prominence in the frame.

MOUNTAIN RESCUE TEAM
The establishing shot encompasses the whole subject and places it in context.

PORTRAIT FORMAT

I often shoot as many portrait-format frames (vertical orientation) as I do landscape-format, especially for magazine use. By encouraging the dog handler to allow her search-and-rescue dog to climb onto her knee, both achieve equal prominence and look like a team. It is also a pose that suits the vertical format perfectly.

...which acts as an introduction – a bit like the first paragraph in an essay. This image may be no more than a technically competent record of the subject or it may involve 'setting up' a photo such as the group shot shown opposite.

These pictures were to be used to illustrate a magazine feature on my local mountain rescue team and the image of the group had to be captured early in the day before everyone dispersed into the hills to carry out their various duties.

With this frame in the bag early on, I could concentrate on the individuals and their particular responsibilities, and any drama which the day might bring forth.

General settings
Manual (M) mode
ISO 400
f/8 at 1/800 sec
Evaluative metering
White balance: 5200°K
Focus mode: One Shot AF

CONTEXT
Radio communication was all-important in this context. The question was how to dramatize it? I opted for a lower viewpoint to add subtle prominence to the subject and positioned him tight up against the fingerpost. This directs the reader's eye into the image in quite dramatic fashion.

Creating a silhouette

In one sense, capturing a silhouette is simple because it only has two elements: the silhouette itself and the background. The first has line and shape, but no tonal detail, and the latter is simply a matter of colour. So why do so many holiday snaps of sunsets not work?

I would suggest three reasons: people tend to get tunnel vision when viewing sunsets and don't consider the full image area; they put too much emphasis on the sky and not enough on the silhouette; and finally they settle for one or two shots instead of paying attention to all the subtle changes that the scene goes through. In short, they get carried away.

Before I visit a location, I always print off compass directions and sunrise and sunset times. If a good sunset looks likely, I set out early to locate a scene which will give me a strong silhouette. Meter readings should be taken constantly from the sky area because they change so fast, but sometimes, as in the image below, evaluative metering is perfectly adequate.

Settings
Canon EF 85mm f/1.8
Aperture priority (Av) mode
ISO 200
f/5.6 at 0.4 sec
Evaluative metering
White balance: Auto
Manual focus

ROCCO TOWER AT DUSK
When the sun sets, lighting and colour change very quickly. Five minutes after this shot was taken, the sea had lost its colour, the small breakers weren't discernible, and the tower merged into the clouds on the horizon.

Colour, shape and line

Images which rely on colour rarely do so in isolation. Shape and line usually play a part too, as in the photograph below. In this instance, there are two distinct elements: the flowers and the instrument. Both blend well together in terms of colour without the exact shade of the wood being replicated directly by any of the blooms. The instrument's harder lines are softened by its elegant shape.

Settings
Aperture priority (Av) mode
ISO 100
f/8 at 1/250 sec
Evaluative metering
White balance: Auto
Focus mode: One Shot AF

STILL LIFE
The creator of this still life at a flower show has used complementary colours to surround the instrument, the elegant lines of which blend in well.

Street photography

EXPRESSIONS
Like many candid opportunities, this scene was encountered quite by chance. The camera was in standby mode, already set up for the unexpected, and only needed partial pressure on the shutter release to activate it.

This style of photography requires considerable care with regard to people's privacy but can be both exhilarating and rewarding. The laws governing privacy vary from country to country and you should make yourself aware of them before starting out.

In the UK, for example, it is permissible to photograph people in a public place provided it is not a situation in which the subject has a reasonable expectation of privacy, the photograph or its treatment is not defamatory, and the image is not used

Settings
A-DEP mode
ISO 100
f/4 at 1/000 sec
Evaluative metering
White balance: 5200°K
Focus mode: One Shot AF

to advertise or market a specific product or service. On the other hand, civil law in France states that every individual owns the rights to his or her own image – a photographer can be sued if permission has not been obtained, even when the subject has been photographed in a public place.

Reflections

Many kinds of reflective surfaces surround us in our everyday lives and they can provide excellent opportunities for interesting images, even when other factors, like the weather, seem to be working against us. Curved reflective surfaces can give a 'fish-eye' effect but demand good control of depth of field when working at close distances.

RIPPLES
This image has been inverted so that the subject appears the right way up. In this instance the strong colours and blue sky are essential components, in conjunction with the reflection.

Settings
Manual (M) mode
ISO 100
f/5.6 at 1/400 sec
Evaluative metering
White balance: 5200°K
Focus mode: One Shot AF

IN THE FIELD

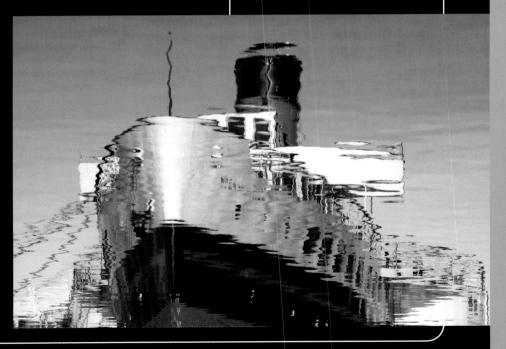

Architecture

The single biggest problem you will face with architectural shots is that of converging vertical lines, especially near the edges of the frame. There is a simple way to resolve this issue: buy one of Canon's three perspective-control lenses (see page 185). However, if your funds won't run to one of these, there are other ways to address the problem, as shown in the images below.

Settings
EF 24–105mm at 35mm
Aperture priority (Av) mode
ISO 100
f/5.6 at 1/160 sec
Evaluative metering
White balance: 5200°K
Focus mode: One Shot AF

GOZO, MALTA
A higher and more distant viewpoint was selected to avoid converging verticals. Increasing the camera-to-subject distance makes this approach easier to apply.

PARALLEL LINES

Be selective about your subject matter and try to shoot subjects that won't be affected by converging verticals. Alternatively, instead of capturing the whole building or group of buildings, select just a portion of the subject.

STRIKING COMPOSITION

Another approach is to incorporate the tendency towards converging verticals into your shot, making it an integral part of the image. This will involve an open mind with regard to composition but can also produce some interesting images.

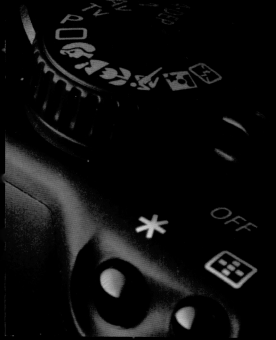

Chapter **4**

Flash

Flash photography has developed to such an extent that it is often imbued with almost magical properties. Magic, say some, is simply the science that other people know but we don't: the following pages should help to dispel some of the mystery.

There are a great many camera users who have little or no idea of the principles of flash photography. They can be seen on aircraft flying over the Alps as they use flash to photograph the dramatic scenery below. You don't need a scientific explanation of Guide Numbers to realise that these people are being a trifle optimistic.

The EOS 1000D/Rebel XS comes equipped with a built-in flash that provides a wide enough beam to be used with a 17mm (full-frame) lens and sufficient power to provide adequate lighting of a subject 10ft

TREE DETAILS
It is surprising how few people think of using flash outdoors when the camera has been put on a tripod. This study of a tree (right) was initially photographed using a tripod in poor ambient light, then shot again with ambient light balanced with E-TTL II flash. In the second shot (above) the colours are richer, the shadow areas more interesting, and the bark detail more apparent.

(3m) away, assuming ISO 100 at f/4. In other words, it is a very useful tool in compact situations. The coverage is very even, not as harsh as earlier models such as the EOS 10D, and blends well with ambient light. It can be used as the main source of lighting or simply as fill-in to relieve some of the dark shadows on a sunny day. In Basic Zone modes built-in flash is automatic.

The advantages of the built-in flash compared with using an EX Speedlite come down to weight and convenience. None of the Speedlites is exceptionally heavy, but it still means extra weight plus an extra set of batteries or a power pack, and possibly extra recharging at the end of the day. Both make use of E-TTL II metering, AF-assist beam, red-eye reduction, flash exposure bracketing, flash exposure lock and first- or second-curtain synchronization. The advantages of using a Speedlite are its added power, high-speed synchronization, adjustable power output, off-camera capability and variable output.

E-TTL II flash exposure system

The third generation of Canon's auto flash exposure system provides almost seamless integration of flash and camera in most situations. The E-TTL designation stands for 'evaluative through-the-lens'

metering, as opposed to measuring the flash exposure from a sensor within the flash gun. The fact that the exposure is based on what is seen through the lens means that you can position the flash off-camera, at a different angle to the subject to that of the camera, and still achieve accurate exposure.

When the shutter-release button is fully depressed, the E-TTL II flash fires a pre-exposure metering burst. The data gathered on the brightness levels of the subject during this initial burst of flash is compared with the data for the same areas under ambient light and the correct flash output and exposure are calculated automatically. With many EF lenses this burst will also assess the distance to the subject. The shutter activation and the main flash burst (assuming first-curtain sync is set) will follow so quickly on the back of the metering burst that the two will be inseparable to the naked eye.

Note
While all current EF and EF-S lenses are E-TTL II compatible, not all are capable of delivering distance information to help calculate flash exposure more accurately. See page 150 for a list of these lenses.

The following lenses provide the distance information that is necessary for full compatibility with E-TTL II metering:

EF 14mm f/2.8L II USM	EF 17–40mm f/4L USM
EF 20mm f/2.8 USM	EF-S 17–55mm f/2.8 IS USM
EF 24mm f/1.4L II USM	EF-S 17–85mm f/4-5.6 IS USM
EF 28mm f/1.8 USM	EF-S 18–55mm f/3.5-5.6
EF 35mm f/1.4L USM	EF 20–35mm f/3.5-4.5 USM
EF 50mm f/1.2L USM	EF 24–70mm f/2.8L USM
EF-S 60mm f/3.5 USM Macroa	EF 24–85mm f/3.5-4.5 USM
MP-E 65mm f/2.8 1–5x Macro Photo	EF 24–105mm f/4 IS USM
EF 85mm f/1.2L II USM	EF 28–90mm f/4-5.6 III
EF 85mm f/1.8 USM	EF 28–105mm f/4-5.6
EF 100mm f/2 USM	EF 28–105mm f/3.5-5.6 II USM
EF 100mm f/2.8 Macro USM	EF 28–105mm f/4-5.6 USM
EF 135mm f/2L USM	EF 28–135mm f/3.5-5.6 IS USM
EF 180mm f/3.5L Macro USM	EF 28–200mm f/3.5-4.5 II USM
EF 200mm f/2L IS USM	EF 28–300mm f/3.5-5.6L IS USM
EF 200mm f/2.8L II USM	EF 55–200mm f/4.5-5.6 II USM
EF 300mm f/2.8L IS USM	EF-S 55–250mm f/4-5.6 IS
EF 300mm f/4L IS USM	EF 70–200mm f/2.8L IS USM
EF 400mm f/2.8L IS USM	EF 70–200mm f/2.8L USM
EF 400mm f/4L DO IS USM	EF 70–200mm f/4L IS USM
EF 400mm f/5.6L USM	EF 70–200mm f/4L USM
EF 500mm f/4L IS USM	EF 70–300mm f/4.5-5.6 DO IS USM
EF 600mm f/4L IS USM	EF 100–300mm f/4.5-5.6 IS USM
EF 800mm f/5.6L IS USM	EF 100–300mm f/4.5-5.6 USM
EF-S 10–22mm f/3.5-4.5 USM	EF 100–400mm f/4.5-5.6L IS USM
EF 16–35mm f/2.8L II USM	

Guide Numbers

There is an easy way to compare the performance of different models of flashgun and that is to look at their Guide Numbers. This is a measurement of power that can be applied equally to any flash unit, and measures the maximum distance over which the flash will provide effective coverage. As this distance is dependent upon the sensitivity of the film or sensor, the measurement is qualified by the addition of an ISO setting. The Guide Number for Canon's 580EX II Speedlite is 190/58 (ft/m) at ISO 100.

Calculating flash exposure

Aperture also affects flash coverage, but the equations involved in calculating flash exposure are simple enough for us to calculate the third factor involved as long as we have the other two. (In the following examples, the term 'flash-to-subject distance' is used because the flash could be used off-camera.)

The basic equation is as follows: *Guide Number / Flash-to-subject distance = Aperture.* This could also be written as *Guide Number / Aperture = Flash-to-subject distance* or *Flash-to-subject distance × Aperture = Guide Number.*

Take the 580EX II as an example using the maximum flash-to-subject distance: *190 (GN) / 190 ft = Aperture.* We would therefore need an aperture of f/1 to achieve flash coverage. As this is unrealistic, let's take another example using a flash-to-subject distance of 50ft: *190 (GN) / 50ft = f/3.8* (f/4 for practical purposes).

If we know the Guide Number and we know the aperture we want to use, f/16 for example, but aren't sure of the Flash to subject distance limitations we can still calculate this easily: *190 (GN) / f/16 = Flash to subject distance.* This would give us an answer of 12.4ft (3.7m) as the maximum distance over which the flash would perform adequately with f/16 as our working aperture.

To make life easier, Canon provide zoom heads on some flashguns. These sense the focal length in use and harness the power of the flash more effectively by narrowing (or widening) the flash beam to suit the lens. For this reason the full Guide Number also refers to the maximum focal length that the zoom head will accommodate automatically. Consequently, the full Guide Number for our example of the 580EX II Speedlite is 190/58 (ft/m) ISO 100 at 105mm. EX Speedlites also display a useful graphic indicating the distance over which flash can be used at current settings.

FLASH

Flash exposure lock

When part of the subject is critical in terms of exposure, you can take a flash exposure reading of that area of the image using the same metering circle as the Partial metering mode, and lock it into the camera/flash combination.

1) Having adjusted all appropriate settings and switched on the external flash or raised the built-in flash, aim the camera at the critical part of the subject.

2) Focus with the centre of the viewfinder over the important part of the subject and press the ✱/◨• ⚲ FE lock button.

3) The flash head will emit a metering pre-flash and the camera will calculate the correct exposure.

4) In the viewfinder, **FEL** Flash Exposure Lock is displayed momentarily, then replaced with the ⚡ * symbol.

5) Recompose the shot and press the shutter-release button.

6) The flash will fire, the picture will be taken, and the ⚡ * symbol will be replaced by the ⚡ Flash Ready symbol, indicating that no exposure settings have been retained.

Flash exposure bracketing

This function is not built into the EOS 1000D/Rebel XS but can be found on EX Speedlites from the 550EX upwards. It will enable three exposures to be made, just as with the normal exposure-bracketing procedure. A slightly less convenient but equally effective alternative is available via the camera's functions in that you can adjust the flash exposure compensation settings for each of three shots, thereby matching the bracketing process.

Tips
Flash exposure compensation can be set at any time. The built-in flash does not need to be in its active position, nor does an external flash need to be switched on.

When the flash-to-subject distance is too great and correct exposure cannot be achieved, the ⚡ Flash ready symbol blinks in the viewfinder.

As you double the flash-to-subject distance, 4x illumination is required. This is known as the Inverse Square Law.

Flash exposure compensation

It is possible to select Flash exposure compensation when using either the built-in flash or a compatible external flash, providing you are using one of the Creative Zone modes. This works in exactly the same way as normal exposure compensation, taking three different pictures up to +/-2 stops, and permits you to control the end result so that the subject has a more natural appearance.

1) Press the **MENU** button.

2) Select ﬃ' Set-up menu 2, then Flash exposure compensation. The increment can be set to either ½- or ⅓- stop in Custom Function I).

3) Press **SET**. The �² Flash exposure compensation symbol appears in the viewfinder at bottom left.

4) Take the picture and review the result, adjusting compensation and repeating the shot if necessary,

Common errors
Flash exposure compensation settings will be retained after the camera is switched off. Pay attention to the viewfinder symbol as a reminder that an adjustment has been made before entering a different shooting situation.

Bounce and direct flash

The two most popular techniques for reducing the impact of direct flash are the use of a diffuser and bouncing the flash off a suitable reflective surface. While there is a small diffuser on the market that will fit the built-in flash, bounce flash remains the sole preserve of those using EX Speedlites and other compatible flashguns mounted on the hotshoe or used off-camera with the Off-camera shoe cord.

Depending on the model, if the flashgun is mounted on the camera's hotshoe, bounce flash can be achieved by rotating and tilting the flash head to point at the reflecting surface – which, ideally, should normally be a little above and to one side of the subject. Bounce flash, especially when used with the flash gun off-camera, is a good way of both softening shadows and controlling where they fall.

Bounce flash

The concept of bounce flash is that the surface(s) being used to reflect the flash will provide, in effect, a larger and therefore more diffuse light source. This also assumes that it is light enough in tone to perform this purpose and that it won't imbue the subject with a colour cast. If the reflecting surface has a matt finish or is darker in tone, it will be less effective because it will absorb some of the light and will require a much wider aperture or shorter flash-to-subject distance to work.

With the bounce flash technique, the flash-to-subject distance includes the distance to the reflecting surface and from that surface to the subject. In addition, about two stops of light are likely to be lost when using this technique, so the flash-to-subject distance will be considerably shorter than would normally be the case for any given aperture.

Tip
When the flash is at the same height as the subject, an otherwise pleasing shot can be ruined by hard shadows against the background. To avoid this, try to put some distance between the subject and background. With a wide aperture the background will also be more out of focus and less distracting.

HARVEST
Direct flash would be too harsh at such a close distance so the light from a 550EX Speedlite, mounted on the camera, was bounced off the white ceiling.

Direct flash

One of the common problems with direct flash (i.e. not diffused or bounced) is red-eye, when light from the flash is picked up by the blood vessels at the back of the eye. It is particularly noticeable when the flash gun is mounted on top of the camera. At one time, the only technique for dealing with this was to use diffused lighting or to move the flash gun away from the lens axis, or both.

The red-eye reduction function on the 1000D/Rebel XS, enabled in 📷˙ Shooting Menu 1, uses the flash to direct a beam of light at the subject prior to the actual exposure and before the flash fires in the normal way. This beam causes the pupils to narrow so that red-eye is reduced. When red-eye reduction is enabled and either the built-in or external flash is switched on, the exposure compensation scale ▬▬▬ at the bottom of the viewfinder is replaced by ‖‖‖‖‖ when focus is confirmed. This shows in all modes except Landscape, Sports and Flash Off.

The use of direct flash should always be considered carefully, particularly its harshness when used on close or highly reflective subjects. It is worth noting that many press photographers keep a Sto-fen Omnibounce diffuser on their camera-mounted flashguns at all times to soften the appearance of direct flash.

LOCOMOTIVE WHEEL
Controlling the glare from direct flash when it is used with reflective surfaces can be a problem. In this image, the brushed finish of the metals helped to reduce the glare.

Attaching an EX Speedlite

1) With both camera and Speedlite switched off, mount the Speedlite on the camera's hotshoe and tighten the locking ring.

2) Turn the camera's power switch to **ON** and turn on the Speedlite.

3) On the camera, adjust the White balance setting to ↯ Flash if using a Creative Zone mode. (Auto white balance will be selected automatically in Basic Zone modes and cannot be changed.)

First- and second-curtain flash explained

A focal-plane shutter works by two shutter curtains moving across the frame. Both move across the focal plane at the same speed, but there is a small gap between them which is how the sensor is exposed to the image projected by the lens. With a higher shutter speed, the curtains don't move any faster but the gap between them gets narrower. With an extremely slow shutter speed, the entire frame may be exposed before the second curtain begins to follow the first. This makes it possible to control shutter speeds precisely and reach speeds of up to 1/4000 second.

With the E-TTL flash system the flash actually fires twice. The first burst is a pre-flash in the sense that it fires just before the shutter opens in order to determine exposure. The second burst is the one which illuminates the subject.

When first-curtain synchronization is selected, the illuminating burst occurs as soon as the travel of the first curtain opens the gap between it and the second curtain. This second burst is normally so soon after the metering burst that, to the naked eye, the two are indistinguishable.

When second-curtain synchronization is selected, the illuminating burst is fired at the end of the exposure, just before the second curtain catches up with the first. Because there is a longer time lag between metering and illumination, it may be more obvious that the flash has fired twice.

The duration of the flash is extremely short and, like using a fast shutter speed, it has the effect of freezing movement. However, the exposed image is subject to two light sources: the flash and the ambient light. If the exposure is long enough for the ambient light levels to record subject detail, then the final image will be illuminated by of a mixture of flash and ambient light. The subject will be seen as being frozen and sharp but there will also be a ghost image which

156

is not, and there may also be light trails from moving highlights. It is these light trails that are affected most significantly by switching from first- to second-curtain flash synchronization.

Imagine a subject moving across the frame from left to right. With first-curtain sync, the flash will fire immediately the shutter opens and freeze the image towards the left of the frame. Any ambient light will continue to expose the subject as it moves across the frame. The end result is a sharp subject with light trails extending into the area into which it is moving, making it appear as if it is moving backwards.

With second-curtain sync in the same situation, the subject would be lit by the ambient light first and then frozen by the flash at the end of the exposure. This adds to the impression of forward movement and looks much more natural.

FIRST- AND SECOND-CURTAIN FLASH
The effects of first-curtain (top) and second-curtain flash (below). In both images the subject is moving from left to right across the frame, but the results are very different.

Wireless and multiple flash

When a single flash head is no longer sufficient, either in terms of power or to control highlights and shadows, Canon make it easy to use multiple flash units with either wired or wireless connectivity. Wired connection can be achieved using the accessories listed at the end of this chapter, but it is important to note that, with the exception of the off-camera shoe cord, the benefits of E-TTL II metering will be lost. A wireless system, however, will retain full E-TTL II compatibility and can be established using either the Wireless Transmitter ST-E2 as the camera-mounted control unit or an EX Speedlite (550EX upwards) as the master unit. All other flash units will be deemed 'slave' units. The ST-E2 is purely a control unit and transmitter and does not incorporate a flash head.

EX Speedlites

Canon's EX range of Speedlites is fully compatible with E-TTL II metering. The range runs from the inexpensive 220EX to the high-powered 580EX II, and barely used discontinued models can readily be found on eBay. The model number is a quick indication of the power of each unit, with the 580EX having a Guide Number of 58 (metres at ISO 100) and the 430EX having a Guide Number of 43 (metres at ISO 100), for example. If you are interested in wireless flash, check whether any particular model is capable of acting as a master unit or only as a slave.

220EX Speedlite

The 220EX Speedlite is the smallest and least expensive of Canon's range. It includes flash exposure lock compatibility and high-speed (FP) synchronization. However, this model is not compatible with use as a wireless slave unit, and it can't take Canon's external power pack.

Max. guide number 72/22
(ISO 100 ft/m)
Zoom range 28mm fixed
Tilt/swivel No
Recycling time 0.1–4.5 seconds
AF-assist beam Yes
Weight (w/o batteries) 160g

430EX II Speedlite

The 430EX II Speedlite includes flash exposure lock compatibility, high-speed (FP) synchronization and can be used as a wireless slave unit with the 550EX, 580EX, 580EX II, Speedlite Transmitter ST-E2, Macro Twin Lite MT-24EX and Macro Ring Lite MR-14EX. Its zoom range has been extended from 24mm on the 420EX down to a very useful 14mm.

Max. guide number 141/43 (ISO 100 ft/m) at 105mm
Zoom range 24–105mm (14mm with wide panel)
Tilt/swivel Yes
Recycling time 0.1–3.7 seconds
AF-assist beam Yes
Wireless channels 4
Weight (w/o batteries) 320g

FLASH

580EX II Speedlite

The 580EX II provides flash exposure lock, high-speed (FP) synchronization, flash exposure bracketing, automatic or manual zoom head and strobe facility. It can be used as either a master or slave unit for wireless flash photography. It provides colour temperature control and manual settings down to 1/128 power in ⅓-stop increments. It also has weather sealing, 20% faster recycling, a PC socket and external metering sensor for non-TTL flash.

Max. guide number 190/58 (ISO 100 ft/m) at 105mm
Zoom range 24–105mm (14mm with wide panel)
Tilt/swivel Yes
Recycling time 0.1–6 seconds
AF-assist beam Yes
Custom functions/settings 14/32
Wireless channels 4
Catchlight reflector panel
Weight (w/o batteries) 375g

MR-14EX Macro Ring Lite

This unit consists of a control unit which is mounted on the hotshoe and a ring-flash unit which is mounted on the lens. The ring-flash unit has two flash tubes on opposite sides of the lens and the lighting ratio between these can be adjusted to provide better shadow control. It also has built-in focusing lamps and modelling flash and is capable of acting as master unit for wireless flash photography. The Ring Lite is designed for close-up photography where a hotshoe-mounted flash would be ineffective due to the short camera-to-subject distance.

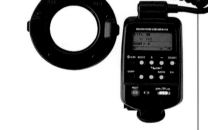

Max. guide number 46/14 (ISO 100 ft/m)
Designed for use with EF macro lenses
Tilt/swivel No
Modelling flash Yes
Recycling time 0.1–7 seconds
Weight (w/o batteries) 404g

MT-24EX Macro Twin Lite

The Twin Lite consists of a control unit which is mounted on the camera's hotshoe plus two small flash heads which are mounted on either side of the lens and which can be adjusted independently. This model offers far more flexibility than the Ring Flash. It has the same wireless capabilities as the Ring Flash and is designed for use with the same EF Macro lenses.

Max. guide number 79/24 (ISO 100 ft/m)
(with both heads firing)
Zoom range N/A
Tilt/swivel Yes
Recycling time 4–7 seconds
Weight (w/o batteries) 404g

160

Tip

Expo Imaging have recently released a ring flash accessory with adaptors to fit the 580EX II and the original 580EX. It fits directly onto the flash head and, because of the flash unit's much higher guide number compared with dedicated ring flash units, it provides a much greater flash-to-subject distance. This means it can be used for portraits and other subjects as well as close-up work. Called the Ray Flash Adaptor, it is considerably less expensive than either the Canon or Sigma ring flash units.

Flash accessories

One of the great advantages of using a system camera is the range of accessories available, and Canon produce a wide range of useful additions for its flash units. These will increase the range of situations in which you can work and give you maximum control of the end result. In particular, they will help you to use the flash off-camera to reduce red-eye when shooting people and animals and for improved shadow placement, giving a more natural appearance to your photographs.

Speedlite Transmitter ST-E2

This unit acts as an on-camera wireless transmitter for all current EX Speedlites except the 220EX. It can control two groups of slave flash heads with flash ratio variable between the two groups.

The ST-E2 is not entirely necessary for wireless flash as some EX models can also act as master units, with or without the master unit firing.

Off-camera Shoe Adaptor OA-2

This is a simple hotshoe socket for a Speedlite and incorporates a ¼in tripod socket, to be used with either of the connecting cords (see page 162).

TTL Hotshoe Adaptor 3

This can be used with either the connecting cords and the TTL distributor, or the off-camera shoe cord to connect up to four separate Speedlites.

FLASH

TTL distributor

This accessory provides four connection sockets: one to connect to the TTL Hotshoe Adaptor 3 and three for connecting to off-camera shoe adaptors via Connecting Cords 60 and 300.

Off-camera shoe cord OC-E3

This is one of the first accessories many people buy, enabling an EX Speedlite to be used up to 2ft (0.6m) away from the camera while retaining all normal functions. It is ideal for close-ups with a small light cube or similar variation such as the Lastolite ePhotomaker, as well as improving bounce flash capability and helping to avoid red-eye.

Connecting Cords 60 and 300

These cords consist of either a 2ft (0.6m) coiled lead or a 10ft (3m) straight lead to connect the TTL Distributor and TTL Hotshoe Adaptor 3.

Speedlite L bracket SB-E2

This allows a Speedlite to be positioned to the side of the camera rather than on the hotshoe, helping to reduce red-eye by taking the flash head off the camera-lens axis. It requires an off-camera shoe cord.

Tips

Wired flash accessories are not compatible with E-TTL II metering, irrespective of the capabilities of the flash unit you are connecting. For full E-TTL II compatibility, use a wireless system with the 580EX or 580EX II, or an ST-E2 transmitter as the master unit.

In order to ensure maximum compatibility, new accessories are often released at the same time as new Speedlites. Sometimes, but not always, these will also be compatible with discontinued flash units. To check compatibility, consult the Canon website or, even better, obtain a copy of EOS Magazine's annual products supplement, which lists all current and discontinued Canon products, in some cases as far back as the late 1980s.

Compact battery pack CD-E4

The CD-E4 improves recycling times and the number of flashes available. It also permits the fast changeover of CPM-E4 battery magazines.

162

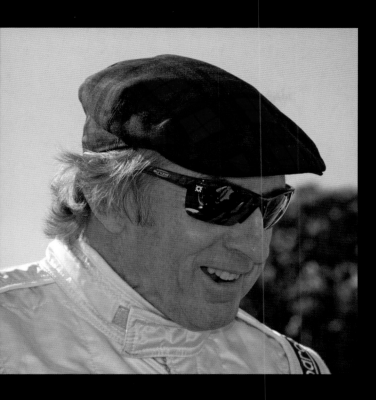

SIR JACKIE STEWART
This image of the world-famous
racing driver sharing a humorous
moment in the Paddock at
Goodwood was captured using
the camera's built-in flash to
eliminate shadows in the high-
contrast lighting conditions
created by strong sunshine.

Settings
ISO 100
f/8 at 1/250 sec
Evaluative metering
White balance: 5200°K
Focus mode: One Shot AF
Built-in flash

Chapter **5**

Close-up

The revealing world of close-up photography is both fascinating and rewarding, and is available to all photographers with the minimum of additional equipment. What it does require, however, is great attention to technique and rock-solid camera support. The high magnifications involved mean that a slight error in focusing or the smallest camera movement will be immediately noticeable.

The other factors of great importance in close-up photography are lighting and depth of field. The latter is easily dealt with by choosing a very narrow aperture, though newcomers to close-up photography will still be surprised by how little depth of field is available – often no more than a few millimetres, even at the narrowest aperture. For this reason, purpose-built macro lenses often have a narrower aperture than usual, perhaps f/32 rather than f/16 or f/22. Apertures like these make the use of depth-of-field preview more difficult and require even slower shutter speeds, making lack of camera movement crucial, and this is one reason why much extreme close-up photography requires flash.

VALLETTA, MALTA
Opportunities for close-ups present themselves all the time. It is just a matter of learning to be observant. We are often distracted by the bigger picture.

Lighting for close-ups

Lighting is one of the most difficult aspects of extreme close-up work. The very narrow apertures and slow shutter speeds necessary cannot be overcome by using a high ISO speed unless quality is to be sacrificed, so diffuse ambient lighting is often not sufficient unless working outdoors, when the additional problem of wind has to be borne in mind.

Flash might seem the obvious solution, but it has its own problems. To start with, a flashgun mounted on the camera's hotshoe cannot be tilted down sufficiently to illuminate the subject at close proximity.

The starting point, then, for lighting close-ups is off-camera flash. This requires the Canon Off-camera shoe cord OC-E3 that will retain all E-TTL II features. However, direct flash will produce a rather harsh light at such short distances so it is best to diffuse it. The two simplest ways of doing this are to either bounce the light off a white or near-white surface such as a sheet of white card or a Lastolite reflector, or to put translucent material between the flash and the subject. The oldest trick in the book is to drape a white handkerchief over the flash head.

One reason why bounce flash works so well is that the effective size of the light source has been increased. If you bounce the light off a standard Lastolite reflector, you have a much larger light source of approximately 3ft (0.9m) in diameter.

The best inexpensive solution for photographing small objects with just one off-camera flash is some form of light tent. Lastolite's ePhotomaker, originally designed to help people photograph items for sale on eBay, is a small light tent with one internal side consisting of reflective material, the rest being translucent fabric that acts as both diffuser and reflector. By mounting the off-camera flash outside the

CLOSE-UP WITH LIVE VIEW
In Live View mode, the image on the LCD monitor can be magnified to check focus and depth of field. The optional grid lines are an aid to composition.

ePhotomaker on the opposite side to the reflective material, a good balance of light and shadow can be achieved quickly and easily.

For maximum control of shadows, two or more flash heads are even better. One solution is to use a ring-flash unit. This has two small flash heads within a circular reflector that fits on the front of the lens with the flash heads on opposite sides of the lens. However, this brings us back to

the harsher effects of direct flash and can also produce small doughnut-shaped reflections in shiny surfaces. Ring flash is best reserved for matt subjects and for shooting flowers and similar subjects outdoors.

Canon also manufacture a very expensive lens-mounted two-head unit. This consists of a control unit that mounts on the hotshoe and has two independently adjustable heads. A similar but less expensive model is produced by Sigma. The ratio of one flash to the other can be adjusted for better three-dimensional modelling.

There are also many proprietary products that enable you to use two separate flash heads in a similar

PEPPERS
Two simple close-ups using off-camera flash in Live View mode. Also used were Lastolite's standard white ePhotoMaker (below) and a black version (opposite), which was being tested.

configuration using either wired or wireless flash. A wireless set-up is the most flexible choice when working in controlled conditions indoors. With a Canon 430EX, 550EX or 580EX Speedlite acting as a master, other flashguns (580EX, 550EX, 430EX, 420EX) can be used as wireless slave units to control highlights and shadows, retaining full E-TTL II exposure control.

Because depth of field is so limited in close-up photography, it is often impossible to get the whole of the subject, from front to back, in acceptably sharp focus. Subjective decisions may need to be made about which parts of the subject need to be in sharp focus and which can be sacrificed. This means that there are great advantages to be had from adopting manual focus for the task. This is where the Live View feature comes into its own.

With Live View you have the advantage of a large image on the camera's monitor on which you can check depth of field. By making use of the 5× or 10× magnification function you can check focus in detail. The small white rectangle on the monitor shows the area currently selected for magnification. Note also the grid lines which are useful for lining up the camera but which can also be disabled.

Working distance

The nature of the subjects you plan to photograph will play a large part in determining the working distance between the camera and subject, which in itself will help to determine the focal length(s) of the lens you use. Inanimate objects can be photographed from mere inches away, whereas live subjects will require a greater distance. If you plan to photograph live subjects that are camera-shy or dangerous, you should opt for a longer focal length to increase the working distance.

Because the sensor on the 1000D/Rebel XS is only 22.2 × 14.8mm in size, any lens which is designed for use on a full-frame camera will have its field of view cropped by a factor of 1.6. This means that you can fill the frame from slightly further away than would be the case with a 35mm or full-frame camera body. This is useful if you plan to use extension tubes on a conventional lens. Extension tubes bring the front element of the lens closer to the subject (see page 173).

HUMMINGBIRD HAWKMOTH
Your working distance needs to be great enough not to frighten away your subject.

170

Close-up attachment lenses

These are one of the easiest routes into close-up photography and screw onto the lens thread just like filters. If you are not planning significant enlargements of your photos, close-up attachment lenses are good value and can produce great results.

They are best used with prime lenses such as a 50mm standard lens or a moderate wide-angle with close focusing capability, and work by reducing the minimum focusing distance even further. Magnification is measured in dioptres, generally +1, +2, +3 or +4, and their great advantage for the novice is that all the camera functions are retained.

Close-up attachments can be used two or more at a time, for example combining a +2 with a +3 attachment to obtain +5 dioptres. However, the optical quality will not be of the same standard as your lens and using two or more will reduce image quality more noticeably. This is another reason to use prime (fixed focal length) lenses – their image quality, despite many advances in zoom lens quality, still tends to be better.

There are some very inexpensive close-up attachment lenses on the market, but as with filters, you will have to pay more for better quality. Canon produce both 2 dioptre (Type 500D) and 4 dioptre (Type 250D)

lenses in both 52mm and 55mm fittings, plus a 2 dioptre (Type 500D) lens in both 72mm and 77mm fittings. All are double-element construction for higher quality. The Type number indicates the greatest possible lens-subject distance in millimetres. The 250D is optimized for use with lenses between 50mm and 135mm; the 500D is designed for lenses between 75mm and 300mm.

ISOLATED SUBJECT
A small Lastolite reflector is a useful and versatile aid to take into the field with you for close-up work. It folds up very small, can be stuffed in a pocket and can be used to keep the wind off a subject as well as to reduce shadows. Perhaps best of all, it can be placed behind a subject to isolate it from its background, as shown in this image.

Lens magnification table

The table below shows the level of magnification you can achieve by attaching either the 250D or 500D close-up attachment lenses (see page 171) to a selection of prime (fixed focal length) lenses.

Lens	Size (mm)	Magnification	
		250D	500D
EF 20mm f/2.8 USM	72	N/A	0.17–0.04
EF 24mm f/2.8	58	0.25–0.10	0.20–0.05
EF 28mm f/2.8	52	0.24–0.12	0.19–0.06
EF 35mm f/2	52	0.36–0.14	0.30–0.07
EF 50mm f/1.0L	72	N/A	0.24–0.10
EF 50mm f/1.4 USM	58	0.35–0.21	0.25–0.10
EF 50mm f/1.8 II	52	0.36–0.20	0.25–0.10
EF 50mm f/2.5 Macro	52	0.68–0.20	0.59–0.10
EF-S 60mm f/2.8 Macro	52	1.41	1.21
EF 85mm f/1.2L USM	72	N/A	0.28–0.17
EF 85mm f/1.8 USM	58	0.50–0.34	0.31–0.17
EF 100mm f/2 USM	58	0.57–0.40	0.35–0.20
EF 100mm f/2.8 Macro	52	1.41–0.41	1.21–0.20
EF 135mm f/2.8 SF	52	0.70–0.55	0.41–0.27
EF 200mm f/2.8L USM	72	N/A	0.57–0.39
EF 300mm f/4L USM	77	N/A	0.70–0.59
EF 400mm f/5.6L USM	77	N/A	0.91–0.78

Extension tubes

Extension tubes fit between the lens and the camera body and can be used singly or in combination. Canon produce two: Extension Tube EF 12 II and Extension Tube EF 25 II. The former provides 12mm of extension and the latter 25mm. By increasing the distance from the lens to the lens mount and thus the focal plane, the minimum focusing distance and the magnification of the image are both increased. Both of Canon's extension tubes retain autofocus capability. They are compatible with most EF and EF-S lenses.

TUBES AND BELLOWS
(Right) Extension tubes EF 12 II and EF 25 II. (Below) This Balpro Novoflex bellows features tilt and shift adjustments for maximum control of perspective and depth of field. Metering is still possible with the appropriate adaptor.

Bellows

Bellows work on the same principles as extension tubes, but are a much more flexible tool. The basic concept is simplicity itself – a concertina-style light-proof tube mounted on a base which allows minute adjustment. This facilitates better control over the magnification ratio and focusing. Their greatest benefit is that bellows do not employ any glass elements at all and consequently can be used to deliver maximum image quality.

The downside is that there is a significant loss of light and exposure must be adjusted to correct this. At one time it was necessary to employ complex calculations to work out the correct exposure but, quite frankly, today's digital cameras are so easy to use that you may as well work on a trial-and-error basis. Canon, for some reason, do not produce this particular accessory, but alternatives are available from independent manufacturers, notably Novoflex.

Reverse adaptors

Yet another simple solution for close-up work involves the use of a reverse adaptor that allows you to mount your lens back to front on the camera. With this method, unlike bellows and extension tubes, there is no loss of light reaching the sensor. However, as the lens contacts are now at the front of the lens, all the information they normally transmit will no longer be usable.

Macro lenses

There are three types of lens that tend to be sold as macro lenses. The first is a specialist lens designed for extremely high magnifications, such as Canon's MP-E65 f/2.8 Macro lens which has a maximum magnification of an astonishing 5x life-size. The second is a purpose-built conventional macro lens with a maximum reproduction ratio of

1:1, though half life-size is now commonly accepted in this category. These are excellent lenses for everyday use too, often giving crisp and contrasty results in everyday situations. Finally, there are those lenses that boast what they refer to as a 'macro setting', which may offer a magnification ratio of up to perhaps 1:4, or one quarter life-size.

For close-up photography in general, a dedicated fixed focal-length macro lens is the ideal choice and provides excellent image quality at close focusing distances. Canon manufacture several.

There are two with shorter focal lengths – the full-frame but only half life-size EF 50mm f/2.5 and the 1:1 true macro EF-S 60mm f/2.8 USM.

174

Both of these will fit the 1000D/Rebel XS but the 50mm version lacks the faster and quieter Ultra Sonic Motor. The 50mm version can achieve 1:1 magnification with the addition of the dedicated four-element Life-size Converter or with the aid of extension tubes, the latter also being compatible with the 60mm lens to achieve magnifications even greater than life-size. The 60mm lens is the first true macro lens in the EF-S range, designed specifically for digital photography with APS-C sensors, and will focus as close as 8in (20cm).

Two longer close-up lenses are also available from Canon, allowing greater working distances: the EF 100mm f/2.8 Macro USM and the EF 180mm f/3.5L Macro USM. Both of these lenses provide a reproduction ratio of 1:1 and, like Canon's two other conventional macro lenses, have a minimum aperture of f/32. The 180mm version is designated an L-series lens and as such comes with the build quality associated with these legendary pieces of equipment, though it does weigh in at over two pounds (1kg).

OPPORTUNITIES
When you don't want to carry a full range of lenses, a 50mm or 60mm macro lens is a lightweight, reasonably fast and highly flexible lens for both landscapes and unexpected close-up opportunities.

Chapter **6**

LENSES

Lenses

One of the main reasons photographers choose a manufacturer such as Canon is the extensive range of lenses and other accessories available. At the time of writing Canon offer no fewer than 70 lenses, including specialist items such as tilt-and-shift lenses.

The range encompasses Canon's standard EF lenses, which fit all EOS cameras; EF-S lenses, which have a smaller image circle and are optimized for APS-C digital bodies (from 20D and 300D onwards); and their renowned L-series lenses, which are popular with professionals due to their rugged design, weather-proofing and high optical quality. All three ranges feature ultrasonic (USM) motors on most lenses, and IS (Image Stabilization) is slowly being added model by model.

EF-S lenses

The EF-S lens series was developed to accompany the smaller body of the 300D and later 350D and 400D, and they are consequently very light in weight. The 'S' designation identifies them as having shorter back focus, a smaller image circle, a specific mount not compatible with a standard EF mount, and a difference in build quality in order to reduce weight. The only prime lens in this series is the EF-S 60mm f/2.8 macro and at first only wide–standard zooms were on offer. These are now complemented by the superwide 10–22mm and more extensive 55–200mm models, with an 18–200mm scheduled for launch at the time of writing.

EF lenses

This is Canon's standard range and stretches from a 15mm fisheye up to 400mm and includes the macro lenses, with the exception of the 180mm L-series macro. It also includes two of the three manual-focus-only tilt-and-shift lenses and the 1.4x and 2x teleconverters (or 'extenders'). Zooms range from 16–35mm to 100–400mm. It is worth studying their specifications as some EF lenses use L-series technology and represent terrific value, such as the EF 70-300mm f/4–5.6 IS USM.

L-series lenses

These are considered the cream of the line-up. The L-series prime lenses stretch from 14mm f/2.8 to 800mm. This range includes all the super-fast Canon lenses such as the 24mm f/1.4, 35mm f/1.4, 50mm f/1.2, 85mm f/1.2 and 400mm f/2.8. A recent addition is the image-stabilized 200mm f/2 L IS USM (above) which will surely find its way into every sports photographer's bag sooner or later.

The build quality of the L-series is superb and later lenses have a rubber skirt on the mount to improve weather- and dust-proofing. Longer focal lengths and extended zooms are off-white in colour, allowing the world to see the extent to which Canon are dominant in the fields of news and sports photography: the Beijing Olympics saw 70% of press photographers using Canon equipment.

Image stabilization (IS)

For decades photographers have relied on either very fast lenses or some form of camera support to cope with the slow shutter speeds necessitated by low lighting. Fast lenses have always meant greater weight and significantly higher cost: for example, the EF 50mm f/1.2 is thirteen times the price of the EF 50mm f/1.8. However, in 1995 Canon introduced an IS lens design for their EF 75–300mm which revolutionized low-light photography.

Canon's IS system uses tiny gyro sensors to detect lens vibration. They send signals to a microcomputer which controls a shifting lens group that can compensate for vertical and

lateral movement. It is now possible to shoot at speeds up to four stops slower than would previously have been possible, without loss of image quality. While IS lenses are more costly than their non-stabilized counterparts, the price differential is nowhere near as great as when purchasing very fast lenses.

Focal length and angle of view

No matter how much is written, nor how often, about the focal length of lenses in this new age of 'less than full-frame' digital cameras, confusion and debate continue to fill internet forums with threads about related topics on a daily basis. These pages should clarify a few of those points.

Focal length

When parallel rays of light strike a lens that is focused at infinity, they converge on a single point known as the focal point. The focal length of the lens is defined as the distance from the middle of that lens to the focal point. Photographic lenses are a bit more complicated because the lens is comprised of multiple elements, but the principle holds good and the measurement is taken from the effective optical centre of the lens group. The focal point is referred to in photography as the 'focal plane' and this is the plane on which the film or sensor lies. Focal length is an absolute characteristic of any lens and can be measured and replicated in laboratory conditions. The focal length of a lens always remains the same, irrespective of any other factor such as the type of camera it is mounted on.

Crop factor

This term refers to the digital multiplier that must be used with 'less than full-frame' sensor cameras when making comparisons with 35mm/full-frame sensor cameras. The 'crop factor' on the EOS 1000D/Rebel XS is 1.6×. It refers only to the field of view that the sensor covers (see pages 122–3). Technically speaking, the term should not be applied to the focal length of a lens used with the smaller sensor. Remember, a 300mm lens is always a 300mm lens, no matter what type of camera it is used on.

Field of view

The field of view of a lens, in photographic terms, is the arc through which objects are recorded on the film or sensor. This arc of coverage is measured in degrees (°). Although the image projected by the lens is circular, in photography we are only

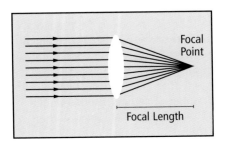

Focal Point

Focal Length

concerned with the usable rectangle within that circle (see pages 123), and consequently the field of view of a camera lens can be found quoted as three figures: horizontal field of view, vertical field of view and diagonal field of view. Where only one figure is quoted, it is generally assumed to be the diagonal field of view.

The field of view of a lens is not an absolute measurement and depends on two factors: the focal length of the lens and the area of the sensor or film which is to record the image.

As the focal length of a lens is fixed, the angle of view should be quoted alongside the image area it is intended for, but unfortunately this practice is not followed by lens manufacturers. Lenses continue to be marketed using the focal-length designation which would be applied to a full-frame (36mm × 24mm) sensor or 35mm film. One reason for this is that lenses designed to fill full-frame sensors/35mm can be used on a smaller format too, so at least three sets of figures would need to be given for Canon lenses alone.

Another reason is that different camera manufacturers who produce 'less than full-frame' sensors make their sensors in different sizes – so the angle of view for, say, a 24mm Nikon lens is

not the same as that for a 24mm Canon lens when used on their respective 'less than full-frame' sensor cameras.

Focal length comparison

When the focal length is doubled, the area covered is one quarter of the previous area. This image below was captured using a lens with a focal length of 20mm. If a 40mm lens was used, the image area would be that shown by the larger dotted rectangle. If an 80mm focal-length lens was used, the image area would be that shown by the smaller dotted rectangle. The solid rectangle in the centre appears to be a logical progression (i.e. 160mm) but actually represents 320mm in focal length, because as the focal lengths get longer, the numerical difference in the angle of view is reduced as you double the focal length.

Standard lenses

The term 'standard lens' dates back to the early days of 35mm photography, long before today's extensive range of prime lenses and, particularly, zoom lenses available were even conceived of. The working photographer would carry three bodies equipped with a moderate wide-angle lens of 28mm or 35mm, a 50mm standard lens and a short telephoto of up to 135mm. The standard 50mm lens was sold with the camera and approximated the field of view of the human eye.

With APS-C sensor bodies like the EOS 1000D/Rebel XS, because of the crop factor explained on page 180, it is necessary to divide the 50mm focal length by 1.6 in order to arrive at a focal length that may be considered 'standard'. This means we're looking at a focal length of approximately 30mm. Today, the zoom lenses that are packaged with new cameras instead of the old 50mm prime lens tend to straddle this 30mm figure. Canon's 18–55mm EF-S lens is a classic example, to such an extent that it cannot be purchased as a separate item.

Historically, the standard lens was always the least expensive in any line-up, unless it was a particularly fast version, because it could be manufactured more cheaply and in greater quantities. But standard zooms have come down in price, size and weight, and have increased in quality. Add to this the shift towards APS-C bodies by huge numbers of Canon users and it looks like the 50mm standard lens is turning into a museum piece. Or is it?

Canon still produce 50mm f/1.4 and f/1.2 versions to act as standard lenses for 35mm film and full-frame sensor cameras. For users of APS-C Canon bodies such as the EOS 1000D/Rebel XS, these serve as really fast portrait lenses, with a field of view similar to an 80mm lens on 35mm, for a very competitive price.

182

Wide-angle lenses

The net effect of using APS-C sensor bodies has been a real boon for telephoto users because the field of view can be reduced by a factor of 1.6, but at the opposite end of the focal-length scale, wide-angle users have suffered. Even a 17–40mm lens provides the field of view of only a 27–64mm equivalent, and 27mm is definitely not considered wide-angle by today's standards. However, in 2004, Canon introduced the EF-S 10–22mm lens which, for the first time, meant that there was an affordable Canon option that offered real wide-angle characteristics. Prior to this the only choice for those determined to stick with Canon lenses was the extremely expensive 14mm f/2.8L introduced way back in 1991.

Three independent lens manufacturers currently produce lenses to compete with the EF-S 10–22mm. Sigma and Tamron produce 10–20mm and 11–18mm lenses respectively, the Canon versions both designed to work exclusively with APS-C sensor bodies and both having a 77mm filter thread, just like the EF-S 10–20mm. Tokina also produce a 10–17mm zoom, but this is a full-frame fisheye lens. Both Sigma and Tokina also manufacture 12–24mm lenses, the Sigma being a full-frame lens and the Tokina only suitable for APS-C bodies.

The fast moderate wide angle, a 35mm f/1.4 on 35mm for example, was always a photojournalist's mainstay, but the chances of an APS-C equivalent of 21mm f/1.4 being brought out are probably nil, so anyone wanting that sort of lens performance will be looking at a full-frame body.

Today's wide zooms are really quite slow: for the best performance it is usually necessary to stop down a couple of stops from the maximum aperture. This means working with an aperture of at least f/5.6 and more probably f/8 – which places limits on working in low light because the shutter speeds will be very slow, making Image Stabilization an even more desirable feature.

Telephoto lenses

Telephoto users, whether using prime lenses or zooms, gain hands down from using APS-C sensor bodies like the 1000D/Rebel XS because the field of view is reduced by ×1.6. My favourite long lens combination is a 300mm f/2.8 with a ×1.4 converter,

giving the equivalent field of view on the 1000D/Rebel XS as a 672mm f/4.0. With a ×2 converter instead of the ×1.4 this would equate to a staggering 960mm f/5.6, still with AF capability. Such possibilities are incredibly cost-effective.

Telephoto lenses give the appearance of compressing the different planes in an image, making distant subjects look closer than they are. The longer the focal length, the more this is true. However, telephotos also require faster shutter speeds, which is why you will see sports photographers carrying huge lenses along the touchline. It is not the focal length alone that results

in such huge lenses so much as the combination of focal length and fast maximum apertures. But doesn't Image Stabilization remove the need for fast maximum apertures? No. Image Stabilization is designed to compensate for camera shake but has no impact on the need for a high shutter speed, and therefore fast maximum aperture, when trying to freeze a moving subject.

One of the bonuses of using longer lenses is the attractive out-of-focus background (known as 'bokeh') which can result. This effect is determined to some degree by the number of blades in the diaphragm and by the extent to which they create a perfect circle when open.

Perspective

There are several reasons why we might choose a particular focal length: angle of view, depth of field, and perspective chief among them. Perspective is the term used to describe the relationships between the different elements that comprise an image, particularly with regard to the apparent compression or expansion of planes.

Let's start with the most obvious examples. With a very wide-angle lens, taking a head and shoulders portrait will involve a very short camera-to-subject distance, and the nearest facial features will appear quite distorted and overly large. Conversely, try photographing a line of parking meters with a long telephoto and the image will give the impression that the meters are spaced only a couple of feet apart.

Between these two extremes are a host of options, especially if you use zoom lenses. There are no hard-and-fast rules except to say that if you want natural-looking portraits, it is best to opt for a slightly longer than standard focal length, traditionally 85mm full-frame or 50mm on the EOS 1000D/Rebel XS. Canon's prime lenses in this bracket are excellent value (not counting the fabulous but pricey 85mm f/1.2), with wide maximum apertures and superb image quality.

SPIDER CRAB
The perspective with any given focal length will change according to the camera-to-subject distance and the viewpoint.

Teleconverters

Canon use the term 'extender' to describe their two teleconverters. The first is the 1.4× extender which is fitted between the camera body and the lens to increase the focal length by a factor of 1.4 and which causes the loss of one stop of light. The 2× extender doubles the focal length with a loss of two stops.

Teleconverters are an inexpensive way of increasing the power of your telephoto lenses, but do not provide the same quality as a lens of the same focal length. Autofocus will be slower and the AF may 'hunt' unless it can lock onto a suitable part of the image.

Tip
It is important to pay attention to the maximum aperture of your lens if you are considering purchasing an extender. If the recalculated maximum aperture with an extender fitted is smaller than f/5.6, you will lose autofocus capability.

Only selected lenses can be used with Canon extenders without causing damage to the rear element of the lens. To check which current lenses can be used, visit the Canon website and check the specification of the lens concerned.

Teleconverter	Optical features and supported features	Dimensions: diameter × length	Weight
Extender EF 1.4× II	USM, I/R, Float, FT-M, CA, 1×S-UD, 3×AL, IS, DO	72.8 × 27.2mm	220g
Extender EF 2× II	USM, I/R, Float, FT-M, CA, 1×S-UD, 3×AL, IS, DO	71.8 × 57.9mm	265g

Tilt-and-shift lenses

One of the main drawbacks of using normal lenses for any architectural subject is that tilting the camera and lens to accommodate the height of the building results in the convergence of vertical lines, usually the sides of the building. You can get around this by finding a viewpoint that is at roughly half the height of the building. However, a more satisfactory solution comes in the shape of a tilt-and-shift lens.

These lenses adopt the same principles as a view camera but are much more portable. They work by allowing the lens to perform different movements in relation to the plane of focus, with the added benefit of improving depth of field without changing the aperture.

Canon manufacture three such lenses, with only the widest being an L-series version: the TS-E 24mm f/3.5L, the TS-E 45mm f/2.8 and the TS-E 90mm f/2.8. All of these lenses are manual focus only.

CASTLE KEEP
This image clearly demonstrates the problem of converging vertical lines. This can be overcome by using a tilt-and-shift lens.

Modern lens technology

Canon use a variety of different lens technologies to improve their performance in a number of respects, including optical quality, focusing and handling. This table describes the main features that Canon now incorporate into their range of lenses.

AF-S – Autofocus stop feature	The AF-S button prevents the lens from inadvertently refocusing on unwanted subjects that have impinged on the frame. **Main benefit** Saves time that would be wasted if the lens focused on unwanted intrusions.
UD – UD glass	Not as effective as either super-UD glass elements or fluorite elements, UD glass elements still offer more correction of chromatic aberration than standard glass elements. **Main benefit** Decreases fringing and increases colour clarity, particularly with long focal-length lenses.
Float – Floating system	The focusing mechanism adjusts the gaps between particular lens elements in order to minimize the occurrence of optical deficiencies when focusing on subjects close to the lens's minimum focus distance. **Main benefit** Improves image quality for subjects at close focusing distances.
FP – Focus preset	Focus preset stores a focus distance as a preset, allowing the lens to be switched almost instantly from any focusing distance to the preset focus distance. **Main benefit** Allows instant switching to a preset focus distance.

CaF2 – Fluorite elements	Incorporating fluorite in lenses brings the points of focus of the three primary spectral colours of red, green and blue to the same point in order to correct chromatic aberration. **Main benefit** Reduces chromatic aberration and reduces ghost flare to a negligible level.
DO – Diffractive optics	Diffractive optics concentrate image-forming light into a narrower beam than a standard lens. This allows a lens to be more compact and lighter than a normal lens of an equivalent focal length. Diffractive optics also provide high image quality. **Main benefit** Smaller and lighter lenses with high optical performance.
DW-R – Dust- and water-resistant construction	Lenses that have a dust- and water-resistant construction are more durable than standard lenses. There is also a rubber skirt that seals the lens-body connection, protecting both the lens and the camera body, as well as minimizing the risk of dust adhering to the sensor. **Main benefit** Enhanced protection for both lens and camera, useful in adverse conditions.
EMD – Electromagnetic diaphragm	A diaphragm drive-control actuator, which is comprised of a stepping motor and diaphragm blade unit. The integration of these components in one unit overcomes the problems of time lag and low durability, which are inherent in units that convert drive power from the camera body. All EF lenses (except TS-E and MP-E lenses) use an EMD for aperture diameter control. **Main benefit** Fast and reliable diaphragm control.

LENSES

FT-M – Full-time manual focusing	Overrides the autofocus, allowing manual focus in AF mode. Canon has two types: electronic manual focusing, which detects the rotation of the manual focus ring and drives the focusing motor electronically; and mechanical manual, where the rotation of the focus ring mechanically adjusts the focus.
	Main benefit Saves time switching between focus modes.
AS – Aspherical elements	Aspherical lens elements correct the inability of spherical elements to bring the various colours of the spectrum into focus at one point. This enables a lens to deliver a high-clarity image with reduced colour fringing and coma.
	Main benefit Particularly useful for correcting aberrations in wide-angle lenses, even at large apertures.
IF – Internal focusing **RF – Rear focusing**	Internal focusing allows a lens to focus without changing its size. Rear focusing uses the elements behind the diaphragm to focus the image.
	Main benefit Produces a lens that is more compact and lightweight, particularly in long telephoto lenses. Rear focusing provides quicker and smoother autofocus operation.
IS – Image stabilization	Image stabilization lenses use internal sensors that detect camera shake and operate gyros and a shifting optical system to automatically adjust the lens elements to minimize blur. Canon claim that this technology allows you to hand-hold the lens at shutter speeds up to four stops slower than the same lens without IS, without camera shake becoming visible.
	Main benefit Reduces the occurrence of blur in images caused by camera shake.

CA – Circular aperture	Apertures' irises consist of a number of blades, so out-of-focus areas of an image take on a polygonal appearance. The closer the aperture is to a circle, the less noticeable the individual shapes. **Main benefit** Smoother out-of-focus areas.
L – L-series	Canon's top-quality lenses are given the designation L. L-series lenses incorporate a range of features that give them their characteristically excellent optical performance. **Main benefit** Extremely good image clarity.
S-UD – super-UD glass	While not quite as effective as fluorite elements, super-UD glass elements have almost twice the effectiveness of UD elements in suppressing chromatic aberration. **Main benefit** Increased colour clarity, particularly with long focal-length lenses.
SC – Super-spectra coating	This coating is common to all EF and EF-S lenses, ensuring sharp, high-contrast images with a colour balance that is consistent throughout the EF lens range. **Main benefit** Enhanced image clarity and colour consistency.
USM – Ultrasonic motor	Makes the motor in the lenses that drive the autofocus mechanism almost silent, yet autofocus is quick and precise. The direct-drive construction is very simple, making it both durable and efficient, while consuming little power. **Main benefit** Fast, precise and quiet autofocus.

LENSES

EF lens chart

Lens name	Optical features	Angle of view (horizontal) nearest 10th of a degree	Min. focus distance
EF 14mm f/2.8L USM	USM, 1xAL, I/R, FT-M, Float	76°48′	0.25m
EF 14mm f/2.8L II USM	L, USM, 1xAL, 1xUD, CA, SC	81°	0.20m
EF 15mm f/2.8 Fisheye	I/R	–	0.20m
EF 20mm f/2.8 USM	USM, I/R, FT-M, Float	58°6′	0.25m
EF 24mm f/1.4L USM	USM, 1xAL, 1xUD, I/R, FT-M, Float	49°36′	0.25m
EF 24mm f/2.8	I/R, Float	49°36′	0.25m
TS-E 24mm f/3.5L	1xAL	49°36′	0.30m
EF 28mm f/1.8 USM	USM, 1xAL, I/R, FT-M	43°12′	0.25m
EF 28mm f/2.8	1xAL, Float	43°12′	0.30m
EF 35mm f/1.4L USM	USM, 1xAL, I/R, FT-M, Float	35°12′	0.30m
EF 35mm f/2		35°12′	0.25m
TS-E 45mm f/2.8	Float	27°42′	0.40m
EF 50mm f/1.2L USM	L, USM, CA, SC	40°	0.45m
EF 50mm f/1.2L USM	L, USM	25°	0.45m
EF 50mm f/1.4 USM	USM, FT-M	25°	0.45m
EF 50mm f/1.8 II		25°	0.45m
EF 50mm f/2.5 Compact Macro	Float	25°	0.23m
EF-S 60mm f/2.8 Macro	USM, I/R, FT-M	21°	0.20m
MP-E 65mm f/2.8 1–5x Macro Photo	Float, 1xUD	19°24′	0.24m
EF 85mm f/1.2L USM	USM, 1xAL, FT-M, Float	14°54′	0.95m
EF 85mm f/1.8 USM	USM, I/R, FT-M	14°54′	0.85m
TS-E 90mm f/2.8		14°6′	0.50m
EF 100mm f/2 USM	USM, I/R, FT-M	12°42′	0.90m
EF 100mm f/2.8 Macro USM	USM, I/R, FT-M, Float	12°42′	0.31m

Min. aperture	Max. magnification	Filter size dia. × length	Dimensions	Weight
f/22	0.10×	rear	77.0 × 89.0mm	560g
f/22	0.15×	rear	80.0 × 94.0mm	645g
f/22	0.14×	rear	73.0 × 62.2mm	330g
f/22	0.14×	72mm	77.5 × 70.6mm	405g
f/22	0.16×	77mm	83.5 × 77.4mm	550g
f/22	0.16×	58mm	67.5 × 48.5mm	270g
f/22	0.14×	72mm	78.0 × 86.7mm	570g
f/22	0.18×	58mm	73.6 × 55.6mm	310g
f/22	0.13×	52mm	67.4 × 42.5mm	185g
f/22	0.18×	72mm	79.0 × 86.0mm	580g
f/22	0.23×	52mm	67.4 × 42.5mm	210g
f/22	0.16×	72mm	81.0 × 98.0mm	645g
f/16	0.15×	72mm	85.8 × 65.5mm	580g
f/16	0.15×	72mm	85.4 × 65.5mm	545g
f/22	0.15×	58mm	73.8 × 50.5mm	290g
f/22	0.11×	52mm	68.2 × 41.0mm	130g
f/32	0.50×	52mm	67.6 × 63.0mm	280g
f/32	1.00×	52mm	73.0 × 69.8mm	335g
f/16	5.00×	58mm	81.0 × 98.0mm	730g
f/16	0.11×	72mm	91.5 × 84.0mm	1,025g
f/22	0.13×	58mm	75.0 × 71.5mm	425g
f/32	0.29×	58mm	73.6 × 88.0mm	220g
f/32	0.14×	58mm	75.0 × 73.5	460g
f/32	1.00×	58mm	79.0 × 119	600g

EF 135mm f/2L USM	USM, 2xUD, I/R, FT-M	9°24'	0.90m
EF 135mm f/2.8 with soft focus	1xAL, I/R	9°24'	1.30m
EF 180mm f/3.5L Macro USM	USM, 3xUD, I/R, FT-M, Float	7°6'	0.48m
EF 200mm f/2L IS USM	USM, 5-stop IS, UD, FT-M, FP	10°	1.9m
EF 200mm f/2.8L II USM	USM, 2xUD, I/R, FT-M	6°24'	1.50m
EF 300mm f/2.8L IS USM	USM, 1xCaF2, 2xUD, I/R, FT-M, FP, IS, AF-S, DW-R	4°12'	2.50m
EF 300mm f/4L IS USM	USM, 2xUD, I/R, FT-M, IS	4°12'	1.50m
EF 400mm f/2.8L IS USM	USM, 1xCaF2, 2xUD, I/R, FT-M, FP, IS, AF-S, DW-R	3°12'	3.00m
EF 400mm f/4L DO IS USM	DO, USM, 1xCaF2, I/R, FT-M, FP, IS, AF-S, DW-R	3°12'	3.50m
EF 400mm f/5.6L USM	USM, 1xCaF2, 1xS-UD, I/R, FT-M	3°12'	3.50m
EF 500mm f/4L IS USM	USM, 1xCaF2, 2xUD, I/R, FT-M, FP, IS, AF-S, DW-R	2°30'	4.50m
EF 600mm f/4L IS USM	USM, 1xCaF2, 2xUD, I/R, FT-M, FP, IS, AF-S, DW-R	2°6'	5.50m
EF 800mm f/5.6L IS USM	USM, 4-stop IS, AS, UD, FT-M, FP	2°35'	6.0m
EF-S 10–22mm f/3.5–4.5 USM	USM, 3xAL, 1xS-UD, I/R, FT-M	96°–53°30'	0.24m
EF 16–35mm f/2.8L USM	USM, 3xAL, 2xUD, I/R, FT-M, DW-R	69°30'–35°12'	0.28m
EF 16–35mm f/2.8L II USM	L, USM, 3xAL, 2xUD, CA, DW-R, FT-M	98°–54°	0.28m
EF 17–40mm f/4L USM	USM, 3xAL, 1xS-UD, I/R, FT-M, DW-R	66°18'–31°	0.28m
EF-S 17–55mm f/2.8 IS USM	USM, 3xAL, 2xUD, IS	66°18'–22°48'	0.35m
EF-S 17–85mm f/4–5.6 IS USM	USM, 1xAL, I/R, FT-M, IS	66°18'–14°54'	0.35m
EF-S 18–55mm f/3.5–5.6 II	1xAL	63°18'–22°48'	0.28m
EF-S 18–55mm f/3.5–5.6 USM	USM,1xAL	63°18'–22°48'	0.28m
EF 20–35mm f/3.5–4.5 USM	USM, I/R, FT-M	58°6'–35°12'	0.34m
EF 24–70mm f/2.8L USM	USM, 3xAL, 1xUD, I/R, FT-M, CA	49°36'–18°	0.38m

194

f/32	0.19×	72mm	82.5 × 112mm	750g
f/32	0.12×	52mm	69.2 × 98.4mm	390g
f/32	1.00×	72mm	82.5 × 186.6mm	1,090g
f/32	0.12×	52mm drop-in	128 × 208mm	2,520g
f/32	0.16×	72mm	83.2 × 136.2mm	765g
f/32	0.13×	52mm drop-in	128.0 × 252.0mm	2,550g
f/32	0.24×	77mm	90.0 × 221.0mm	1,190g
f/32	0.15×	52mm drop-in	163.0 × 349.0mm	5,370g
f/32	0.12×	52mm drop-in	128.0 × 232.7mm	1,940g
f/32	0.12×	77mm	90.0 × 257.5mm	1,250g
f/32	0.12×	52mm drop-in	146.0 × 387.0mm	3,870g
f/32	0.12×	52mm drop-in	168.0 × 456.0mm	5,360g
f/32	0.14×	52mm drop-in	163 × 461mm	4,500g
f/22–f/29	0.17×	77mm	83.5 × 89.8mm	385g
f/22	0.22×	77mm	83.5 × 103.0mm	600g
f/22	0.22×	82mm	88.5 × 111.6mm	635g
f/22	0.24×	77mm	83.5 × 96.8mm	500g
f/22	0.17×	77mm	83.5 × 110.6mm	645g
f/22–f/32	0.20×	67mm	78.5 × 92.0mm	475g
f/22–f/32	0.28×	58mm	68.5 × 66.0mm	190g
f/22–f/32	0.28×	58mm	68.5 × 66.0mm	190g
f/22–f/27	0.13×	77mm	83.5 × 68.9mm	340g
f/22	0.29×	58mm	83.2 × 123.5mm	950g

Lens	Construction	Angle of view	Min. focus
EF 24–85mm f/3.5–4.5 USM	USM, 2xAL, 1xUD, I/R, FT-M, CA, DW-R	49°36'–14°54'	0.50m
EF 24–105mm f/4L IS USM	USM, IS, 1xUD, FT-M	49°36'	0.45m
EF 28–80mm f/3.5–5.6 II	USM, I/R	43°12'–30°	0.38m
EF 28–80mm f/3.5–5.6 V USM	FP, AF-S, 3xAL	65°–25°	0.38m
EF 28–90mm f/4–5.6 II USM	USM, 1xAL	43°12'–22°40'	0.38m
EF 28–90mm f/4–5.6 III	1xAL	43°12'–22°40'	0.38m
EF 28–105mm f/3.5–5.6 II USM	USM, I/R, FT-M	43°12'–12°6'	0.50m
EF 28–105mm f/4–5.6 USM	USM, I/R, 1xAL	43°12'–12°6'	0.48m
EF 28–135mm f/3.5–5.6 IS USM	USM, 1xAL, I/R, FT-M, IS	43°12'–9°24'	0.50m
EF 28–200mm f/3.5–4.5 II USM	USM, 2xAL, I/R	43°12'–6°24'	0.45m
EF 28–300mm f/3.5–5.6L IS USM	USM, 3xAL, 3xUD, I/R, FT-M, IS	43°12'–4°12'	0.70m
EF 35–80mm f/4–5.6 III	1xAL	35°12'–15°48'	0.40m
EF 55–200mm f/4.5–5.6 II USM	USM	22°48'–6°24'	1.20m
EF 70–200mm f/2.8L IS USM	USM, 4xUD, I/R, FT-M, IS, DW-R,	18°–6°24'	1.40m
EF 70–200mm f/2.8L USM	USM, 4xUD, I/R, FT-M	18°–6°24'	1.50m
EF 70–200mm f/4L IS USM	USM, 1xCaF2, 2xUD, I/R, FT-M, IS	18°–6°24'	1.20m
EF 70–200mm f/4L USM	USM, 1xCaF2, 2xUD, I/R, FT-M	18°–6°24'	1.20m
EF 70–300mm f/4.5–5.6 DO IS USM	USM, 1xAL, I/R, FT-M, DO, IS	18°–4°12'	1.40m
EF 70–300mm f/4–5.6 IS USM	USM, UD, IS	18°–4°12'	1.50m
EF 75–300mm f/4–5.6 III USM	USM	16°42'–4°12'	1.50m
EF 75–300mm f/4–5.6 III		16°42'–4°12'	1.50m
EF 80–200mm f/4.5–5.6 II		15°48'–6°24'	1.50m
EF 90–300mm f/4.5–5.6	CA	22°40'–6°50'	1.5m
EF 100–300mm f/4.5–5.6 USM	USM, I/R, FT-M	12°42'–4°12'	1.50m
EF 100–400mm f/4.5–5.6L IS USM	USM, 1xCaF2, 1xS-UD, I/R, FT-M, Float, IS	12°42'–3°12'	1.80m

196

f/22–f/32	0.16×	77mm	73.0 × 69.5mm	380g
f/22	0.23×	77mm	83.5 × 107.0mm	670g
f/28–f/38	0.26×	67mm	67.0 × 71.0mm	220g
f/22–f/38	0.26×	58mm	67 × 71mm	220g
f/22–f/32	0.30×	58mm	67.0 × 71.0mm	190g
f/22–f/32	0.30×	58mm	67.0 × 71.0mm	190g
f/22–f/27	0.19×	58mm	72.0 × 75.0mm	375g
f/22–f/32	0.19×	58mm	67.0 × 68.0mm	210g
f/22–f/36	0.19×	72mm	78.4 × 96.8mm	540g
f/22–f/36	0.28×	72mm	78.4 × 89.6mm	500g
f/22–f/38	0.30×	77mm	92.0 × 184.0mm	1,670g
f/22–f/32	0.23×	52mm	65.0 × 63.5mm	175g
f/22–f/27	0.17×	77mm	86.2 × 197.0mm	1,470g
f/32	0.17×	77mm	84.6 × 193.6mm	1,310g
f/32	0.21×	67mm	76.0 × 172.0mm	705g
f/32	0.21×	67mm	76 × 172mm	760g
f/32	0.16×	77mm	78.5 × 137.2mm	650g
f/32–f/38	0.19×	67mm	82.4 × 99.9mm	720g
f/32–f/45	0.26×	58mm	76.5 × 142.8mm	630g
f/32–f/45	0.25×	58mm	71.0 × 122.0mm	480g
f/32–f/45	0.25×	58mm	71.0 × 122.0mm	480g
f/22–f/27	0.16×	52mm	69.0 × 78.5mm	250g
f/38–f/45	0.25×	58mm	71 × 114.7mm	420g
f/32–f/38	0.20×	58mm	73.0 × 121.5mm	540g
f/32–f/38	0.20×	77mm	92.0 × 189.0mm	1,380g

Chapter **7**

Accessories

All photographers have a mental shortlist of accessories they can't live without. Here we examine some of the most popular items, covering a range of techniques and photographic styles, but concentrating largely on filters, as these are very popular with almost all photographers.

Filters

LEE FILTER HOLDER
Considered by many to be the ultimate filter system, Lee filter holders and filters represent a considerable, but worthwhile, investment.

There are essentially four types of filter: colour-correction filters used on the lens, colour-correction filters used on the light source, filters that help to enhance an existing characteristic but preserve a fairly natural feel to the photograph, and special-effects filters. In some circumstances a mixture of these types may be used.

The materials that are used in the construction of filters range from gelatine (usually reserved for lighting), through resins to glass. The quality may vary widely and, generally speaking, you get what you pay for. A major factor to consider when purchasing glass filters is the number of additional coatings to reduce flare. Glass filters come with no coating at all, single-coated and multi-coated, the latter being considerably more expensive.

The alternative to glass is one of the rectangular filter systems that make use of resin filters and a special holder into which the filters are inserted. The filter holder, which will accept two or three filters, fits onto an adaptor ring which screws into the lens's filter thread, and it is a simple matter to carry several adaptor rings for different lenses as well as numerous filters.

> **Tip**
> The larger rectangular filter systems are very versatile, and the same filters will fit multiple lenses using inexpensive adaptor rings.

200

Special-effects filters

An astonishingly wide range of effects filters is available, far too many to even begin to describe here. It is suggested that you explore the websites of filter manufacturers such as Lee, Cokin, Hitech and Hoya to get some idea of what is available. Their website addresses can be found on page 237.

Drop-in glass and gelatine filters

Some lenses have very large front elements which would necessitate equally huge filters. This caused manufacturers to seek an alternative, which they found in the form of drop-in filters. These are literally dropped into a slot in the lens which is located near the back and thus only requires a relatively small filter. Canon produces them in two sizes, 48mm and 52mm. They also make drop-in holders for gelatine filters in the same sizes. Unfortunately, the glass versions are restricted to polarizing filters.

Tips

To retain the best possible image quality, filters should be treated like lenses and kept clean, free from dust and protected from scratches.

Filters can be expensive, so take time to research the different systems and their compatibility with your existing equipment. The outlay on a professional system such as Lee can be considerable, but once you have made that decision you will never regret it.

CHINON, FRANCE
A four-point star filter was used to pick out the streetlights in this shot. Like all images taken at night, differences in the types of lighting provide a variety of colour depending on which inert gases the lights use (e.g. neon or helium).

Polarizing filters

Polarizing filters are best known for boosting the depth of blue skies and making white clouds stand out against them, and are most effective when used at 90° to the sun. Of the hundreds of filters available, the polarizing filter is the one that landscape photographers would least like to do without – and, coincidentally, it is also the most expensive. The filter is mounted in a holder that allows it to be rotated using a knurled ring on the front of the filter mount. The filter effect is transitional, shifting through maximum effect at 90° and 270° to the direction of the sun and minimum effect at 180° and 0/360°, bearing in mind that the sun's height in the sky also plays its part.

A polarizing filter always reduces the light reaching the camera sensor and therefore requires a degree of exposure adjustment, though this will be achieved automatically in any auto-exposure mode. The degree of exposure adjustment required is not constant and varies according to the extent to which the filter blocks the polarized light waves.

Sometimes the combination of side-lighting (ie the sun at 90°) and maximum filter effect can produce

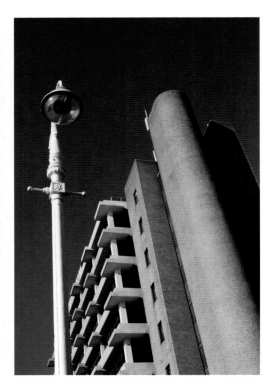

> **Tip**
> A polarizing filter can be used instead of a plain neutral density filter to reduce exposure by approximately two stops.

SKYLINE
Polarizing filters are perennially popular with landscape photographers as they boost blue skies and fluffy white clouds, but there are also situations in towns and cities in which the same qualities are useful.

CANON EOS 1000D/REBEL XS

images which have far too much contrast with a lot of deep shadow. In these circumstances it should be remembered that the polarizing filter's effect is not 'all or nothing' and it does not necessarily have to be rotated to achieve maximum effect when partial effect will do.

The other main function of a polarizing filter is to control reflections in an image. While its most obvious use is to reduce unwanted reflections from shiny surfaces and water, it is also highly effective at reducing the light reflected by foliage, producing richer green tones.

There are two types of polarizing filter: circular and linear. These terms refer to light-wave behaviour and the word 'circular' has nothing to do with the shape of the filter. Both types of polarizer are equally effective but linear polarizers don't work well with autofocus cameras that employ beam-splitter technology, so you should use a circular polarizing filter with your EOS 1000D/Rebel XS.

Vignetting

This is the term given to the loss of image detail at the outer edges of the frame, starting at the corners, and may have several causes – one of which is the use of filters on wide-angle lenses. Manufacturers expect filters to be used on their lenses or they wouldn't incorporate

filter threads on them. The problems usually start when you 'stack' filters, using two or more screw-in filters together, especially if you then screw a lens hood onto the front of them. Vignetting can also occur when using rectangular filter holders, especially if you add a second one to allow for rotation.

This problem is highly unlikely to manifest itself if you are using full-frame lenses on the EOS 40D because the sensor is not making full use of the image circle projected by the lens (see pages 122–3).

Tips
Step-up or step-down adaptor rings can be used to make a glass filter fit more than one lens with different sizes of filter threads, significantly reducing the cost of using the more expensive filters such as polarizers.

Step-up or step-down adaptor rings can be used to make a glass filter fit more than one lens with different sizes of filter threads, significantly reducing the cost of using the more expensive filters such as polarizers.

UV and skylight filters

These are designed to absorb ultraviolet light, thus reducing the blue colour cast which can be a nuisance in landscape shots at high altitude and on hazy days. The UV filter renders a natural result and the skylight version provides a warmer, slightly pinkish tone. In reality, far more photographers use these to protect the front element of the lens from wear and tear than to filter out ultraviolet light. Others wouldn't dream of unnecessarily using a filter on their expensive high-quality lens as the optical quality of the filter cannot match that of the finest lenses. Nevertheless, a UV filter is a worthwhile accessory as its benefit cannot be effectively replicated in computer software.

SUNRISE

With film, colour correction filters are needed to produce images like this. With the 1000D/Rebel XS you can make the necessary adjustments to colour temperature in-camera.

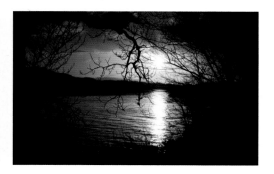

Colour-correction filters

Most colour-correction filters have become largely redundant, because even entry-level cameras now have a facility to adjust colour temperature. In addition, Canon's own software provides the option to adjust the colour temperature of RAW images in post-processing. There is one particular filter, however, which is worth mentioning here: a combined polarizing and warm-up filter.

Traditionally, warm-up filters have been available in several densities, with 81A being the weakest and 81E being the densest. An 81A or 81B can provide a slightly tanned skin tone, with an 81B or 81C providing a distinct earthy appearance to landscapes. Several years ago an American landscape photographer hit on the idea of combining a polarizing filter with a warming filter, and this combined filter is still available, its effect being not quite the same as using a polarizing filter combined with in-camera colour-temperature control.

Neutral density filters

Sometimes there can be too much available light. The most common scenario is when a very slow shutter speed is needed to create blur – when shooting a waterfall, for example. In these circumstances a neutral density (ND) filter, which

reduces the light passing through the lens equally across the frame, is a valuable aid. Theoretically, ND filters should not affect the colour balance, but resin ones in particular can have a grey tinge to them.

ND filters come in a range of strengths and are available in 1- to 4-stop versions in both glass screw-in and resin varieties. Strength may be indicated as ND2 for 1 stop, then ND4 for 2 stops, and so on; or ND0.3 for 1 stop, ND0.6 for 2 stops and so on, with ND0.45 being 1½ stops.

Graduated neutral density filters

Second only to a polarizing filter in the landscape photographer's tool kit, graduated neutral density (GND) filters are half clear, with the other half having a neutral density coating that is increasingly dense as it approaches the upper edge of the filter. Like plain ND filters, they are available in various strengths.

A GND filter's strength relates to the maximum light reduction at the upper edge. The area in the centre, where the clear half merges with the weakest edge of the neutral-density coating, can have different grades of transition: commonly soft, hard or razor. Hard- or razor-edged graduations are useful when you are photographing a flat horizon.

GND filters are used to balance exposure in different areas of the image. You can vary the effect by how far you slide the filter into the holder, or insert a filter upside down to darken the bottom of the image. Furthermore, if you 'piggy back' two filter holders, one can be rotated to darken a corner of the image.

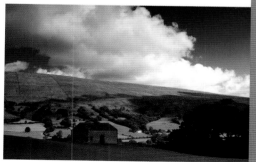

PIGGY BACK
Making use of two Lee filter holders in tandem, two soft grad ND filters were used for this image. One was used at an angle to darken just the brooding cloud in the top left corner. The other was raised in the holder to provide just a touch of transition towards the upper edge of the frame.

Camera supports

Two aspects of digital technology that are continually being improved are image stabilization (IS) and noise reduction, both of which have some impact on the need to provide additional support for your camera.

Canon now claim an effective 4-stop reduction in shutter speeds for their latest IS lenses, meaning that a previous shutter speed of, say, 1/250 sec could now be reduced to 1/150 sec without significant loss of sharpness due to camera shake. Improved noise reduction also means that a higher ISO setting can be used, also reducing the need for additional camera support.

Tripods

Despite these advances, there will always be circumstances in which a tripod or other form of support is necessary. The tripod remains the primary form of support and relies on three things for its effectiveness: weight, appropriate feet for the situation, and leg-angle. Much recent development has gone into reducing the first of these factors using materials like carbon fibre.

Tripod feet aren't something you think about about too often, but if you own a tripod that offers various alternatives, such as a Manfrotto, you may be aware of the difference they can make. Spiked feet are good for using on soft ground but no use on a wooden floor, for example, as they will scratch it and – more importantly in this context – the entire set-up will be balanced on three tiny points. The usual compromise consists of threaded spikes with rubber feet which can be screwed up or down according to your requirements. There are also wider, flat feet designed for use on snow or soft ground.

As for leg angle, the broader the base of the tripod, the more stable it will be. This concept has been extended to produce models like the Benbo, which offers unlimited leg movement in any direction for absolute stability. Mini-tripods and table-top tripods are a lightweight solution out in the field, and there are some intriguing versions with flexible legs that can be manipulated to improve stability.

206

Alternative supports

The monopod is a firm favourite for action photography, especially when used with the tripod collar that is attached part-way along some longer focal-length lenses. There are also clamps that can be mounted in birdwatching hides or over a partly opened car window; ball heads mounted on short columns with a large suction pad at the base; chestpods; clamps for screwing onto trees; and even bean bags on which to rest the lens or camera body when using a wall or other feature for support.

No single camera support will serve in every situation and most photographers end up collecting a variety over the years.

> **Tip**
> Bean bags are a particular favourite of birdwatching enthusiasts as they can be filled with bird seed, some of which can also be used to attract birds into a photogenic setting.

(Right) The central column of this Manfrotto professional tripod can also be fitted as a horizontal arm.

(Below) This tripod head has a three-way pan-and-tilt mechanism to allow easy adjustment in both the horizontal and vertical planes.

(Below) Monopods such as this Gitzo model are widely used in action photography and are very light and easy to carry when closed.

ACCESSORIES

Other accessories

Canon manufacture a wide range of accessories to support the EOS 1000D/Rebel XS and a full brochure can be downloaded from their website (see page 237). Here we will examine some of the most useful accessories available.

AC Adaptor kit ACK-E5
A mains adaptor enabling the use of household power directly on the Canon EOS 1000D/Rebel XS.

Battery charger LC-E5E
A mains charger for use with LP-E5 batteries.

Battery pack LP-E5
A rechargeable lithium-ion battery for the EOS 1000D/Rebel XS. Beware of using non-Canon products.

Car battery charger CBC-E5
A useful accessory for charging LP-E5 batteries when away from home and on the move.

Battery grip BG-E5
This grip attaches to the base of the camera, doubles shooting time by carrying two batteries and provides an additional shutter release when shooting vertical images. The battery grip significantly improves handling, especially with heavier lenses.

EX Speedlites
EX Speedlite is the name given to Canon's wide range of hotshoe-mounted or off-camera flashguns, designed to work intelligently with EOS bodies using their own E-TTL II auto flash system. Full details of EX Speedlite models and their supporting accessories can be found in Chapter 4.

Speedlite transmitter ST-E2
This can be used to control wireless flash using two groups of compatible EX Speedlites.

Remote switch RS-60 E3
A short electronic remote-release cable. The shutter-release switch can be half-depressed to activate autofocus and metering just as on the camera.

Eyepiece extender EP-EX15 II
Extends the eyepiece by 15mm to provide more comfortable viewing. The extender also reduces contact with the LCD monitor.

E-Series dioptric adjustment lenses

Removes the need to wear spectacles while shooting. Available in ten strengths between +3 and -4 dioptres.

Angle finder C

Allows viewing at right angles to the camera eyepiece for low-viewpoint photography.

Portable storage devices

Canon manufacture the Media Storage M30 and M80 storage devices, each with a 3.7in (9cm) LCD screen and offering 30GB and 80GB storage respectively. These are portable hard drives onto which memory cards can be downloaded, and can be less expensive than carrying several high-capacity CF cards.

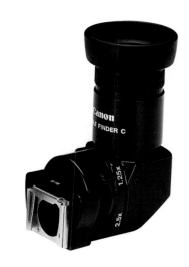

Lens hoods

'L' series lenses come with hoods, but they need to be purchased separately for other lenses.

Body and lens end caps

It is always worth carrying one of each of these.

Chapter 8

Connection

If you want to save and organize your images, print them, or show them to others on your television, you need to be able to connect your camera to a variety of other devices.

These devices would usually include a computer, a printer and a TV. When the 1000D/Rebel XS is connected to a computer, it is also possible to control shooting remotely via the keyboard.

Connecting to a computer

Screen calibration

Before manipulating images on your computer, ensure that your monitor is calibrated for brightness, contrast and colour using dedicated software or graphics freely available on the internet. You should be able to discern a good range of tones from pure black to pure white. If the dark grey tones blend into black, the screen is too dark. If the light grey tones blend into white, the screen is too bright.

When calibrating colour on your monitor, ensure that both RGB and CMYK colours are represented. A very useful screen calibration image – which includes a colour photo, grey scales, RGB and CMYK panels, and a colour chart – can be downloaded from Adobe's website.

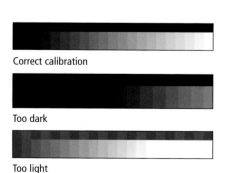

Correct calibration

Too dark

Too light

Correct colour calibration

EOS Digital Solution Disk

1) Ensure that your camera is NOT connected to your computer.

2) Insert the EOS Digital Solution Disk (provided with the camera).

Warning!
Do not connect your camera to your computer before installing the software provided, as it may not be installed correctly.

3) Click on **Easy Installation** and follow the prompts through the rest of the installation procedure.

4) When installation is completed, you will be prompted to restart the computer (leave the CD in the drive).

5) When your computer has rebooted, remove the CD from the drive.

EOS Digital Software Instruction Manuals Disk

1) Insert the disk into the CD drive of your computer.

2) Open the CD in **My Computer** (or in the **Finder** if using a Mac).

3) Click on **START.pdf files**.

Warning!
All Canon's software instruction manuals are in PDF format so ensure that you have the necessary reader software installed before you start. You can download Adobe Reader free from www.adobe.com.

4) Adobe Reader will display the Instruction Manuals index.

5) Save each PDF file to your computer in the location of your choice.

Note
Software updates for the programs on the EOS Digital Solutions Disk are available to download from the Canon website (see page 237).

CONNECTION

Connecting the camera

Warning!
Before connecting the camera to a computer, install the EOS Digital Solution Disk and ensure that the camera battery is fully charged.

1) Ensure that the camera is switched off.

2) Connect the USB cable (provided with the camera) to the camera's ↤ port. The ↤ symbol must face the front of the camera. Connect the other end of the cable to a USB port on the computer.

3) Turn the camera's power to **ON**.

4) EOS Utility should start automatically. If it does not, select **EOS Utility** from the program selection screen and **EOS 1000D** from the camera model selection screen.

5) The **EOS Utility** screen will be displayed on the computer screen and the Direct Transfer menu will appear on the camera's monitor. The 🗁↝ button's blue lamp will illuminate to indicate the camera-to-computer connection.

Transferring images

Images will be saved in My Pictures (Windows) or Pictures (Mac) and organized by shooting date. You can choose to transfer **All images**, **New images**, **Transfer order images**, **Select & transfer** or **Wallpaper**.

1) Select the required images and press the 🗁↝ button. The button's blue lamp will blink to indicate the transfer process and a progress screen will display on the camera's monitor.

2) Press **MENU** to exit.

3) Transferred images will automatically open in Digital Photo Professional ready for editing.

Tip
If you choose **Select & transfer**, you can use the **Transfer order** function in the ▶ Playback menu to select the images beforehand. Use the ◀ and ▶ buttons to scroll through the images and ▲ and ▼ to select or deselect an image. Press **MENU** twice to save the selection to the memory card. Up to 998 images can be selected. An image which has been captured as both RAW and JPEG will count as a single image.

214

Canon software

Canon produce their own software specifically designed to work with their digital cameras. It is largely aimed at EOS digital SLR users but also works with certain Powershot models. It is sometimes possible to launch one program from within another. Due to the complexity of this integration, and because programs such as Digital Photo Professional and Picture Style Editor now represent significant pieces of software in their own right, only a brief outline of their capabilities can be given here. For detailed information, refer to the instruction manuals on the CD provided with your camera.

Picture Style Editor

Picture Style Editor applies six Picture Styles to base images, saving you from repeatedly making the same adjustments to each one. Each Picture Style can be customized and registered in order to fine-tune the desired results. Changes to colour tone, saturation, contrast, sharpness and gamma characteristics can all be applied. Picture styles that have been defined in-camera can also be saved onto the computer. Picture Styles can be even applied to images that have been shot previously on cameras which do not support Picture Styles.

Digital Photo Professional

Digital Photo Professional is a standalone RAW workflow tool that links with or incorporates other Canon software such as PhotoStitch and Picture Style Editor. It can be used to adjust RAW images, apply Picture Styles, and convert RAW to JPEG or TIFF files both singly and through batch processing. It also supports the use of JPEG and TIFF files as base images with which to work. Digital Photo Professional includes sophisticated colour-management techniques including CMYK simulation.

EOS Utility

EOS Utility facilitates batch downloading of your images from the camera to the computer, also allowing you to only download selected images. It also enables you to capture images remotely by controlling the camera from the computer. The latter supports Live View shooting in EOS cameras and links with Digital Photo Professional in order to view and work with remotely captured images.

ZoomBrowser EX

ZoomBrowser EX is used for viewing, organizing and editing images and folders via a variety of windows. It also facilitates the printing of images with Canon inkjet printers. Secondary software such as Camera Window and Raw Image Task may be started from within ZoomBrowser. The programme's editing suite supports adjustments to brightness, colour, cropping, sharpness, red-eye correction, adding images to e-mails or using them as wallpaper or screen-savers, and the insertion of text into images. It also facilitates the transfer of images to Canon iMAGE Gateway.

Canon iMAGE Gateway

Canon iMAGE Gateway provides 100MB of web space, allowing you to share photos with friends and family by creating online albums. It even supports the customization of your camera by adding start-up images and sound effects as well as downloadable Picture Styles.

PhotoStitch

PhotoStitch permits the opening and arranging of images to be merged, saved and printed.It is frequently used to create panoramic images.

File formats

A file is a collection of data stored as a single unit and identified by a filename with a suffix (referred to as an 'extension') which identifies the file type. Files can be opened, saved, deleted, and moved to different folders as well as being transferred across network connections.

If you are a recent convert from film, the advantages of digital photography become clear very quickly, but so do a number of other factors. It is all too easy to have duplicate images in different folders (which can be an advantage, but also a nightmare, especially for the professional), you can lose an image through accidental deletion or file corruption, and you need to establish a management system very early on if you anticipate building a collection of images that might eventually run into tens of thousands. A safe back-up system needs to be put in place very quickly.

For those reading this guide who have just upgraded from a camera that could only record JPEG images, the whole subject of file types may be unexplored territory. But the 1000D/Rebel XS also has the ability to shoot RAW images, which will open up significant new horizons for the former JPEG shooter.

Changing from shooting JPEG to shooting RAW will introduce a completely different approach to processing images on computer and may involve a complete overhaul of shooting technique into the bargain. The shortcuts to printing and displaying images, with little or no processing beyond what takes place in-camera, will be replaced by what RAW shooters in particular call 'digital workflow'. This is a set of procedures that covers every stage between capturing the image and its final resting place, be that a print in a frame, in an online album, as a submission for publication, or simply as a screensaver.

JPEG files
JPEG stands for Joint Photographic Experts Group, the committee that developed the format. A JPEG file uses 'lossy' compression, which means that image information is lost during the compression process. If the image is compressed too much or too frequently, the image quality degrades significantly. A useful attribute of JPEGs for commercial purposes is that they are 'cross-platform', meaning that any file will look the same on both a Mac and a PC. Its file extensions are .JPEG or .JPG (in either upper or lower case).

JPEGs take up a lot less memory than any lossless format, regardless of whether they are saved at low, medium or high quality settings. They are useful at low resolution for use as thumbnails, for emailing, and even for use on a website when 72 ppi is sufficient. When saved at a resolution of 300 ppi they are good enough to be used for publication.

The disadvantage of JPEGs is that cameras tend to perform a number of processing tasks on them at the time of shooting and consequently there is far less control over the final result than with a RAW file, even using sophisticated post-processing software. To some extent, the 1000D/Rebel XS gets around this by giving the user some control over shooting parameters in Creative Zone modes.

TIFF files

TIFF stands for Tagged Image File Format. It is a lossless format that can handle up to 24-bit colour for a wider range of tones. Files use the extensions .TIF or .TIFF and are the preferred format for many professionals when converting RAW files.

RAW files

RAW files are entirely unprocessed, so they are popular with those who wish to retain total control over their images. Because RAW files are uncompressed, they are much larger than typical JPEG images. This means using larger capacity memory cards or downloading images more frequently.

The usual analogy is that RAW files are like negatives and the computer is the darkroom. With RAW files you have complete control over white-balance adjustments, exposure, sharpness and contrast. However, RAW files cannot be opened by many image-viewing programs and require specialist software to process and save them to JPEG or TIFF. When you save a RAW image in another file format you still retain the original RAW file. The 1000D/Rebel XS saves RAW files with the file extension .CR2.

The term RAW refers to a range of file types which have much in common but are not identical. Canon initially used the CRW format but have now replaced this with CR2; other camera manufacturers have their own versions of RAW. Many think that the only sensible solution is to adopt a single RAW format that can be shared across different software and even different platforms. Adobe believe they have the solution to these problems in the form of the DNG (Digital Negative) format. Several camera manufacturers already support DNG and it seems likely that it will eventually become the industry-standard archival format for RAW files.

RIVER CLYDE BY NIGHT
Complex lighting situations like this are best captured using RAW files. This gives you maximum flexibility for adjustment when processing the image.

Settings
Aperture priority (Av) mode
ISO 100
f/8 at 1/15 sec
Evaluative metering
White balance: 5200°K
Focus mode: One Shot AF

Using a printer

You can connect the EOS 1000D/Rebel XS directly to a printer and print the images held on the memory card. It is also possible to pre-select which images you wish to print. The camera is compatible with ✔ PictBridge. The printing procedure is controlled directly from the camera using the LCD monitor to view the operation. If your printer has slots for

Warning!
Printers that are only compatible with CP Direct or Bubble Jet Direct cannot be used with the 1000D/Rebel XS.

memory cards, you may also be able to simply insert your memory card into the printer without connecting the camera.

Connecting to a printer

1) Check that the camera's battery is charged or use the AC Adaptor Kit ACK-E2 (sold separately) to use mains power.

2) Ensure that the camera is switched off.

3) Connect the USB cable (provided) to the camera's ⟳ terminal. The ⟳ symbol must face the front of the camera.

4) Connect the cable to the printer according to the printer's manual.

5) Turn on the printer.

6) Turn the camera's power switch to **ON**.

At this point some printers may emit a beep. If this beep is prolonged, there is a problem with the printer. To discover the error, press the ▶ playback button on the camera. When the image is played

back, press ▶. On the Print Setting screen, select **Print** and the error message should be displayed on the LCD monitor.

Possible error messages include Paper Error, Ink Error, Hardware Error, and File Error. These messages may also be displayed at any time during the printing process. Press **SET** to pause printing while you resolve the issue, then select **Continue**.

Note
Photos remaining on the memory card after being shot on a different camera may not be compatible. Similarly, photos on the memory card which have been adjusted on the computer may not print.

220

7) Press the ▶ playback button to bring up the first image. The ⚡ symbol will show on the monitor at top left indicating camera-printer connection. The 🖶~ button's blue lamp will illuminate.

8) If this is not the image you wish to print, use the ◀ or ▶ buttons to scroll through the images on the card.

9) Press **SET**. If you delay, the message **Press SET/SET to print** will be displayed as a prompt. If you have selected a RAW image, the monitor will display an error message instead.

10) The LCD monitor will display the **Print Setting** screen with the selected image reduced in size plus a list of settings covering printing effects, date, file number, quantity, trimming, paper size and layout. Amend these as desired using the ▲ and ▼ buttons to scroll through the menu and **SET** to select an item to change.

At this point you may wish to go to Step 11 on page 222 where you can find the full setting procedure followed by trimming instructions. If you want to skip the full Print Settings procedure and Trimming at this stage, or are already familiar with them, go to Step 27 opposite.

27) When you are ready to begin printing, select **Print** and press **SET**.

28) The 🖶~ button's blue lamp will blink and printing will start.

29) While **STOP** is displayed you can stop printing by pressing **SET** and then **OK**.

30) To print further images using the same settings, select each image and press the 🖶~ button.

31) When you have finished printing, turn off the camera.

32) Turn off the printer.

33) Disconnect the USB cable.

CONNECTION

Paper Settings

11) From the **Print Setting** menu reached in step 10 (see page 221), select **Paper settings** and press **SET**.

12) The **Paper size** screen will be displayed first. Select the paper to be loaded into the printer and press **SET**.

13) The **Paper type** screen will be displayed next. Select the type of paper to be used and press **SET**.

14) Finally, the **Page layout** screen will appear. Select and press **SET**. Depending on the printer in use, possible page layouts may include: Bordered, Borderless, Bordered with info, and Default.

Bordered with info prints will have shooting information printed on the border for 9x13cm and larger prints. Default prints on a Canon printer will be borderless.)

15) The display will now revert to the **Print Setting** screen.

Common problems

If your printer cannot print borderless prints, it will probably rescale the image and print it with a border.

Tips

Images can also be printed as thumbnails, as either a set of 20 or a set of 35 on A4 paper. A set of 20 will also print shooting information. See DPOF printing on page 227.

16) On the **Print Setting** screen, select the 🖻 symbol and press **SET**. The default setting is **Off** but the options in the tables which follow may be available.

17) Select the effect you wish to apply and press **SET**.

18) If the 🖻 icon is displayed next to **DISP**, additional options are available if you press the camera's **DISP** button.

Preset Printing Effects	
Item	**Description**
🖻 Off	Same as the printing characteristics turned **On**. No automatic correction will be performed.
🖻 On	The image will be printed according to the printer's standard colours. The image's Exif data is used to make automatic corrections.
🖻 Vivid	The image will be printed with higher saturation to produce more vivid blues and greens.
🖻 NR	The image noise is reduced before printing.
B/W B/W	Prints in black and white with true blacks.
B/W Cool tone	Prints in black and white with cool, bluish blacks.
B/W Warm tone	Prints in black and white with warm, yellowish blacks.
◘ Natural	Prints the image in the actual colours and contrast. No automatic colour adjustments will be applied.
◘ Natural M	The printing characteristics are the same as the **Natural** setting. However, this setting enables finer printing adjustments than with the **Natural** setting.
🖻 Default	The printing will differ depending on the printer. For details, see the printer's instruction manual.

* The LCD screen display may differ depending on the printer.
* When the printing effects are changed, the changes will be reflected on the LCD screen. However, the actual result of the printing effects might look different from what you see on screen. The LCD screen only shows an approximate rendition.

CONNECTION

Adjustable Printing Effects

Brightness	The image brightness can be adjusted.
Adjust levels	When you select **Manual**, you can change the histogram's distribution and adjust the image's brightness and contrast. With the **Adjust Levels** screen displayed, press the **INFO** button to change the position of the indicator. Turn the ⊙ Quick Control Dial to freely adjust the shadow level (0–127) or highlight level (128–255).
Brightener	Effective in backlit conditions which can make the subject's face look dark. When **On** is set, the face will be brightened for printing.
Red-eye corr.	Effective in flash images where the subject has red eye. When **On** is set, the red eye will be corrected for printing.

* The **Brightener** and **Red-eye corr.** effects will not show up on the screen.
* When you select **Detail set.** you can adjust the **Contrast**, **Saturation**, **Color tone** and **Color balance**.
* When you select **Clear all**, all the printing effects will revert to the default.

Date / Time / File Number

19) Select ⊙, then press **SET**.

20) Select the desired setting and press **SET** again.

Number of copies

21) Select ▣ then use the ▲ or ▼ buttons to set the number of copies required. Press **SET**.

22) Unless you want to trim images, go back to step 27 on page 221 to start printing.

Trimming the image

Trimming should only be done after all other print settings are complete.

23) On the **Print Setting** screen, select **Trimming**.

24) Use the ⊟/⊕ Enlarge and ✱/⊡● ⊖ Reduce buttons to adjust the size of the trimming frame and the □□□□ buttons to move the frame.

25) Press the **DISP** button to rotate the image through 90°.

26) Press **SET** to exit Trimming and go back to Step 27 on page 221.

Digital Print Order Format (DPOF)

Commonly abbreviated to DPOF, this is a system for recording printing instructions to the memory card. The DPOF system is managed through the **Print Order** option in the ▶ Playback Menu.

With the 1000D/Rebel XS connected to a compatible printer, it is possible to use the **Print Order** menu to manage the direct printing of your images from the memory card in the camera. In addition, because the DPOF data is stored on the memory card, it is possible to simply take the card to an in-store photo printing facility.

Digital Print Order Format (DPOF) settings can be applied to all JPEG images on the memory card or to selected images. (RAW images are not compatible with direct printing.) However, different settings cannot be applied to individual images in the same batch and therefore the same print type, date and file-number settings will be applied.

CONNECTION

Print ordering

First set up the print type, date and file number to be applied to all the images to be printed. File number and date settings are restricted to **On** or **Off**. **Standard** print type prints a single image per sheet. **Index** prints thumbnail images.

1) Select the ▶ Playback menu and press **SET**.

2) Select **Set up** and press **SET**.

3) A menu showing Print type, Date, and File number options will be displayed. Select the one required and press **SET**. On the sub-menu select the option desired and press **SET**.

4) Press **MENU** to return to the Print order menu and select either **All images** or **Select images** to finalize your settings.

Before printing with DPOF you will need to select the images you wish to print. You can do this with single images displayed on the monitor or a group of three images. Use the ✱/⊟• ⊖ reduce button and the ⊟/⊕ enlarge button to toggle between the two different display formats.

5) If you have opted for **Sel. Image** in step 4 above, you can add images one by one to the print order.

6) For **Standard** or **Both** settings, use the ▲ or ▼ buttons to change the required number of copies of the image displayed.

7) For **Index** printing, use the ▲ or ▼ buttons to check the box so that the image is included.

Tips

With **Index printing** you cannot print both **Date** and **File number**.

Even with **Date** or **File number** selected, some printers may not print this information.

Unless it has been reformatted, do not insert a memory card which has already had DPOF settings applied in a different camera and try to apply new print order settings.

Up to 400 images can be selected for a single print order with a PictBridge printer.

226

Direct printing with DPOF

Having determined your print order, you can use DPOF to print directly to a PictBridge printer.

1) Connect the camera and printer as described in Steps 1–6 on page 226.

2) Select the ▶ Playback menu and then **Print order**.

3) Select **Print**.

4) Set the **Paper settings** as in Steps 11–15 on page 222.

5) Set the **Printing effects** as in Steps 16–18 on page 223.

6) Select **OK**

Viewing images on television

The 1000D/Rebel XS comes supplied with the leads necessary for this method of playing back your photos on a television, which is an ideal way of displaying them to a group of friends and family.

1) Ensure that both the camera and television are turned off.

2) Open the terminal cover on the camera's left side.

3) Insert the video cable (provided) into the **VIDEO OUT** terminal.

4) Insert the other end of the video cable into the television set's **VIDEO IN** terminal.

5) Switch on the television and select the **VIDEO IN** channel.

6) Turn on the camera.

7) Press the ▶ playback button on the camera. When the images are displayed on the television, the camera's LCD monitor will remain blank. However, you can manage the playback options using the camera's controls just as you would when using the camera's LCD monitor.

8) To disconnect, turn the camera's power switch to **OFF** then turn off the television and disconnect the video cable.

Common problems

If the video system selected in 𝖄𝖳ᵢ Set-up menu 2 does not match that of the television, images will not be displayed properly. Change the camera setting.

Some televisions use different screen formats. Consult your TV's instruction manual for details.

ALL THAT GLITTERS
Fine white sand, sunshine, and a strengthening breeze hold the promise of a great afternoon. But that same combination can spell danger for cameras and lenses.

Settings
Canon EF 28mm f/2.8
Aperture priority (Av) mode
ISO 100
f/5.6 at 1/1250 sec
Evaluative metering
Exposure compensation -⅓
White balance: Auto

Glossary

Aberration An imperfection in the image caused by the optics of a lens.

AE (autoexposure) lock A camera control that locks in the exposure value, allowing an image to be recomposed.

Angle of view The area of a scene that a lens takes in, measured in degrees.

Aperture The opening in a camera lens through which light passes to expose the CMOS sensor. The relative size of the aperture is denoted by f-stops.

Autofocus (AF) A reliable through-the-lens focusing system allowing accurate focus without the user manually turning the lens.

Bracketing Taking a series of identical pictures, changing only the exposure, usually in half or one f-stop (+/-) differences.

Buffer The in-camera memory of a digital camera.

Burst size The maximum number of frames that a digital camera can shoot before its buffer becomes full.

Cable release A device used to trigger the shutter of a tripod-mounted camera at a distance to avoid camera shake.

Centre-weighted metering A way of determining the exposure of a photograph placing importance on the light-meter reading at the centre of the frame.

Chromic aberration The inability of a lens to bring spectrum colours into focus at one point.

CMOS (complementary oxide semi-conductor) A microchip consisting of a grid of millions of light-sensitive cells – the more sensors, the greater the number of pixels and the higher the resolution of the final image.

Colour temperature The colour of a light source expressed in degrees Kelvin (°K).

CompactFlash card A digital storage mechanism offering safe, reliable storage.

Compression The process by which digital files are reduced in size.

Contrast The range between the highlight and shadow areas of an image, or a marked difference in illumination between colours or adjacent areas.

Depth of field (DOF) The amount of an image that appears acceptably sharp. This is controlled by the aperture: the smaller the aperture, the greater the depth of field.

Dioptre Unit expressing the power of a lens.

dpi (dots per inch) Measure of the resolution of a printer or a scanner. The more dots per inch, the higher the resolution.

Dynamic range The ability of the camera's sensor to capture a full range of shadows and highlights.

EF (extended focus) lenses Canon's range of fast, ultra-quiet autofocus lenses.

Evaluative metering A metering system whereby light reflected from several subject areas is calculated based on algorithms.

Exposure The amount of light allowed to hit the CMOS sensor, controlled by aperture, shutter speed and ISO-E. Also the act of taking a photograph, as in 'making an exposure'.

Exposure compensation A control that allows intentional over- or underexposure.

Extension tubes Hollow spacers that fit between the camera body and lens, typically used for close-up work. The tubes increase the focal length of the lens, and magnify the subject.

Fill-in flash Flash combined with daylight in an exposure. Used with naturally backlit or harshly side-lit or top-lit subjects to prevent silhouettes forming, or to add extra light to the shadow areas of a well-lit scene.

Filter A piece of coloured, or coated, glass or plastic placed in front of the lens.

f-stop Number assigned to a particular lens aperture. Wide apertures are denoted by small numbers such as f/2; and small apertures by large numbers such as f/22.

Focal length The distance, usually in millimetres, from the optical centre point of a lens element to its focal point.

Focal length and multiplication factor
The CMOS sensor of the 1000D/Rebel XS measures 22.2 x 14.8mm – smaller than 35mm film. The effective focal length of the lens appears to be multiplied by 1.6.

fps (frames per second) The ability of a digital camera to process one image and be ready to shoot the next.

Histogram A graph used to represent the distribution of tones in an image.

Hotshoe An accessory shoe with electrical contacts that allows synchronization between the camera and a flashgun.

Hotspot A light area with a loss of detail in the highlights. This is a common problem in flash photography.

Incident-light reading Meter reading based on the light falling on the subject.

Interpolation A way of increasing the file size of a digital image by adding pixels, thereby increasing its resolution.

ISO-E (International Organization for Standardization) The sensitivity of the CMOS sensor measured in terms equivalent to the ISO rating of a film.

JPEG (Joint Photographic Experts Group) JPEG compression can reduce file sizes to about 5% of their original size.

LCD (liquid crystal display) The flat screen on a digital camera that allows the user to preview digital images.

Macro A term used to describe close focusing and the close-focusing ability of a lens.

Megapixel One million pixels equals one megapixel.

Memory card A removable storage device for digital cameras.

Microdrives Small hard disks that fit in a CompactFlash slot, resulting in larger storage capabilities.

Mirror lock-up A function that allows the reflex mirror of an SLR to be raised and held in the 'up' position, before the exposure is made.

Pixel Short for 'picture element' – the smallest bits of information in a digital image.

Predictive autofocus An autofocus system that can continuously track a moving subject.

Noise Coloured image interference caused by stray electrical signals.

Partial metering A metering system that is unique to Canon, it meters a relatively small area at the centre of the frame.

PictBridge The industry standard for sending information directly from a camera to a printer, without having to connect to a computer.

Red-eye reduction A system that causes the pupils of a subject to shrink by shining a light prior to taking the flash picture.

RAW The file format in which the raw data from the sensor is stored without permanent alteration being made.

Resolution The number of pixels used to capture or display an image. The higher the resolution, the finer the detail.

RGB (red, green, blue) Computers and other digital devices understand colour information as combinations of red, green and blue.

Rule of thirds A rule of thumb that places the key elements of a picture at points along imagined lines that divide the frame into thirds.

Shading The effect of light striking a photosensor at anything other than right angles, incurring a loss of resolution.

Shutter The mechanism that controls the amount of light reaching the sensor by opening and closing.

SLR (single lens reflex) A type of camera (such as the EOS 1000D/Rebel XS) that allows the user to view the scene through the lens, using a reflex mirror.

Spot metering A metering system that places importance on the intensity of light reflected by a very small portion of the scene.

Teleconverter A lens that is inserted between the camera body and main lens, increasing the effective focal length.

Telephoto lens A lens with a large focal length and a narrow angle of view.

TTL (through the lens) metering
A metering system built into the camera that measures light passing through the lens at the time of shooting.

TIFF (Tagged Image File Format)
A universal file format supported by virtually all relevant software applications. TIFFs are uncompressed digital files.

USB (universal serial bus) A data transfer standard, used by the Canon EOS 1000D/Rebel XS when connecting to a computer.

Viewfinder An optical system used for composing and sometimes focusing the subject.

White balance A function that allows the correct colour balance to be recorded for any given lighting situation.

Wide-angle lens A lens with a short focal length and consequently a wide angle of view.

Useful websites

CANON

Worldwide Canon Gateway
www.canon.com

Canon USA
www.usa.canon.com

Canon UK
www.canon.co.uk

Canon Europe
www.canon-europe.com

Canon Oceania
www.canon.com.au

Canon EOS
www.canoneos.com

Canon Camera Museum
Online history of Canon cameras
www.canon.com/camera-museum

Canon Enjoy Digital SLR Cameras
Advice on using digital SLRs
web.canon.jp/Imaging/enjoydslr/index.html

GENERAL SITES

Photonet
Photography discussion forum
www.photo.net

The EOS Experience
EOS-related seminars
www.eos-experience.co.uk

Bureau of Freelance Photographers
Expert advice and tuition
www.thebfp.com

ePHOTOzine
Online magazine with a photographic
forum, features and monthly competitions
www.ephotozine.co.uk

SOFTWARE

Adobe USA
www.adobe.com

Adobe UK
www.adobe.co.uk

EQUIPMENT
Lee Filters
www.leefilters.com

Cokin Filters
www.cokin.com

Hitech Filters
www.formatt.co.uk

Hoya Filters
www.hoya-online.co.uk

SanDisk
www.sandisk.com

Speedgraphic
Mail order dealers
www.speedgraphic.co.uk

PHOTOGRAPHY PUBLICATIONS

Photography books
www.pipress.com

***Black & White Photography* magazine**
***Outdoor Photography* magazine**
www.thegmcgroup.com

***EOS* magazine**
www.eos-magazine.com

Index

Contact us for a complete catalogue or visit our website:
Ammonite Press, Castle Place, 166 High Street, Lewes, East Sussex, BN7 1XU, United Kingdom
Tel: 01273 488005 Fax: 01273 402866
www.ae-publications.com